Early Christian Art

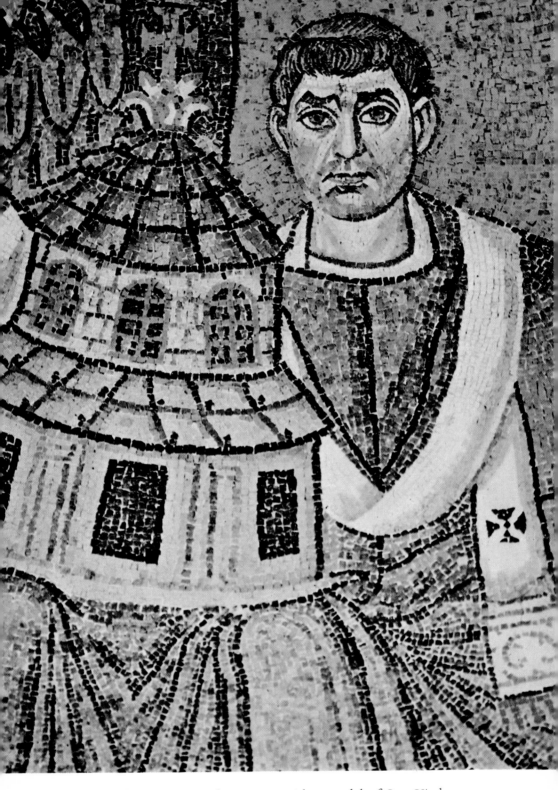

Bishop Ecclesius of Ravenna with a model of San Vitale
ca. 549. Detail of the mosaic in the apse, San Vitale

EARLY CHRISTIAN ART

F. van der Meer

Translated by
Peter and Friedl Brown

THE UNIVERSITY OF CHICAGO PRESS

The title of the original Dutch edition was
Oudchristelijke Kunst

The University of Chicago Press, Chicago 60637
Faber and Faber Limited, London, W.C.1

1959 © Uitgeversmaatschappij W. de Haan N. V. (Zeist)
This translation © 1967 by Faber and Faber Limited

All rights reserved. Published 1967
Library of Congress Catalog Card Number 67-25083

Composed and printed in England

TRANSLATORS' NOTE

When the original Dutch version of this book was translated into German the author took the opportunity of incorporating some revisions and fresh material into the text. We have, therefore, with the author's approval, translated from the German rather than from the original Dutch.

Contents

Illustrations

(see also Commentary on Plates, p. 127)

Bishop Ecclesius of Ravenna with a model of San Vitale ca. 549. Detail of the mosaic in the apse, San Vitale

colour frontispiece

9

Preface

Examples of Early Christian art are far from numerous; and, with the exception of those in Ravenna, they are relatively inaccessible, at any rate to travellers who insist on a reasonably comfortable journey. Yet, to us today, they seem oddly familiar and comprehensible, since their creators so often appear to be trying to express a vision very similar to the vision of many modern artists. I stress the word *appear*, for in fact they belong to a very different world.

Our knowledge of this world and its forms and ideas is very fragmentary; and to attempt a survey of it, is perhaps an over-ambitious undertaking. But without some knowledge of the ancient world, and also of Byzantine and early medieval art, it is difficult to grasp the full meaning and significance of Early Christian art. For a long time it was ignored, and for a while it was despised; today it is almost universally admired, though often uncritically (for, even in this art, as in any other, the masterpieces are few and far between).

This book deals with the discovery of Early Christian art and with its most important manifestations, arranged according to subject. I have deliberately taken as my point of departure, not outward forms, which in many ways are simply continuations of earlier traditions, but the meaning and purpose of the works discussed. The necessity for this emphasis on content is obvious enough. The men who created these works of art did not create them for their own sake. They were skilled if simple craftsmen, fully aware that the forms their creations took should make their meaning plain. They were adherents

of a Christianity that had a message for the men of their time, and a precious inheritance to leave to coming ages.

At the end of the book I have added a short commentary on individual pictures.

F. van der Meer

The Discovery

A hundred and fifty years ago Early Christian art was almost totally ignored. With the exception of a few scholars, no one was interested in – or indeed knew about – the works that had come down to us from that remote age. Admittedly, since the opening of the catacombs in 1590, learned archaeologists had described them and their contents time and again with exactitude and erudition, had collected and published inscriptions, had deciphered pictures on the walls of tombs, had interpreted the mosaics of a few Roman churches; but they never thought of these things as works of art in their own right.

It was true, of course, that it was not simply taken for granted that these works were inferior, as it was of those belonging to the 'barbarian' Middle Ages: they were still regarded as part of the heritage of the ancient world, even though they originated in a time when that world was on the point of expiry. Their period was certainly thought of as decadent; but it was transformed by the touch of tragedy and a certain death-bed dignity. Its few monuments excited the interest of historians and theologians; but they were rarely if ever regarded as sources of aesthetic pleasure in their own right.

In the museums which began to be established around 1800 even pagan sarcophagi were placed in the background. The Lateran Museum was exceptional: Christian sarcophagi (Plates 30b and c), which were just beginning to attract interest, especially in Rome, did have a special department to themselves after 1800. But almost everywhere else they lay forgotten in storerooms; in the crypts of Spanish, Italian and Southern French churches, among medieval

tombs; and as often as not they had been defaced with later inscriptions. A magnificent collection of this kind can still be seen in the vaults beneath the great Cathedral at Palermo (Plate 30a). Many sarcophagi had been placed under old altars and no one knew how long they had been there. They contained the relics of local saints and altar cloths obscured ancient carvings that no one bothered to inspect.

In the nave of Sant' Apollinare Nuovo in Ravenna an organ covered a considerable expanse of the now world-famous mosaics (Plate 19) and, as a result, some irreparable damage was done to them. In the Baroque period the dome of San Vitale was adorned with gay but completely second-rate frescoes, in such a way as to make the main building, with its barely accentuated conchshell vaulting, its openwork niches and the lace-like appearance of its imposts, look provincial and shoddy. Yet, today, hundreds of thousands of visitors come to admire it–indeed it has become one of the highlights of an Italian journey. The area around the altar, where all the mosaics still survive undamaged (Plate 7), was cluttered with the usual heavy Baroque furnishings, and here too a small organ was erected in front of the mosaics.

In those days it would never have occurred to a northern traveller on his Grand Tour, to visit Ravenna, even if he were familiar with its former history: even if he knew that in the fifth century the last Christian Emperors of the West lived there in the midst of melancholy marshland in constant terror of the barbarians. Montesquieu did not stop in Ravenna, nor did Stendhal. If by some chance a traveller found his way thither, he would certainly have visited the tomb of Dante beside the Basilica of San Francesco and the new Baroque eighteenth-century cathedral–light, aristocratic, yet irredeemably mediocre. It would never have crossed his mind–or, if it did, the thought would have left him undisturbed–that the ancient fifth-century basilica of the bishop Ursus–the Basilica Ursiana–had been demolished to make room for the new cathedral; and it would have been surprising if the sexton had ever thought of showing him the interior of its neighbour, the ancient baptistery, also dating from the fifth century. Today, every student of art history is familiar with it and with its mosaics, from reproductions: it is perhaps the most beautiful interior in the world.

Since 1845, of course, the educated public knew about the catacombs, and it was the catacombs that first aroused interest in what

we now call Early Christian art. Yet it was the same catacombs which were responsible for a picture of the ancient Christians and their world which was almost purely fictitious and romantic and which has made it immeasurably more difficult for us today to understand the true character of their age.

As early as 1590, part of the catacombs had been uncovered purely by chance, and this 'underground Rome' was made known to the world by Bosio and others in a series of handsome folio volumes, in Latin and Italian, illustrated with magnificent engravings in which the faint outlines sketched in ancient times were transformed into all too typical Baroque figures, placed without any regard to or conception of the true relationship between them. But after 1830, a group of Roman archaeologists began a systematic excavation of all the catacombs in Rome and its surroundings known from literary sources. The material thus brought to light, under the directorship of Giovanni Battista de Rossi, was so extensive and so interesting, that it not only provoked animated debates in learned circles, but formed, too, the subject of polite conversation in cultivated Italian salons and in the cloisters of the southern monasteries. Indeed a visit to at least one of the catacombs soon began to be *de rigueur* for any visitor to Rome; and they, more than anything else, brought the days of early Christianity to life in the European imagination.

From that period on, these secret subterranean cemeteries were regularly inspected not only by the scholar and pilgrim, but also by the passing tourist–or at any rate such of them as could then be visited: some thirty or forty corridors of the Catacomb of Calixtus close to the Via Appia to the South of Rome. Then back at home the tourists would read Wiseman's *Fabiola* and find there a moving description of the early Christians and their lives; of men who, during the centuries of persecution, celebrated the holy mysteries below ground. By the light of countless lamps, clad in white robes adorned with the initials of Christ, they buried their martyrs by the thousands. Anonymous artists had depicted the mysterious figures of Daniel, Jonah, Noah and Susannah, and the even more mysterious *orantes*–praying figures–on the walls of burial niches carved out of the tufa rock. These figures could actually be seen, executed with extreme economy, but scholars differed as to their meaning. Readers of *Fabiola*, however, accepted without question the picture presented there by Wiseman–a picture to which their children returned, re-

17

produced with very little variation, in *Ben Hur* and *The Last Days of Pompeii*.

This romantic view of the catacombs was almost universally accepted. Everyone talked of the 'Church of the Catacombs', as if its existence could be taken for granted, and even today this concept has not been entirely superseded. But a hundred years ago even archaeologists thought that Early Christian art had originated in the catacombs; and some textbooks on the history of art still accept this without question, even though it entails the supposition that city dwellers, as the Christians of the second or third century must have been, lived as troglodytes in the midst of–or beneath–their 800,000 fellow citizens in the capital of the world.

Sentimental engravings depicting this subterranean Christianity were reverently contemplated in countless homes. Maidens and senators in 'Empire' robes strolled side by side with slaves and paupers, also invariably well dressed; and all of them were grouped round the grave figure of a bishop, dressed in a mixture of ancient and medieval costume such as had never been worn by any living person. And if later on the readers of these books and the owners of these pictures visited Rome, they would see, by the light of wax tapers, underground chambers which seemed to confirm the authenticity of the scenes shown in the engravings. They would see the endless corridors and inspect recently excavated burial chambers of the martyr-popes of 250 to 290; and there were fragments of inscriptions of former tombs scattered on the ground (Plate 20) which gave the impression that Christian communities had lived there, submerged, for hundreds of years, constantly raided by a ruthless Roman police and decimated by bloody executions.

The visitor would envisage Christian life in early times as more or less confined to this setting–a life lived out in passages in which there was hardly room to walk side by side (Plate 27). It was confidently believed that Christian life ran its course in chambers where no more than a mere handful of people could find standing space around a tomb. Any seat carved out of the rock became all too easily a bishop's throne; and any worn bench conjured up the celebration of the Last Supper. Nobody then knew that both seat and ledge were necessary for setting out the meal of the dead, an ordinary act of piety in the ancient world which Christians as well as pagans carried out beside the graves of their relatives.

No one then realized that as early as A.D. 258 there were no less than forty large churches in private houses owned by the Christian community in Rome, which were well known to the authorities. Nor did it occur to anyone that only twice, so far as we know (in 258 and 304), the police intentionally set out to ravage and desecrate a Christian cemetery.

In short, it is a misconception to think that Christians before 313 lived as an underground community. People were misled by the number of underground burial places and failed to take into account the life lived above ground for centuries. They forgot that four-fifths of these underground passages dated from a time after the persecutions, a time of peace when Rome was almost entirely Christian (though of course the Christianization of that great city took longer than that of any other city in the ancient world). It is almost as if men in some future civilization were to try to reconstruct the life of Paris from the plundered and only partly rediscovered remains of the cemetery of Père Lachaise.

The catacomb frescoes eventually came under scrutiny. In earlier publications they were reproduced as engravings, and not until the beginning of the twentieth century did Monsignor Wilpert, a German scholar who lived on the Campo Santo near St. Peter's, have water-colour copies of all the frescoes then known made by a skilful painter. They were published in an imposing volume which still remains the standard work on the subject.

The great mosaics on the walls of some of the oldest churches of the fourth and fifth centuries fared little better. True, they could be seen *in situ*, but they were usually overshadowed by a heavy, Baroque setting. And a hundred years ago there were no reproductions available other than those that appeared in slow succession in de Rossi's *Musaici delle chiese di Roma*, a prohibitively expensive work only to be found in large libraries. It was illustrated with full-colour lithographs; but they were pale in tone and blurred in outline. Once more it was Monsignor Wilpert who published reproductions of most of them, just before the First World War, and in a more adequate and complete edition. He also published such of the sarcophagi (Plates 30b and c, 31, 32) as were known around 1922 – about a thousand, including some of the more complete fragments. In the previous century Le Blant had brought out a handsome volume on the sarcophagi, but only those from the South of France. Sarcophagi

from Rome and Ravenna–about eight hundred–had not been in-
cluded; they were thought to resemble each other so closely as to be
virtually interchangeable and no one understood the problems they
posed or set about analysing their different styles. So scholars for
years contented themselves with identifying the various Biblical
scenes depicted in them. This was no easy business: 'the somewhat
condensed presentation of Biblical events will put even people well
versed in the Bible to some trouble'–that was the opinion of Burck-
hardt. At the time, no one had any inkling of typological connec-
tions: the sequence of the different scenes was not what might
have been expected, and often seemed pointless; yet scholars
tried to find all kinds of ulterior meanings behind and beneath
them.

The search for ulterior meanings became, indeed, accepted prac-
tice. After all, there was no doubt that these 'Early Christian works
of art' were very valuable historical documents. Though the form
was poor and decadent, the content must be worthwhile, must even
be highly significant. A very wide range of patristic texts would be
minutely studied to find some meaning in a humble sarcophagus
with its frieze of stereotyped figures. It never occurred to most
scholars that even these expensive examples of craftsman's work
were, like many others, composed of clichés: and a religious cliché
can only be understood if it is followed back and traced to the point
where it first occurred, the point before it became a cliché. But the
origin of most of these Christian clichés was unknown until com-
paratively recently, and a hundred years ago people were satisfied
if they were able to identify the Biblical scenes which the figures
represented.

These Early Christian remains were very interesting; but were
they works of art? The blurred frescoes with only a few outlines
visible (Plate 29) faded a little more every year; they had deteriorated
considerably from the sharply etched pictures in Campini's books
of 1597, and those of the Roman scholars of 1840 and after. As
for the badly drawn mosaics, of which, for the most part, only
fragments remained, could one not see in them the dispiriting
influence of Byzantine rigidity, a sure sign that ancient concepts
of the beautiful were in decline? The assessment of the ancient
basilicas most frequently made was that they were badly and flimsily
built (although a few of them had managed to last a good fifteen

hundred years); and their colonnades were said to have been lifted from the nearest pagan temple.

Even if they were worth consideration as works of art, they belonged indisputably to a period of decline, the period of Gibbon's *Decline and Fall*. The French spoke of *bas Empire* and of *basse latinité*, the 'low' Empire and 'low' Latin; and the idea that Roman glory came to a full stop after Marcus Aurelius was riveted in their minds – indeed it is hardly less firmly fixed in the minds of their grandchildren today. The period between Augustus and Antoninus Pius was for them the zenith of the Empire. What came after was a speedy degeneration; and after the age of Constantine, a generation poised between two worlds, the catastrophes began – the West was submerged, and, in the East, time stood still. What remained of the Empire had become arid, its art contorted and shrunken into a deformed style – the Byzantine. The survival of this Empire for a further thousand years impressed neither the average scholar nor the schoolmaster. No one was capable of appreciating the high achievement of Byzantine culture, for they had no eye for the splendour of its art and the nobility of its self-limitation. Today we are beginning to understand it, and to see that, as with all great creative works, it is not to be measured by standards outside itself.

That Early Christian monuments were the artefacts of a degenerate culture seemed almost beyond dispute. Stiff, unmoulded figures, with no light or shade, no graceful lines, no background, no knowledge of the anatomy of the human body, almost without a trace of classic grace. Everywhere lurked the spectre of Byzantine rigidity, and at that period 'Byzantine' was considered a synonym for 'lifeless stereotype'. Surely there must be better things to see in Rome, and in Italy, that country so rich in artistic sublimity?

Even the Romantic artists – in particular those who, after 1800, discovered medieval art and praised it extravagantly – paid almost no attention to any pre-medieval work. This was true, too, of the scholars. In the course of the nineteenth century they added a mass of detail to the understanding of the content of these works, and they had included Early Christian inscriptions in vast collected folios (even though they always came after the secular inscriptions, and were usually at the very end). From 1850 onwards they examined with interest and meticulous care all the Early Christian works known at the time, yet it never occurred to them that these works

reflected a whole culture. Nor did any of their novel features excite
them, only those elements which could be linked with a disappearing
past. Even where the content was new, in that it was Christian, they
were relieved to find that the form was still classical. Here and there
they would note with satisfaction an afterglow of the beauty of the
ancient world. Whether deliberately or not, they brought much
more attention to bear on the themes these monuments represented
than on any artistic qualities they possessed, whether they were the
mass-produced artefacts of ancient workshops or expressions of an
original artistic vision. In short, they were concerned almost exclu-
sively with the content, and form did not mean much to them. They
were incapable of giving the aesthetic meaning its due; though some-
times, in spite of the limitations of their vision, they seemed to have
an inkling of the artistic qualities of the works they studied with such
myopic care.

What would they have said if they had been told that these monu-
ments would become a precious part of the aesthetic heritage of
thousands of artists, art-historians and ordinary educated people; that
fifth- and sixth-century mosaics would be copied stone by stone, and
the reproductions, displayed in exhibitions, would make an indelible
impression on those who saw them? Furthermore, that mosaics from
that decadent period, the third to the fifth century, found a few years
ago on the floor of a Roman country house in Piazza Armerina in
Sicily (Plate 47), would far outshine in their splendour all similar
mosaics from earlier times? Moreover, no one then would have
guessed that pagan mosaic floors would come to be regarded merely
as forerunners of the great wall-mosaics of 400 and later; and that
today, those of Santa Maria Maggiore in Rome (Plate 12) and those
in Ravenna would be universally regarded as the culmination of this
classical art–and not merely because of their incomparable colours.
Who would have foreseen then, that André Malraux, for example,
would consider the artefacts of Roman Imperial times, the official
works of propaganda at least, and the copies of Hellenistic sculpture,
as those of an uncreative and unimportant period, to be passed over
briefly and hastily, in order to deal more fully and in detail with the
period that follows it–the period of those works of art that had
either been ignored by previous generations or had been regarded
with positive distaste. Today the mosaics of the basilicas are no longer
regarded as curiosities, nor as mere religious documents, but as pure

22

works of art on their own terms: as unique, in their own way, as the stained glass of Bourges and Chartres, or the greatest paintings of Correggio and Titian.

This revolution in artistic taste is due not so much to the archaeologists as to the painters and sculptors of the period after 1870. They discovered the wonderful colour schemes of late antique mosaics; they saw how in them colour had become something of value in its own right, in a way that would have been unimaginable in classical Greece. Next they developed a feeling for the suggestive power of a draughtsmanship that never aimed at idealization, and that had refused to take as its model the dominant convention of the ancient world – the harmoniously proportioned human figure. Such works of art, they realized, aimed at communicating the intangible. Naturally, this aesthetic tradition was applied most meaningfully where the subjects most demanded it, in the apses (Plate 11) and the side-walls of Christian basilicas; but we find it just as powerfully in representations of the majesty of the Emperor and his entourage, as in the famous Ravenna mosaics of San Vitale. Artists were the first to feel the impact of the unearthly, superhuman vision communicated by these half-abstract compositions. Sometimes they adopted in their own work features of Early Christian art, which sensitive historians such as Jacob Burckhardt, and later Max Dvořak, Alois Riegl and Emile Mâle, had also perceived. Public taste followed, after the usual time-lag. The artists eventually reached the striking expressionist quality that is in some ways typical of Early Christian art – telling scenes, postures, gestures and piercing glances used to convey a message (Plates 31, 32, 33, 34, 35). The intense look, the face that gazes directly at us, is a typical creation of late antiquity. It stems from the Egyptian mummy-portraits of the later Roman period, through the oldest icons of Egyptian and Greek Christianity, and lives on to the present day in the traditional icons of the Greek church (Plate 37).

Historians in their turn, began to perceive in this age, the ferment of new forms of creativity. Despite the thousands of surviving sarcophagi and superb examples of ivory carving and goldsmiths' work, the culmination of Early Christian art is not, it is generally considered, only to be found in the realms of the plastic arts. Nowadays the consensus of opinion is that its greatest achievement is the one unitary masterpiece to which all the other arts were subordinated; the basilica interior, splendid with mosaics and inlaid marble.

23

Universally accepted though this view is, opinions have varied widely as to whether this great artistic achievement was 'classical' or 'Christian'. For some it belongs to 'baptized' Greco-Roman antiquity; for others it is specifically Christian, in itself a sign of a complete change of direction and a deliberate turning away from all that was most characteristic of classical art. Scholars less inclined to take extreme views recognize that the ancient Christian basilica, in common with all other major works of this period—excepting those which were mere anthologies of outworn artistic clichés—could be classified as completely Christian yet still belonged unquestionably to the ancient world. It was that crucial transitional period which bridged the gap between classical times and, in the West, the Middle Ages; and, in the East, the thousand years of Byzantium.

An 'age of transition' is a different thing from an 'age of decline'. It is realized now that there is little or no connection between the break-up of Roman temporal power and the emancipation of Christianity after 313 (in spite of the domestic upheavals which the Arian controversy brought in its wake). The causes of Roman decline lie much deeper in the past and are to be discovered in a study of the economy and the politics of the Empire. Constantine indeed may have been more perceptive than most of his contemporaries, for the Christian community was the most powerful factor operating to ensure the continued existence of Roman culture, though not of political unity. The Empire as such did not wholly perish, for in the East it was to survive for another thousand years. Nor did it merely vegetate; it existed and flourished under conditions that were always difficult and often hostile. The Roman Empire of the East became an historic and venerable realm, continually threatened from without but capable apparently of almost limitless renewal. And, to crown its achievements, it became the spiritual mother of all the Orthodox states, including Russia.

In all transitional periods some old elements vanish and some new ones are effectively adopted. The picture of Early Christian culture which, during the last fifty years, has become generally accepted, can perhaps be outlined as follows. In works of art of the period of major stresses and of major disasters between 300 and 550, can be seen the unmistakable traces of a profound transformation wrought in the context of general political and economic collapse. The vital clues to the future are there. The Christian Roman Empire was by

no means the mere negative antithesis of pagan Rome, as it existed before the age of Constantine and Theodosius. Many traces of the former Rome remain, but much was jettisoned to make room for the new and vital elements that had entered the Empire, above all for the Christian Church, now irrevocably linked with the Roman State and prepared for a measure of co-operation with it. Because of this transformation we in the West remain linked in our culture not only with Christianity but with the great heritage of Greece and Rome. And this we owe not so much to the Renaissance of the twelfth century, or to that of the fourteenth or fifteenth, as to the process by which the Empire was Christianized after 300. This new burst of creativity (especially after the year 380) was more conspicuous in the field of culture than in that of administration and economics. From an administrative point of view, the Empire had become hopelessly enmeshed in a web of totalitarian bureaucracy, which had first begun to be woven at the time of Diocletian; it has become a régime in which political action was always overshadowed by the spectre of the 'barbarian at the gate', where emperors were deposed and acclaimed by mercenary armies, and the armies themselves had become more barbarian than Roman. It was above all a state in which political responsibility was taken by no one, for citizens were prudently content to confine their ambitions to the enclosed circle of their own trades or professions in a life unremittingly oppressed by the continual exactions of the tax collector and the ever-present menace of the barbarians. In the West, after 410, the administrative machinery of the Empire collapsed at a stroke. The barbarians, Vandals, Goths and Franks, poured in and the former populations in the provinces they occupied were hard put to it to preserve their language and their traditional way of life. What still survived, a century later, can be summarized in two phrases: 'the remnants of classical culture' and 'the life of the church'. In the Greek-speaking East, on the other hand, the administration and the economy survived, though they too by degrees were radically altered.

To us today, architecture and the plastic arts are major elements in what we regard as the culture of a period; and it is impossible, with such arts in mind, to regard the period from 300 to 600 as a period of decline. The new features of this culture are immeasurably more important than the survivals from an earlier age, that would soon vanish entirely. What feature was it that disappeared from the art

of that time? The erection of temples, of course, ceased after the ancient cults were liquidated by Theodosius and his sons at the end of the fourth century. Until then their cost and running expenses had been borne by the state; and when the money was no longer forthcoming no more building was possible. In Asia Minor and Pontus (in modern Turkey) the populace almost everywhere carried out a spontaneous demolition of the temples. In the West they were simply closed, and later their gigantic statues of the gods were set up in other places, in markets and at the roadside. It was a considerable time before the propriety of transforming pagan temples into Christian basilicas was generally accepted, and in the interval they were abandoned to snakes and lizards, to earthquakes and to tourists. So this great form of architecture, which for long had been totally lifeless, disappeared completely from the history of building, and was not to reappear for many centuries.

Though it very soon degenerated, the tradition of classical sculpture in the grand manner did not vanish at once. Its disappearance, when it did finally occur, was by no means a major artistic disaster. For it had come to consist of the mere repetition of existing pseudo-Grecian clichés. The Greek masterpieces themselves were still genuinely understood and appreciated: they were extensively used, for example, to adorn the new city of Constantinople. But the style of the new official monuments, set up in the fourth and fifth centuries, was completely new; it was hierarchical, austerely stylized, unapproachably majestic. In all this it reflected the stately ceremony of the Imperial Court of the time, which in its essentials was derived from the reforms of Diocletian (after 294). Its distinguishing feature was an inflexible magnificence designed to endow the Emperor with a supernatural majesty, and to create around him an atmosphere which would have been totally incongruous with such spontaneously human figures, as, say, Augustus. The aim of Imperial portraitists was not to convey a picture of humanity, however ennobled, but to express the superhuman. It should not surprise us, therefore, to find Christian artists using similar stylistic methods in the representation of their Lord and his saints. They used it with considerable restraint, and with a sure touch so that the representation of Christ (Plate 11), of Biblical figures and of saints of the Church are of a much purer classical dignity than the stiff hierarchical Emperors and Court offi-

cials. Yet they are quite clearly in the same style; and it is a style which equally clearly points in a new direction, away from the classical. The attempt to create an ideal human figure, especially in representations of the Emperor, was abandoned; not because it had become too difficult, but because, as a method of artistic expression, it was dead. What classicists of the early nineteenth century took for mere incompetence was the result of deliberate stylization. And these attempts at stylization in the sixth century – at the end of what is usually called the 'Early Christian' period – resulted in the first true Christian art in the grand manner. Its development took place in the Eastern Empire where, under Justinian, there had been an impressive artistic renaissance and a political expansion. It was a creation of the Greeks. With minds no less acute than those of their great predecessors, they were now baptized Christians; and, in the sixth century, they thought of themselves as the lawful heirs of the Roman Empire and called themselves *Rhomaioi*, 'Romans'. It is we who have given them the strange name of 'Byzantines'. The art of the sixth and seventh centuries, usually called 'Early Byzantine', marks the end of the first Christian period. It possesses greater power and concentration than does Early Christian art; and it has achieved the hallmarks of a true style, recognizable at a glance and uniform throughout the Empire. Nevertheless, Early Christian and Early Byzantine art are so closely connected, both by subject-matter and by general perspective, that they can be considered here as one manifestation.

Thus, the monuments of Early Christian art date roughly from 200 to 600, that is to say, from the time of the earliest paintings in the catacombs and the earliest sarcophagi (Plate 30b) to that of the Hagia Sophia (Plate 9). They span four centuries. The first period (200 to 313) is self-contained. It was the time of the martyrs, of private churches, of cryptic and half-cryptic symbols (Plates 29 and 30b). The following three centuries are the age of the Imperial Church; and its art is powerful, unrestricted and as closely linked with contemporary culture as was the Church itself. The earliest works are the most moving, chiefly because of their content. The later ones are much greater as works of art – though this is not to say that in them the content has declined in importance. It is rather that by degrees, form had come to measure up more adequately to the task of expressing it. This matching of form and content explains

27

the impact and importance of these works; and it determined the course of Christian art for many centuries.

Today it is accepted without question that the fourth, fifth and sixth centuries were in many ways a golden age artistically. It is generally agreed, too, that in wealth of ideas, in formal quality, and in creative power, the Christian literature is far superior to the pagan literature of the time. The outstanding writers around the year 400 are not the poets and rhetoricians who wrote in the old style, Libanius, Rutilius Namatianus, and Claudian, but Augustine, Ambrose and the three great Cappadocian Fathers. In art, as in literature, the historian no longer applies the old standards. The eye of modern men, trained by studying works of art from all over the world, is no longer easily misled. Nowadays, nobody asks if a work of late antiquity is in accordance with the classical ideal, or rather, with what one took for the classical ideal in 1670 or in 1800. In the case of a statue or a bas relief of 350 or 400, nobody points out that it fails to achieve the ideal form of the Apollo Belvedere or the Apoxyomenos of Lysippus. Indeed these celebrated works, which once drew crowds to the Vatican Museum, no longer arouse much interest or attention. Roman copies of later Greek originals are looked upon today with reserve and sometimes, disrespect. Authentic Greek sculpture, mainly of the Archaic period, though little of it has been preserved and much of that is in a fragmentary condition, has almost entirely replaced (perhaps somewhat unfairly) those showpieces of monumental sculpture that were formerly reproduced in every collection of plates. Everyone, of course, is free to find his aesthetic pleasure where he pleases. We may all, according to our predilections, wholeheartedly admire one period and neglect or despise the other, provided that we are aware of our acceptance of preconceived ideas, and are aware, too, that our own personal values are not the only measure of artistic quality. Burckhardt wrote, that to him, Rembrandt was the master of all 'doodlers and daubers', and he was the first person to say of Piero della Francesca's frescoes in Arezzo that they showed 'an individual touch of such energy, such movement and such glowing colours, that one overlooks completely the absence of a more sublime perception of existence'. This is a striking example of an independent judgement; it is based on intensely individual standards, and both the man who makes it and his reader, know how to use it. On works of art with which he felt less in touch

Burckhardt tried all the harder to reach an objective verdict; he was aware of the danger of taking personal prejudices for valid criteria of judgement.

Classical scholars from the seventeenth to the nineteenth century seem to us nowadays to have fallen into this trap almost without exception. It was part and parcel of their whole way of looking at things. To take but one example, we all recognize nowadays that conventional official art in the Roman Empire of about 200 had very little creative impetus or vigour. Nor, for that matter, was it in the true Greek succession; the endlessly repeated stereotypes of deified emperors and gods in human form, the standardized ideal figures of youths, maidens, old men and matrons, are of interest only as parts of the long familiar and doubtless impressive ornamental backdrop of classical life. It was obvious that the myths no longer held any meaning; that the imaginative world of the ancients was not much more than a haunting memory of a great past, poetic, ever present, and very precious to men of conservative sensibilities. Like an ancient tree, the world of antiquity was near its end and soon its last leaves would fall.

Classical scholars were wholly preoccupied with that conventional image of the ancient world, which never in fact existed either in the high noon of antiquity, or in the Later Empire. Faced with Early Christian monuments, these scholars looked immediately for resemblances to classical models – models, in their eyes, unsurpassed. They measured the extent to which Early Christian monuments diverged from the ideal, and marked off the degree of decline accordingly. As for Christian themes, they were simply not interested; and for the new techniques of stylization, they had nothing but contempt; it was mere incompetence, they thought, which resulted in a barbarous lack of form. The capitals of San Vitale in Ravenna (Plate 10) are nowadays admired as the exquisite echo of an interior made up of a play of surfaces – a rotunda covered with mosaic and marble inlay, textured with niches and crowned by a great dome. They would compare these with a typical Corinthian capital, and would turn away in contempt, after noting with due surprise so great a waning of a three-dimensional sense. Today the pendulum has swung the other way, and there is, if anything, a prejudice in favour of late antiquity, and more particularly in favour of Early Christian and Byzantine art.

Artists, archaeologists, art lovers generally, pay homage not only

to works in the grand manner, to the splendours of the new archi-
tecture and the finest of the mosaics, but also to the smallest ivory
plaque, the minutest gold-leaf engraving, the dullest Coptic vine-
scroll frieze. This is not because of their symbolic treatment of the
Christian content. Generally, there is little understanding of this and
little interest in it. This is unfortunate, for the content provides the
key, the indispensable and only key to the whole. Instead, what
interests modern men is the work of art as such, and only the most
perceptive are interested also in its meaning. Today it is thought
possible to make immediate contact with the formal values of these
works of art, because of the strange but apparent affinity between
them and contemporary work. So these objects by the craftsmen of
late antiquity are admired as never before for their own sake. They
were made, after all, by unknown workmen, they were never ex-
plicitly mentioned or praised in Early Christian times, and they were
probably never examined with any special interest. At that time,
exquisite ornament was a usual feature of buildings and interiors; it
attracted no particular attention, and was more or less taken for
granted. The effect of these works, great or insignificant, is due far
more to the manner in which they can powerfully evoke a trans-
cendental world, than to the formal elements that make this evoca-
tion possible.

However this may be, the intelligent traveller today no longer
bypasses Ravenna; and in Rome, he visits Santa Maria Maggiore
(Plate 4), the Mausoleum of Constantia (Plate 16) and the latest
restoration of mosaics. In Trieste, he crosses the Jugoslav border to see
the wonderful church of Porec (former Parenzo) in Istria. This is the
sixth-century basilica of Bishop Euphrasius, completely preserved:
an empty nave, superb colonnades, an apse encrusted with coloured
inlays and with mother-of-pearl; high above, three rows of exquisite
mosaics (Plate 8). In museums, he looks for the rooms in which gold-
leaf glasses glow in small cases that also contain silver caskets, little
ivory tablets and bookbindings of A.D. 400 to 700. I know people
who travel all the way to Brescia, not to see the paintings of Moroni
in the picture gallery (which is what everyone did in the seventeenth
century), nor merely to marvel at the impressive remains of the
Roman city, but for the sake of a tiny piece of gold-leaf glass, six
centimetres across, with three unforgettable portraits from about 400,
set into a cross studded with precious stones (Plate 36).

This is indeed a reversal of what used to be the case. In his *Italian Journey* Goethe does not mention a single Early Christian monument; and of course he did not see the frescoes of St. Francis in Assisi, though he devotes half a page to the insignificant columns in the Piazza. It was Jacob Burckhardt, an avowed classicist, whose magisterial eye lit on Early Christian works of art, and in passing grasped some of their essential features with remarkable clarity. The 'Baptistery of the Orthodox' beside the Cathedral of Ravenna, to which we have already referred, had not yet been restored in 1834, and it was probably in a fairly neglected state; yet Burckhardt wrote in his travel diary that this interior was 'one of the most glorious combinations of colour to be found in art': and he was usually sparing with such judgements. And of the interior of San Paolo Fuori Le Mure (Plate 2) which at that time was just being rebuilt after the fire of 1823, he writes pithily: '(furthermore) only in the Christian basilicas does one come to appreciate the value of great classical colonnades, that have been almost entirely sacrificed to decorating this and similar buildings', and then: 'Whoever saw San Paolo before the fire, with its four rows of twenty columns each, of Phrygian and Numidian marble, would feel that a sight such as this is no longer to be found in the world.' The colonnades of the old San Paolo had neither been 'sacrificed' nor were they taken away from some secular building, as Burckhardt seemed to think; they were specially made for the church. In the days of Theodosius the Great, the founder of San Paolo, this was still entirely possible. However, the most unacceptable feature of such a judgement is that even the great Burckhardt saw the colonnades—to him a direct reminder of his beloved antiquity—in isolation, and not as part of the whole basilica and its function. He was impressed by the majestic interior, but he felt it to be unintegrated: he could see, he said, that 'this architectural form presents simple, sweeping themes and contrasts', but it vexed him that they 'make use of the ancient remains in a spirit quite alien to that in which they were made'. What strikes him, above all, is the borrowed majesty of these columns. Where we today see the first appearance of walls supported by columns that was to be of decisive importance for coming centuries, Burckhardt saw classical colonnades made to support a high clerestory; for a classicist, this was an intolerable combination. Had it never occurred to him that, for colonnades which had surrounded temples in the open sunlight for thousands of years, the

C

time had come for them to be erected in the interior to support the upper storey of an edifice cut off from the day-to-day world and destined no longer to harbour an image of a god in its tiny sanctuary, but to enclose an immense gathering?

Burckhardt's sharp eye resented the fact that this building, which did not belong to antiquity, was still such an excellent classical work. One of the differences between the modern visitor to San Paolo, and the scholars of a hundred and twenty years ago, of whom Burckhardt was one, is that we have learnt to look at these ancient treasures without allowing stultifying preconceptions to cloud our vision. So long undervalued, they may now be in danger of overpraise. We, of course, unlike our predecessors, have the advantage of being able to assess them in the light of discoveries made before our own time.

The Few Remains

The excellent reproductions of the last few years have made Early Christian and Byzantine monuments accessible to a wide public, though two adverse circumstances make it difficult to get to know these works directly: they are hard to reach in the physical sense, and they are few and far between.

Many of them are in remote places. Not everyone can travel to Syria to see with his own eyes the ruins of Qalat Sem'an, beyond Aleppo (Plate 6). This was a centre of pilgrimage that grew up about 480 around the column of Symeon the Stylite, and it equals in splendour any temple precinct of late antiquity. Not everyone is in a position to compare it with, say, Baalbek, which is an extended temple-complex built in Imperial times with an almost Baroque air, lying in a valley between the Lebanon and the anti-Lebanon: if such a comparison were possible, the observer could form a clear impression of the similarities and the differences between this vast pagan building, and an equally typical Christian monument. Such a journey as this would be most rewarding; how, otherwise, could he appreciate the perfect design of the details, and the importance of the dimensions? Yet how many people have ever been to Qalat Sem'an?

Not even the expert has much hope of visiting the many ruins, some of them extremely impressive, that are to be found both on the coast and in the interior of modern Turkey, the former Roman provinces of Asia and Pontus. Above all, the central plateau of Asia Minor is particularly difficult to reach. Since the pioneering days of Hermann Rott, Josef Strzygowski and Miss Gertrude Bell, and since Guillaume de Jerphanion discovered the rock churches of Cappadocia

33

in 1920–25, its sites have hardly been revisited; they have certainly not been investigated more thoroughly. The new American roads that cut straight through Turkey have done little to change this. Yet Asia Minor was one of the most flourishing parts of the Early Christian world. Here, for instance, were the Seven Churches mentioned by St. John in the first chapter of Revelations – Ephesus, Smyrna, Thyatira, Pergamon, Sardes, Laodicea and Philadelphia. The ruins of each one of these places have been found, and in each one or more Christian basilicas have been excavated; but knowledge of them has remained superficial, and hardly anyone visits the sites. Troas, also, Lystra, Derbe, Antioch in Pisidia, Iconium (modern Konya), Ancyra in Galatia (the modern capital city Ankara), Perga and Tarsus, are all known from the Acts of the Apostles and from the Epistles of St. Paul, and all of them played a leading role in the earliest history of the Church. It is the same with Nicomedia, Caesarea in Cappadocia (modern Kaisarye), Nicea (modern Iznik), Amaseia (Amasya) and many others. They were all comparatively large cities in Early Christian times: the site of these towns is well known, but few have actually been to see them, and generally speaking, very little remains of them. Only the impressive site of Ephesus (the Turkish Efes), the metropolis of Asia Minor, has been thoroughly explored by Austrian scholars, and has been more or less opened up to the modern tourist. We can see not only the remains of the ancient township that was known to St. Paul, but also the vast ruins of the church of the Virgin, and the six-domed church that rose above the tomb of the Apostle John. What else may lie hidden in this great subcontinent nobody knows; and much careful work still has to be done before we can describe all its Early Christian monuments.

But even nearer home, in Italy say, or in Provence, the Early Christian monuments are rarely on the beaten path. Who, in Rome for instance, would have the patience, the time and the means to spend hours having one after another of the sixty or so catacombs unlocked and shown to him: who would be prepared to spend his time being led by the invaluable *fossore* through pitch dark underground passages, to see by the tiny glow of his taper, not much more than some plundered tombs, and here and there the faint traces of a fresco? Who is sufficiently enterprising to travel to some out-of-the-way little town in the depths of Calabria or Provence,

to see a neglected baptistery, rebuilt out of all recognition, that has a few fragments of a fifth-century mosaic on the wall inside? Who would dream of going out of his way in the ruined Roman cities of North Africa – in Timgad, Lambaesis, and Dougga – to visit the Christian remains there? In the centre of Sicily, near the little township of Piazza Armerina, the mosaic floor of a spacious villa, owned perhaps by an Emperor, was excavated only a short time ago (in 1956–57); it dates from the third century, and over a hundred scenes provide what is by far our best evidence of the life of rich and fashionable people of the time – above all, of their chief pleasure, the *venatio* (the hunt). But most people shy away from taking the road from Syracuse or Gela that leads into the interior towards Enna, and from subsequently turning down a little side road, so as to take a look at this remarkable site lying in the middle of a thickly-wooded valley, a site which from the moment of discovery took its place among the most interesting monuments of the ancient world (Plate 47).

But it is not only a matter of physical remoteness. These remains of Early Christianity would elude our imagination even if we had them in front of us. Take for example the hundreds of basilicas that are known today, scattered over almost the whole extent of the former Roman Empire, an area stretching from Spain to the Crimea, from the Rhineland to the depths of Numidia, even to the northern tip of Eritrea and Abyssinia. What of all that has remained? Even where the buildings are still there, as in Rome and Constantinople, they have been rebuilt at least four or five times, and restored from top to bottom, having been in use for at least fifteen hundred years; alternatively, not much more is left of them than an excavation site. In the first case, usually in towns that are still inhabited today, and in Rome particularly, such a basilica is a palimpsest – a piece of parchment on which the ancient text has been obliterated, to make room for a new one. In entering Santa Maria Maggiore, for example, (Plate 4), you are immediately made aware, as you glance round the interior, that the columns of the nave were refashioned in the eighteenth century; that the apse is obviously late thirteenth century; that the decorations on the wall come from the 1590's. Only the mosaics on the 'Triumphal Arch' round the apse and in the nave still date from 431 and after. But the expert alone can see this; the average visitor reads this list of facts with some confusion in his

Blue Guide, and tries in vain to conjure up the original building, which has really nothing in common with what he sees today, except for its space effects and the general layout of the whole. To make such a reconstruction successfully, one must be able to, as it were 'transpose' historically, to know how to translate the visible interior into a different style.

In the second case, when an actual excavation is involved, the visitor has to supply from his imagination whatever is lacking to the eye, and in most cases this is everything; for, except for the foundations, which are almost always clear and precisely recognizable (except, also, for some of the old mosaic pavement, usually tolerably well preserved), there is usually but little to satisfy the eye. What we usually see is total confusion: tumbled columns, the ruins of an architrave, the bare pedestals of the pillars, eroded capitals, and here and there the remains of a stark, corroded wall. Sometimes, the pieces of marble have been assembled in a small museum. In any case we can see without difficulty the traces of the foundation, from which the ground plan can be deduced. The existence of a few dozen small basilicas, still almost undamaged, with only the roof missing, in the Syrian desert between Antakya (Antioch) and Aleppo (ancient Beroea), is an exception to the rule and something of a miracle, for which we have to thank the dry climate and excellent building materials, and the fact that the Christian population left this region for good after 640, when the Arab nomads conquered it, bringing with them the religion of Islam.

However, what is there for the layman to see in those other places, including the most famous sites, in which archaeologists have done their best? Take, for example, the town of Salona in Dalmatia (Plate 25). The inhabitants left it helter-skelter when the Avars raided them from the Hungarian plains in about 640. Formerly, it had been the brilliant metropolis of ancient Dalmatia. Even today we can find there the remains of no less than twenty-one basilicas and chapels. Outside the city wall, there are numerous cemeteries, with hundreds of stone sarcophagi; and there are many shrines to local martyrs, and around each are the mausoleums of the rich and the simpler graves of others. The relics of these martyrs were shipped to the Italian mainland by refugees after 640, and finally to Rome, where they now rest in a sumptuous chapel adjoining the Lateran Basilica. The chapel is dedicated to San Venanzio, the patron saint

of Salona; and the mosaic portraits of other saints of Salona can be seen on the walls of the chapel. The founder of the chapel had set them up there, with their names inscribed beside them.

The immense site of the ruins of Salona–called Solin, in Jugoslavia–can be reached without discomfort even by tourists who are making a Dalmatian cruise. It lies exactly to the north of Split–the former Italian Spalato. In the Middle Ages, that town was built into another important ancient monument, the enormous Palace of the Emperor Diocletian, the restorer of the Roman Empire. He built this palace for himself between 295 and 304, on the coast of the Adriatic, in his native land. After the failure of the great persecution of the Christians that had been intended to annihilate the 'Fifth Column' of the Church, and which entailed the shedding of rivers of blood, and the endowment of the Church with thousands of martyrs, he retired here, a disappointed, prematurely aged man. This palace also still stands and so does his magnificent mausoleum, today the Cathedral of Split.

But what does the average visitor remember of the ruins of Salona? Even the specialist, when he comes home, reopens the *Forschungen in Salona* in order to bring back to mind at least this or that feature with the help of its ground plans.

The truth of the matter is, that however well informed we may be about the layout and many details, these monuments give us no idea of the whole; and so they remain insignificant as works of art. Even though it is usual to attempt a reconstruction by comparison with similar buildings of the same time that have been better preserved, this requires exceptional knowledge and scrupulous caution. There are very few of us who feel moved by such reconstructions, by ground plans, elevations and cross-sections, taken together with the few uninviting photographs, and with a small collection of weather-beaten stonework. The layman retains only the draughtsman's reconstruction of the site, half of which is usually based upon mere supposition, and is often no more than a free adaptation of themes known from some other place.

Thus the Early Christian monuments remain difficult to appreciate. Furthermore, and this is the second great difficulty, the remains themselves are scanty, for time has annihilated almost everything.

At this point we could give a better idea of this meagreness, by

briefly surveying what has survived. It will help the reader to know what he can expect, and where to find it.

In Early Christian architecture, we can distinguish the following types of building: first, the basilicas (basilica being the ancient name for church); second, the baptisteries; thirdly, the memorial churches for martyrs, built in cemeteries (called *martyria* in Greek, and *memoriae* in Latin); and fourthly the mausoleums, the special tombs of princes and other persons of rank.

From the architectural point of view, the basilicas are more important than the other three types of building. The basilicas are built over a long central axis: by contrast, the baptisteries, *memoriae* and mausoleums have a circular ground plan, and they are built around a central point. Thus we have on the one hand spacious, hall-like buildings, and on the other smaller rotundas. Usually, both kinds of building occur together, along with a number of outbuildings, combined in a single great complex. In every town the baptistery, the bishop's residence, the deaconry and the *secretarium*, the bishop's chancery, originally stood right beside the main church, within the city walls. The mausoleums usually stood in the vicinity of a basilica, erected over the grave of a martyr in one of the cemeteries; that is outside the city walls, for according to Roman Imperial law, it was not permissible to bury the dead in the inhabited part of the city. Only later would a *memoria* be placed near some of the churches within the city walls, as a chapel added to the main building. It would serve as a shrine for small relics of the saints presented by other communities. We can find good examples of complete clusters of buildings – though only in ruins – in Salona, which we have just mentioned, and a more telling example in the ancient Cuicul, modern Djemila, north of Constantine in Algeria (Plate 24).

If we consider everything that has come down to us, the well-preserved buildings can be counted on our fingers. They can best be seen in Ravenna, with Rome perhaps in second place. All the others have been rebuilt to such an extent, that they can barely be recognized, or else they are no more than ruins. As for the ruins, those in North Africa and in the Syrian desert probably give the most complete impression.

Without doubt, pride of place must go to Ravenna. Three basilicas in the town still retain part of their original decorations: the chapel of the palace of Theodoric, today called Sant' Apollinare

Nuovo (Plates 19, 34); the basilica built over the grave of the local martyr, Apollinaris, in the cemetery by the harbour of Classis–now, Sant' Apollinare in Classe, on the autostrada to the south of the town towards Rimini (Plate 14); finally, the round votive church of the martyr Vitalis, today San Vitale. This last church was founded in the sixth century by Bishop Ecclesius, and was completed a little later by the Emperor Justinian and his wife, Theodora: the portraits of the Imperial couple and their entourage can be seen in the apse of the church (Plates 7, 10, 11). The two baptisteries of the town are very well preserved: that of the Catholics, now called the Baptistery of the Orthodox, and that of the Arian Goths, called the Baptistery of the Arians. Furthermore, there are a few churches, large and small, that are well preserved, even if stripped of their furnishings, among them San Giovanni Evangelista, San Francesco, Santo Spirito and Sant' Agata. Finally, there are the two royal mausoleums, one of King Theodoric, a powerful rotunda, now empty, with an upper storey and a roof consisting of a gigantic, single block of stone; and that of the Empress Galla Placidia, which has an interior entirely covered with original mosaics (Plates 13a and b, 17). I believe that this last building is not really a mausoleum but a votive chapel in honour of the Roman deacon and martyr, Lawrence, who died in 258, and whose portrait can still be seen on one of the walls backing a side-arch (Plate 13b). The chapel was joined on to the antechamber of the neighbouring church of Santa Croce (which was later reduced in size).

After 750, when the Lombards conquered the city, Ravenna did not become a dead town, but it was never again the seat of a king or of an exarch of Byzantium. It was not even a provincial capital any longer. In the Middle Ages it was the seat of a bishop, and became rich in monasteries, but that was all. This explains why, in this remote and silent fortress, so much has come down to us from the earlier centuries. Its monuments have been so excellently restored, that no other town, not even Rome, can provide such a relatively comprehensive impression of the highlights of Early Christian art, especially of the fifth and sixth centuries. The town, moreover, boasts a few dozen sarcophagi more beautiful than the average; most of them stand in churches, and those of the bishops of Ravenna are now to be found in the side-aisles of Sant' Apollinare in Classe. The marble-inlays and the mosaics preserved in the three first-

mentioned churches, are without equal for their time. And in the solitude of this small, quiet town, all this makes a much deeper impression, than do the Early Christian basilicas of Rome, which have been extravagantly decorated by later ages, and which now stand amid the deafening hubbub of modern traffic, in a sprawling city of two million inhabitants.

Rome, however, has not only the greatest number, but also the most famous basilicas of Early Christian times. They can be found outside the old city wall that was erected after 275 by the Emperor Aurelian and his successor Probus, and inside the walls, in the town proper. The three largest basilicas are quite colossal, even by Roman standards. There is the Lateran Basilica, originally consecrated as the Church of the Saviour – *Salvatoris* – and which is now called San Giovanni in Laterano; old St. Peter's, that has now disappeared, founded by Constantine on the Vatican Hill; and finally, San Paolo Fuori Le Mure, on the road to Ostia (Plate 2). All three are longer and much wider than the largest medieval cathedral. The apse (the fenced-off space where the chair of the bishop – of the *papa* – stood, as it still does) was almost twenty metres round; and the width of the transept a good twenty metres; a central aisle of the same width was flanked on each side by two side-aisles that were separated from one another by magnificent colonnades. But of all this there is little left; only the immensity of the interior survives.

In the eighteenth century, the Lateran Basilica was changed into a gorgeous Baroque interior, with wide and sumptuous arcades. Old St. Peter's disappeared almost completely when Bramante, urged on by Pope Julius II, began the present building, which received its final shape and dome from Michelangelo, and was completed by Maderna and Bernini. The wonderful church of San Paolo Fuori Le Mure, with all its old frescoes and magnificent columns, was burnt to the ground in 1823, as a result of an accident during lead-casting. The four colonnades were so badly damaged that it was thought that they would have to be complely dismantled. The church was then rebuilt with the most expensive materials, on the ancient foundations, on the same scale, but in the Classical manner of that time: the whole of Christendom, and even the Sultan of Turkey, contributed to its re-erection. What we see today is a new building, which has attempted to reproduce, in the idiom of the nineteenth century, the last great interior of the ancient world (Plate 2).

After these three enormous churches, whose present form gives hardly any idea of what they had looked like inside, comes Santa Maria Maggiore, on the Esquiline, the next also in time, built in the fifth century (Plate 4). Founded by Pope Sixtus III to commemorate the Council of Ephesus, it is the oldest and most important church of the Virgin in Rome, and perhaps in the whole world. Here too, the powerful central nave was repeatedly restored, above all by Ferdinando Fuga, in the eighteenth century, who even standardized the columns and renewed the ancient wall-covering according to its original pattern. The majestic proportions, the solemn atmosphere, and above all the undamaged mosaics of Pope Sixtus that are to be seen on the 'Triumphal Arch' (Plate 12), as well as in the small panels set along the walls of the side-naves (Plate 33), still belong to the original basilica, begun after 431. When, in the Easter Vigil, a discreet indirect illumination suddenly lights up the Triumphal Arch and the massive white heavily-gilded coffer vaulting, adorned thus in 1492 with the first gold that came from America (Plate 4), the total effect is of an unimaginable splendour which contrives to retain something of the noble understatement of a classical building. Curiously enough, this magnificent coffer-vault and even the restored Baroque wall decorations give the present interior more of the atmosphere of the original than is generally supposed. For, in Italy, all this has been preserved: the draperies that hang along the walls and around the main doors; the scented herbs and branches that are strewn on the floor – all this comes down from Early Christian times. This is the way it was done as far back as in the days of Sixtus and Pope Leo the Great. Only the glare of the lighting is wholly alien to a church of ancient times. Despite the myriads of oil-lamps that burnt on mighty candelabra, the lighting in those days was warmer and more subdued; and the innumerable curtains in between the columns made the solemn hall of the basilica seem almost like an enclosed chamber.

The Church of Santa Sabina on the Aventine (Plates 3a and b), known from many reproductions, is only a few years older – it was built between 422 and 430, and has been restored with care. It makes a strong impression on the visitor, even though it is completely empty. One tends to forget that this bare and light interior is not all that it must have been in 430. The new ceiling was made on the model of an insignificant piece of medieval roofing; the windows, filled in with selenite, are restored from Carolingian examples; the

choir with the altar and the two lecterns (the ambons), is taken from a medieval pattern, and somewhat arbitrarily at that; the marble facing of the apse wall is modern. The mosaics in the vault of the apse and on the Triumphal Arch framing the apse, have disappeared. It is only when you turn around in the nave that you can see above the main portal the old monumental inscription in gold letters on a deep blue ground, flanked by two venerable figures, the Church of the Circumcision and the Church of the Gentiles. Pass through a small side door into the entrance hall, and you will be faced with one last surprise: a great door, panelled with carvings in cypress-wood, magnificently framed, showing many Biblical scenes. This was made in Rome in 430.

Santa Sabina is the classic example of a carefully restored Roman basilica. Even though there are still things to be seen there from the earliest period, the interior is bare, and the furnishings date mostly from later centuries. What is felt to be lacking, above all, is that which created its former atmosphere; the dark glow of the mosaics, the muted multiplicity of coloured marbles on all the walls, the hundreds of lamps in candelabra hanging between sumptuous curtains drawn back along the columns.

A famous exception is the mausoleum of a daughter of the Emperor Constantine, the princess Constantia, who died in 350 (Plate 16). It is far beyond the old city walls, on the Via Nomentana, beside the ruins of the first basilica dedicated to Agnes the Martyr, who lies buried there in a small catacomb. The church, no longer in existence today, was founded by the princess. She wished to be buried in a rotunda next door: this rotunda is still there, almost undamaged; formerly, the antechamber of the rotunda had led into the arcade of the basilica in the cemetery. The mausoleum itself is a rotunda, with a circular arcade. The mosaics, of shortly after 350, survive in the vaulting of this arcade, and in two of the wall-niches; those in the cupola have vanished, but we know them from a drawing in the Escorial. The sarcophagus of the princess, a massive block of Egyptian porphyry, is now in the Vatican Museum. With nothing but beams of light from the dome above to relieve the dimness, and with the deliberate lack of symmetry of its arcade ringed with pairs of columns, this truly Imperial mausoleum is one of the best preserved and the most beautiful interiors of all antiquity.

By contrast, several smaller Roman basilicas of the early Middle

Ages (that is, from the eighth to the eleventh or twelfth centuries) are remarkably well preserved. Without doubt, the best are Santa Maria in Cosmedin, in the Forum Boarium, right beside the Tiber; San Giorgio in Velabro opposite it; and the upper church of San Clemente, known from many reproductions, which lies to the south-east of the Colosseum, and dates from the eleventh century. Even these three churches are surpassed by the Church of Santa Maria in Trastevere, across the Tiber, built in the twelfth century: it is a smaller version of the great Church of the Virgin – Santa Maria Maggiore, on the Esquiline. Visitors should not miss its interior; the apse is decorated with contemporary mosaics and some of a later date, executed by no less an artist than Pietro Cavallini.

These and many other medieval basilicas in Rome show clearly that the ancient capital of Latin Christendom rejected the intricate domes of the Byzantines, and the still more complicated architecture of beyond the Alps, which we call by the curious names of 'Romanesque' and 'Gothic'. For century after century, Rome quite consciously kept to the architectural and decorative schemes of its first, golden age of Christian art; to the basilica, with its marble inlays and mosaic. In the rest of Western Christendom, in France, in England, in Spain, in the Germanic countries and in Northern Italy, men built narrow churches with several naves, covered with stone vaulting; beyond the Alps rose the great abbeys and cathedrals; portals came to be adorned with innumerable sculptures, and soon after 1140 the interiors became filled with that peculiar glory still to be found in its pristine form in the Cathedral of Chartres, created by stained glass windows, vast tapestries that are almost mirages of the heavenly Jerusalem. All this time the Romans continued to decorate their churches in the old, well-tried manner, building spacious, one-aisled basilicas, and held fast to the sober liturgy of their ancient city – a liturgy sparing of words, unemphatic, and free of pathos. The Romans loved the old, roomy, solemn places of worship: they did not feel at home with the ecstatic lines of a Gothic cathedral, and such an edifice was certainly out of place in their own city. That is why the more recent basilicas were, in a certain sense, no more than variations on the great basic themes of Early Christian art.

The new Rome, Constantinople, modern Istanbul, possesses but a few, though most impressive, remains of the early Byzantine days, mainly from the sixth century. The ancient city wall can still be

seen, from inland; it is one of the most massive fortifications of any city of the world. Furthermore, there are several of the great underground cisterns which are supported by innumerable columns (one of them is called Bin-Bir-Derek: 'the thousand and one columns'). Then there are the smaller sanctuaries, such as the rotunda of the martyrs Sergius and Bacchus, or the domed basilica of Hagia Irene – Holy Peace – which until recently had been used as a museum of armoury by the Turks. But what every visitor wants to see straight away is, of course, the Hagia Sophia, once the most beautiful church in Christendom. For a long time this was a mosque; it is now restored in a somewhat lackadaisical manner as a Byzantine museum; though fortunately the architecture has not been tampered with. It is the third church of that name; and in its present form, it was built by the Emperor Justinian, after the devastations of the Nike Riot of 532. The architects came from Asia Minor: they were Isidore of Miletus and Anthemius of Tralles. It was dedicated to the Divine Wisdom, the Logos – to Christ, the Word of God. It was simply called 'The Great Church'; and this is how it remained until the fateful year of 1453.

From the outside, the Hagia Sophia (Plate 9) gives the impression of the bare bones of a heavily-buttressed building, with many windows and a flat dome that seems to rest on a circle of little windows: only the four slender minarets of Turkish times give some life to the outline.

By contrast, the interior is bare, apart from the remains of the wall-mosaics, that have been gradually uncovered since 1934. This bareness detracts from the total effect. But the columns, the marvellous capitals, the original facing of the walls and the niches with marble inlays, are all still there, and it has lost nothing of the overwhelming majesty that makes the imagination of the visitor soar. It is a church fit for a palace: the great galleries all lead into the Imperial Vestibule in which Justinian and his successors attended the Holy Liturgy, surrounded by their court. All palace-churches in our barbarian lands are modest imitations of this grandiose edifice. But this interior is far more than the palatine church of the Emperors of the Greeks: it is a House of God. We can appreciate the words of Russia's most ancient chronicler, who relates, that when the envoys of the Grand Duke Vladimir of Kiev had visited all the great centres of Christendom, and reported on what they had seen in the churches,

they said of the Hagia Sophia: 'When we were there, we thought we were in Paradise, and we forgot everything that had gone before.' Russia became a spiritual dependency of Byzantium and so it has remained.

Even the Turkish conquerors came under the spell of the Hagia Sophia. Their great mosques of the fifteenth and sixteenth centuries that crown the hilltops of the city, are nothing other than a skilful variation of the Hagia Sophia, older than themselves by a thousand years.

Further East, we observe that neither in Antioch nor in Egyptian Alexandria, once the two great ecclesiastical centres of the Orient, have any significant remains of Early Christian times been found. Antioch lies buried beneath a little Turkish township. In the neighbourhood only a number of villas have been excavated; their mosaic floors can now be seen in the Louvre, and in the museum at Worcester, U.S.A. Alexandria is a modern town; almost nothing has been preserved of the old metropolis.

As for the holy city of Jerusalem, the sanctuaries that had been erected by the Emperor Constantine at the instigation of his mother, Helena, on Golgotha and over the Holy Sepulchre, were destroyed by the Sassanian Persians in 614, and later by the Arab conquerors of the Holy Land in 1009 and 1244. They were restored between 1099 and 1178 by the Crusaders, in the Burgundian style, which we call 'late Romanesque'; but since then, they have been alternately neglected or restored without understanding. Today, we can see not much more than the basic plan of the original, and the historic places, full of sacred memories, that are vouched for by tradition. The rotunda over the *memoria* of the Holy Sepulchre, the *Anastasis* of the Emperor Constantine, has become so dilapidated, and the whole church is in such bad condition that the present owners have at last agreed to renew completely the rotunda of the Holy Sepulchre and the Crusaders' church.

However, the five aisled basilica, which the Emperor Justinian had erected over the Grotto of the Nativity in Bethlehem, is in an excellent state of preservation. The four magnificent colonnades of the nave not only remind us of Justinian's lavish activities as a builder, they also testify to the enduring appeal of the Corinthian pillar. The sixth-century church on Mount Sinai, a foundation of the same Emperor, is well preserved, together with the ancient mosaic of the

Transfiguration of the Lord on the Mountaintop. In the neighbouring convent of Saint Catherine, the oldest icons in the world, Egyptian in origin, were restored and exhibited a short time ago. An Athenian scholar, Sotiriou, made them known to the world (Plate 37).

In Egypt, the cradle of monasticism, a few monastery churches are still standing, but in a sadly neglected state. The best-known of these are the White and the Red Monasteries, near Sohag, half-way up the Nile. Much of what was found in the interior of the country is assembled in the Coptic Museum in Cairo.

In Syria, the ruins which we have already mentioned (Plate 6) in the hinterland to the east of Antioch and the west of Aleppo, were discovered and described in 1862 by the Marquis de Vogué: Duthoit made drawings of them. Later, many more were found. These various groups of churches, around the mountains of the Hauran in Transjordan, for instance, comprise one of the most impressive assemblies in one region of Early Christian architecture. Some of these churches which were still standing when Duthoit drew them have been dismantled since by the Bedouin for the sake of their stones. Of the countless monuments found in Palestine and Transjordan, the group of eighteen basilicas in the town of Jerash, ancient Gerasa, are the most spectacular of all, sites which no visitor should miss. The secular ruins of the town too are almost unsurpassed. The whole group lies in the midst of practically unrelieved desolation; the artificial lake that was built into it is hardly to be seen.

Today, one of the most precious monuments of Early Christian Syria is to be seen in the Gallery of Fine Arts in Yale, U.S.A. (Plate 1). This is the baptismal chamber of a church in a private house, dating from 232, in the frontier fortress of Dura-Europos on the Euphrates, the furthest corner of the Roman Empire. It was excavated in 1934 and has been painstakingly transported and set up in Yale. The private church, of which this room is a part, is the oldest Christian church known to us. The house stood in a back street, almost next to the fortifications, separated from them only by a single lane. In 256, when the minor fortification was reinforced for the last time and the ramparts heightened, the greater part of the church was buried: it was found almost undamaged under a layer of sand. A few blocks away, a synagogue was found, also from the third century; decorated with dozens of Jewish religious pictures

such as nobody had ever thought existed. These pictures, now to be found in the Museum at Damascus, are astounding evidence of the range of ancient Jewish iconography. In the case of the Christian church, the room for divine service had been severely damaged, but the baptismal chamber, on the right-hand side, contained a baptismal font and a number of wall-paintings. We can see there the usual array of the earliest baptismal symbols: the saving of Peter from the water, the man whose sins are forgiven taking up his bed and walking home, the dialogue on the living water with the woman of Samaria by Jacob's Well, and the women by the tomb. One of these pictures shows our Lord as He stretches out His hand to Peter on the water; this is the oldest known representation of Christ (Plate 1).

To return to the West; there are still a few famous monuments to be mentioned. Beside the Cathedral of Naples, in a small baptistery from around 400, there are a few wonderful pieces of mosaic – a minute reflection of bygone splendour. Similarly diminished are some chapels by the side of San Lorenzo Maggiore in Milan, as is the church itself, a roomy building dating from the 400's. North Africa is particularly rich in monuments. This area includes the former Roman provinces of Mauretania, Numidia, Proconsularis and Byzacena, as well as the coastal region of Tripolitania. In this country, once densely populated, fertile and rich, about five hundred basilicas have been excavated, some with all their annexed buildings; here, of course, the baptisteries are of special interest. One of these baptisteries, in Djemila, the former Cuicul (near modern Constantine), is almost complete with its ambulatory, niches for changing, and a baldachin over the actual *piscina* (the baptismal pool); even the dome has not collapsed (Plate 24). Furthermore, remains of the bishop's church of Augustine in Hippo Regius have been found, also those of the monastery established in his house, with his deaconry, his baptistery and his office. (On the other side of the street there was an older building, that was wrongly supposed to be the church of the Donatists, who were adherents of a schism put down, or apparently put down, by the intervention of an Imperial commissioner in 411.)

In the lonely expanses of Asia Minor, in the mountains of the Kara Dag, the ancient Lycaonia, there is a small number of small ruined sanctuaries and monasteries, standing close to one another, which cannot be exactly dated: the Turks call this place *Binbirkilise*,

'the thousand and one churches'. The coastal areas of Asia Minor, too, are scattered with ruins that are visited from time to time; but there are good publications on only a few of them, for example on the sanctuary of St. Thecla at Seleucia in Cilicia, the modern Silifke. In modern Greece (including the islands) more than a hundred ruins of great and small basilicas have recently been excavated (Plate 5).

This catalogue could be continued. In all the provinces of the former Roman Empire that had been thoroughly 'baptized', Christian monuments of the time before the seventh century have been found: at Silchester, Trier (in Roman Belgica), at Xanten, in the Balearic Islands, and at Pecs in Hungary, in the remotest corner of Bosnia, as at Sebastopol, in the Crimea, and even in Georgia and Armenia. But none of these monuments consists of more than a few impoverished remains. Only lately have reconstructions given a comprehensive picture. A sensational excavation such as that of the main church of the Imperial residence in Trier (the ancient *Augusta Trevirorum*), beneath the present cathedral, may have thrown light on the development of architecture; but it has not given us an exact picture of the succession of particularly interesting buildings, which stood on this famous site before the erection of the present Roman-esque cathedral, flanked by the early Gothic Church of Our Lady: the treasured remains that we can see today in the Diocesan Museum add up to no more than a few pieces of painted mortar, a series of inscriptions, and some smaller objects.

If we pass from the buildings to the cemeteries, we find that far more have been preserved: even if these are plundered and empty, they are important as landmarks. Almost all of them provide valuable historical material, mainly inscriptions: but as a rule, these have been transferred to museums. In the case of underground burial places, however, they are often left where they are, as in the case of the newly discovered Roman catacombs. For new ones are always being discovered. In Rome as recently as 1956, a little catacomb was found on the former Via Latina (beneath the present Via Dino Compagni, in a new suburb): it contained almost a hundred paint-ings, some of them surprisingly interesting.

Of the innumerable cemeteries found almost everywhere, the underground ones are of course the best preserved. They can be seen in many places: mainly in Rome, but also in Naples, Sicily, Malta, and many parts of the Italian peninsula. Nowhere, of course,

do they extend as endlessly as in the great catacombs of Rome. Of all the subterranean cities of the dead, these Roman catacombs (Plates 26, 27, 28) are the most visited, and justly the most famous. According to Jerome, they were already one of the sights of Rome in the fourth century; students and tourists as well as pilgrims made their way there to be edified by the inscriptions that Pope Damasus had commissioned for the graves of the most important martyrs, which he had meticulously uncovered and decorated. They would wander in astonishment through this vast cemetery with its peculiar atmosphere, its dark passages feebly lit here and there by narrow shafts of light. The Roman catacombs are comparatively well preserved because most of them were buried, and then consigned to total oblivion when the Campagna became depopulated in the seventh century. Only since 1590, and principally after 1830, were they excavated. This has been done piecemeal, sometimes with the aid of clues provided by an ancient document, sometimes by mere chance.

A catacomb consists of a precisely delimited piece of territory (today, it is either densely covered with buildings or overgrown with vegetation); underneath it there is an underground network of narrow passages crowded with graves, sometimes arranged one on top of another on different levels; and these passages are connected by stairways, grouped round a number of burial centres. The cemeteries of Lucina, Priscilla, Calixtus and Domitilla are the oldest: the oldest nuclei of these seem to go back far into the second century. But as has been pointed out, most of the catacombs date from after 313. This kind of burial was a cheap expedient for making full use of expensive building land; and it was made possible by the exceptional firmness of the Pozzolano (that is, a kind of tufa-rock ground). Those who dug out the first catacombs to be uncovered, including the most ancient ones, removed everything they found there: sarcophagi, gold-leaf glass, mementoes; today all this is scattered throughout the museums of Rome and (regrettably) also elsewhere. What generally remains, are the wall-paintings of the more richly furnished of the burial chambers. When it was no longer safe outside the city walls, the bodies of the martyrs that lay buried in the oldest parts (from before 313) were transferred to the churches of the town, after the seventh and eighth centuries; they were placed beneath the altars of the basilicas, and there they are venerated even

to this day by the people of Rome. The cemeteries that were above ground–they are usually where the catacombs began–have almost all vanished without a trace: these areas now are all part of the suburban building estates, for today Rome is of course much larger than it was in the year 300.

In other places too, cemeteries at ground level have rarely been preserved: but usually the site of these can be identified. Sometimes even a number of dilapidated mausoleums and sarcophagi lie around on an overgrown piece of land. We have mentioned the impressive cemeteries of Salona; other cemeteries of the sort can be found, for instance in Tipasa in North Africa, and on the Aliscamps not far from Arles (the ancient Arelate).

A usual component of the cemeteries are the ornate sarcophagi of rich Christians. Generally these are costly marble receptacles decorated with sculptures (Plate 30), in which the bodies were placed, with husband and wife usually lying together. They were either kept in a separate mausoleum (which only very wealthy people could afford) or they lay out of doors, or were covered by a simple roof (a *tugurium*). They were placed as near as possible to the basilica of the martyrs, who were the glory of the cemetery. As a rule, the front and the two ends alone were adorned with figures; only the richest are covered on all four sides with sculptures. This expensive kind of sarcophagus developed in Roman Imperial times: in Italy, and above all, at Rome, there are tens of thousands of fragments of these splendid coffers of the dead, as well as some that have been preserved intact. Moreover, if a direct relationship with forms of third-century pagan art is evident anywhere, we can see it in the Christian sarcophagus. Its aesthetic effect is due to a similar play of light and shade. For these are meant to stand out in the open, or at least in an interior lit from the side; and the softened effect of the frieze-like front is quite delightful in many cases, especially in Christian sarcophagi.

As far as content goes, the oldest of the Christian sarcophagi–those from the third century–differ greatly from the secular ones; and after 313, instead of those wary representations of more or less symbolic character, typical of a time of persecution, quite undisguised Biblical and ecclesiastical themes suddenly come to the fore. (Later we shall have a closer look at the iconographical themes of these monuments.)

More than a thousand sarcophagi are preserved, including the larger fragments. Three-quarters or more come from Roman workshops, and so the largest collections can be found in Rome itself, in the Lateran Museum and in the Museo delle Terme; others, discovered at a later date, are in the museum near the Catacomb of Praetextatus and in the museum of San Sebastiano on the Via Appia; many also can be found inside the churches. About a hundred sarcophagi seem to come from the workshops of Arles. The finest of these can be seen all together in the Musée Lapidaire Chrétien, in a side street behind the Hôtel de Ville (Plate 32). No visitor to Provence should miss seeing this museum. Others can be found in the crypt of Saint-Maximin (Var), and in various towns of Languedoc and Aquitaine; and there are some in the Louvre. A third group seems to have originated in the imperial residence in Milan; the most famous of all sarcophagi stands beneath the medieval chancel of Sant' Ambrogio in Milan; others are in San Ciriaco in Ancona, and there is a very fine one in the Cathedral of Tolentino. But such early Christian sarcophagi can be found in all parts of Italy: we have already mentioned the lovely series in the crypt of the Cathedral of Palermo (Plate 30a); and a very impressive example can be seen in the museum of Syracuse. Such sarcophagi are also to be found in outlying parts of the Empire–too many to enumerate. After the sixth century, the sarcophagi become more simple: instead of the many niches filled with figures, and the continuous figurative friezework, there is little beyond very simple symbols and quite short inscriptions.

Scattered around many museums and treasuries, there are also other objects from churches and libraries, from simple and ornate graves, or from the *pastophoria*–the sacristies–of large or small sanctuaries. There are a few more important pieces among them: splendid fragments of lecterns (*ambons*) and *cancelli* (altar rails, from which communion was administered); also precious manuscripts, such as the codex that is preserved in the archbishop's palace of Rossano, in Calabria, with its silver lettering on purple parchment, adorned with the most ancient miniatures that we know of in a Gospel from the sixth century (Plate 44). But perhaps the smallest objects among such remains are the most beautiful: ivory writing tablets, only two hands high, adorned on one side with exquisite carvings in a simple frame. Then there are travel mementoes from the

Holy Land, such as the silver flask in the treasury of the Cathedral of Monza, which used to contain the oil that was taken from the lamps burning in the sanctuary at Jerusalem (Plate 22).

Take this flask carefully in your hand, read the Greek inscription – 'oil from the wood of life from the Holy Places of Christ' – and bring to mind how the Queen of the Lombards, Theodolinda, once received it (around 600) from Pope Gregory the Great, and how the Queen handed it to the bishop of her royal residence, where it has been carefully cherished by his successors, down to the present day. To hold this little jewel in one's hand, is to bring to mind the last great Roman and the courageous woman who held in check her barbarian husband, and so, suddenly to realize how ancient is the garment of European culture and how closely it is woven.

The Basilica

All churches in Christendom, from the greatest cathedrals to insignificant chapels in the Greek Islands with domes like nutshells, are heirs of that compact and unassuming building of the fourth century, which contains them all in essence – the building called a 'basilica'. Century after century, the forms of the buildings based on the basilica have changed, every imposing variant giving way to a successor: the massive Romanesque abbey church, the Gothic cathedral, the Duomo of the Renaissance, the festive halls of the Baroque, and the cold spaciousness of a Classical church-interior; today, every one of these belongs to the past; but the elements that are essential to a basilica reappear over and over again (provided that bad workmanship does not mask them, they appear in even the most modern of modern churches).

The situation is the same in the case of the Orthodox churches of the East. When viewed from the outside, it may seem that few buildings could show slighter kinship with Early Christian basilicas, than Greek or Russian churches, with their five domes; yet the ground plan, the arrangement of the interior, indeed, the layout of the entire building, are very similar to those of the earliest basilicas.

The churches of the faith have remained as constant and unchanging as the faith itself. Builders have tried their hands at many styles, sometimes striking an alien note, sometimes producing a work of almost visionary beauty. Yet always the basilica motif underlies the planning.

It is natural to assume that the oldest churches would not only be the simplest, but they would also express in the most unambiguous way the very nature of a church: what is taken from near the source

we would expect to be crystal clear. But whether or not the oldest churches of all unequivocally display an architectural form valid for all time, is a different question; and the answer to it is, No. The decisive elements that were there from the beginning, and which will last until the end of Christianity – for the believer until the end of the world and the coming again of his Lord – are not so much architectural features as elements bound up with the nature of the Church and its liturgy. The first Christians 'went to church' in houses. From the third century, these might be very great buildings, but nonetheless they still always bore the same name of *domus ecclesiae* – 'house of assembly' – or, since *ecclesia* (assembly) is the same as our 'church' – 'church-house'. For a long time, these 'churches' must have been purely makeshift or occasional. We do not know when the first attempt was made to build a church as such, because in 304 all churches in private houses in the Roman Empire were pulled down by order of the Emperor Diocletian; and if some did survive here and there, they have not been preserved, and we do not know what they look like.

On the other hand, it is obvious that when the Christian Church became a recognized institution of the Empire in 313, Christians everywhere had to set about erecting new churches, intended for public worship: they immediately sought a type of building that could meet the unique requirements of the *domus ecclesiae* – requirements which in those days would have been regarded by an outsider as extraordinary innovations.

The remarkable thing is that as often as not the first attempt at a design was the one that remained valid. We know from the documents that immediately after the Edict of Toleration of 313, the Emperor took in hand the building of gigantic Christian shrines, financed by government funds. From the surviving monuments, which we know well, we can gather that these first buildings were not basically different from the innumerable churches that followed in the course of the next two centuries, throughout all the provinces of the Roman world. This is not to say, that no single church was built that deviated from the usual type. This deviation may well have been intentional: we know of some such exceptions, for instance the Great Church of Antioch, built on an octagonal ground plan; or in Rome itself, four great cemetery-basilicas, surrounded by ambulatories. (These four, the basilicas of the Apostles (now San Sebasti-

ano), of St. Agnes, of St. Lawrence, and of SS. Peter and Marcellinus
– the three last known only from their remains and excavations–
were foundations of the Constantinian dynasty.) The original
Basilica Salvatoris (St. John Lateran) had no transept, and a staggered
western end, with a projecting apse. But it remains true, that the
overwhelming majority of all churches built after 313 are of the
same type–not three-quarters of them, but ninety-nine per cent.
Overnight this type, the 'basilica', seems to have become the
standard form for a church. We are forced to conclude either that
this type of building already existed, in essence, at the time of the
persecutions (before 313) or, failing this, that we are dealing with
one of those simple and latent creations of genius that suddenly come
into being and then determine the history of architecture for
an incalculable stretch of time.

I personally believe, that this last suggestion is the correct one:
at least for the layout of the building. This form did not 'evolve':
things created by the human mind are not subject to 'growth' in
the biological sense. They arrive, once and for all, through the
creative power of an individual–in this case, of an architect (or a
succession of architects) who risked this decisive step, only to be
proved right. It is possible that there were many of them, that they
learnt from each other through what they created, that they had
borrowed certain elements: but this is not necessarily so. At one
point of time, the decisive stage was reached, at which a particular
individual found his way to a synthesis, that carried conviction and
set the tone for the whole future of ecclesiastical building. A parallel
to this is the sudden flowering of the Baroque church-interior. This
interior design is not the result of a gradual evolution: instead, we
owe it to the completely unexpected, unheralded sketch of Vignola
for *Il Gesu*. Or consider the beginnings of classical French Gothic:
the really new idea of making the side walls soar and then covering
them with tapestries of glass, belongs to the architect of Chartres,
who drew up the first design in 1194; it is his idea and no one else's.
We do not know who made the regal ground plan of the first
basilica proper, in 313 or some years later (possibly even, for all I
know, earlier, although this is less probable); but it is a thoroughly
satisfying solution to a complex problem. Perhaps it was the master
of the 'Basilica of the Saviour' (modern St. John Lateran) which, as
the principal church of the first bishop in the Roman world, is still

called 'Mother and Head of all churches of the City and the World'
– *Urbis et Orbis*. Both in origin and in status this church stands first
in the succession of the earliest great basilicas, though its primacy is
not strictly provable.

It is improbable that the basilica existed as an architectural form
before 313; certainly, I myself find it difficult to accept the view that
it did. But what had existed, and for a long time, was the element
that explains the origin of the basilica and the basic lines of its
interior – that is, a *liturgy*, that had already assumed a fixed form.
Before the beginning of the fourth century, this word 'liturgy' stands
for the assembly of Christians as such, as well as for the order in
which its worship was conducted. There was no basilica at that time;
but the basic elements that would distinguish the basilica from similar
buildings were already there. These were determined by the structure
of the Christian community and by the nature of its worship, neither
of which changed markedly in 313, nor at any later date, and which
are today essentially the same wherever Christendom abides by its
most ancient traditions.

The action of the unknown creator of the first monumental basilica
was simply this: in 313, he provided a convincing architectural form
for what were already traditional elements in a Christian place of
assembly – a form which was then taken over as the only possible
one by the whole of Christendom, with amazing unanimity and
speed. For the one surprising thing about the many hundreds of
monuments known to us from the period after 313 is this mystifying
uniformity. In textbooks, we always find that the local variations
are stressed: we are always told how one variant is typical of Africa,
another of Illyricum; that in Syria we can see how the basilica built
after 313 stems directly from the 'house-church', because the doors
are at the side and we enter the church by passing through an inner
courtyard, lying to the south of the main building, as is the case with
a private house . . . and so on. What is more important, however,
than these local individual quirks, is the way in which these hundreds
of basilicas, even in Syria, present the same architectural type; and
even two and a half centuries later, this same type remained as the
basis of the domed basilica, when the domed church came to pre-
dominate in the East.

So far as the Christians of the time were concerned, they were so
accustomed to having basilicas everywhere that they took this fact

for granted. Occasionally, in a distant country, the magnificence of a particular shrine would impress them, or the splendid position of a great church. But the church itself, and its general plan, was so familiar, that they hardly noticed them. It was the same with the liturgy: with the liturgy, as with the church, they 'felt at home'. Everywhere they found the same faith, and they had lost the habit of being surprised by this: only the church, and not any single sect, could claim the name *catholica*. The only difference that struck them was the difference in the liturgical language. If they were Latins, they noted that the service was sung in Greek, or that the lesson was read in Syriac: in cities of international importance, they would find interpreters who would give a rendering in Latin of the Scripture-readings. But the church and the service were the same everywhere. The famous pilgrim, Egeria, a nun of distinguished birth from Northern Spain, visited Jerusalem in 416, during Passion Week and Easter. She describes all the ceremonies that were performed at the Holy Places – ceremonies that no one could have seen elsewhere, in an environment where everything testified, in the most insistent manner, to the Passion and Death of the Lord: but what does she have to say of the usual Sunday liturgy that was celebrated in the great basilica on Mount Calvary? – that it began at such and such a time, and that it was just the same as at home! As for the church, she only mentions it, because it is particularly large and magnificent, and because she happens to know that the Emperor Constantine and his mother had founded it.

Wherever they lived, Christians of the fourth, fifth and sixth centuries, 'went to church' in one and the same kind of building – the basilica: and, once inside, they found the same arrangement and the same incomparable atmosphere.

What, then, are the decisive elements of a basilica? These elements are not essentially, or not primarily, specific architectural features that the basilica had in common with the secular public buildings of the time. The basilica, as much as any other building of its age, is a 'late antique' building. We never hear, not even from hostile pagan writers, that the basilicas impaired the beauty of a city's architecture. I think myself that they would not have been very conspicuous; for it was their interiors that counted.

Some time ago it was fashionable to make the basilica 'originate' or 'evolve' from one of the many forms of late antique buildings:

from the distinguished upper-class mansion, from the market hall, from certain palace rooms, or from a combination of these forms. It is a harmless game, based on the unconscious acceptance of Darwin's principles of evolution; but it has created a flood of worthless erudition, and it has not brought the question of the origin of the basilica one step nearer to a solution.

It is, of course, obvious that particular elements in a basilica can be found elsewhere: one would have to be blind not to see this. The colonnades of the basilica may, in some cases, be on a larger scale, but they are no different from the rows of pillars of other contemporary interiors in the ancient style. The archivolts (the little arches that hold together the head-blocks of the capitals, and so mark the transition between the column and the wall) were once hailed triumphantly as a Christian peculiarity; but even these have also been found in the Palace of the Emperor Diocletian in Split, and, a hundred years earlier, in the city of Septimus Severus, at Leptis Magna in Tripolitania. The great niche that stands at the focal point of the axis of the church as you look lengthways, and so rounds off the interior, and which is called an *apsis* or *absida*, may usually be less spacious in secular buildings; but it is a feature of almost every building, in which a public body had to take seats on a platform – in courts, in the Senate, in Imperial audience chambers. As for the throne of the presiding figure, placed in the centre of a row of bench-seats that run in a concentric semicircle along the sides of this apsidal niche: this existed everywhere, even in schools, and to judge from the mosaics, in literary clubs: the staging of a public meeting in any other way just could not be imagined. The rows of windows placed at a height were already a feature of secular interiors. Soon after 300, round windows appeared. The only impressive innovation was in the structure of the walls, where a clerestory was placed on top of the colonnade. The monumental bronze doors, framed by handsome marble posts, were no different from ornate secular entrances. The veils hung between the pillars were exactly the same as those in the colonnades of palaces (Plate 48). The galleries around the forecourt, the *atrium*, were such as could be seen in rich men's houses, and even – though more as open arcades and more closely connected with the adjacent colonnaded streets – on public squares, in front of great monuments. The fountain in the middle of the *atrium* doubtless took on a symbolic meaning for the Christians, as

they washed their hands in its waters before entering the basilica: but this kind of fountain was part of the usual decoration of any of the larger inner-courts in the ancient world. The perforated balustrades of marble, between short square posts or columns topped with fir-cones, that surrounded the altar, and the latticework gates of stone and metal that shut off the apsidal platform of the bishop, could be seen on the forum, in palaces, and in secular meeting-halls: only here and there would the use of a Christian symbol in the carving make it clear that these barriers, the *cancelli*, were intended for a Christian basilica . . . and so on. Although the basilica did not 'evolve', there was enough that was borrowed, indeed, almost everything; everything, that is, excepting the one thing that was decisive.

For all this is no more than the architectural trappings of the time: we might just as well have added to our list the bricks, the mortar and the blocks of marble. And these external appearances of the basilica will not vanish entirely: it was impossible to abandon all the ancient forms, although a transformation would be brought about by a new feeling for style, that no longer belongs to the ancient world. The one unchanging element, even in the Middle Ages, was the way in which a single building was created to meet certain basic needs which, as we have seen, derived from the structure of the Christian community and the particular nature of their religious gatherings. Such elements were few in number: it will be worth our while to enumerate and emphasize them.

Everyone can see at a glance that the basilica's interior as a place of assembly takes precedence over all other features. As is the case with so many such buildings used for meetings in the ancient world, the basilica has no arresting contours; indeed, it is hardly possible to recognize a careful plan from the exterior. The outside is merely incidental; it is subservient to the needs of the interior. Furthermore, the basilica was but seldom a spectacular public monument, of the type of the earlier 'peripteros' temple, that stood alone on a high façade of columns; and if it became one at all, it would be only in the predominantly Christian East. On the contrary, it was generally built in between blocks of houses or in cemeteries, hemmed in by rows of tombs. Nobody conceived of the idea of erecting a mighty building to dominate the scene high above the roof-tops, as in a medieval town, where the cathedral rises like a citadel of heaven above the tangle of tiny houses: for that matter, the ancient world

had given no thought to endowing their buildings with a marked vertical line; they knew nothing of steeples, nor of the high-pitched dome (their domes were flat, as in the Pantheon). What the early Christians wanted was to build an interior capable of holding many people, and, if possible, to cut it off from the noise of the street and the profanity of life in the city, by a larger forecourt and a thick wall. We must not forget that the Christian community was essentially urban: the church began with small gatherings in houses, always in the towns, always cut off from the bustle of life; Christian propaganda was directed to the individual, and so the Christian assembly was no mass-meeting, but rather a silent forgathering of initiates behind locked doors.

The interior was arranged for the 'gathering of the faithful'. This gathering took place with a strict sense of order: the principle of authority was dominant. The attention of the gathering and its rites were always focused on the throne of the presiding member, that is, of the bishop (*episkopos*, 'overseer'; *proestos*, 'leader'), surrounded by the benches of the presbyters (our 'priests', from *presbyteroi*, 'the elders') (Plate 8). For this reason, the interior had to have a long main axis: all those present stood facing the platform, where the bishop sat on his chair – the *cathedra*. If the bishop was not there, then only a priest who was empowered to do so could lead the gathering; but he never sat on the seat reserved for the bishop. The bishop was the community. The *cathedra* of the bishop was also the symbol of his authority, and, when he expounded the Scriptures, he did so seated: he spoke from his chair – *ex cathedra* – facing his community. Right up to the time of Augustine, in the West, the priests had no right to address the congregation during the service.

But the bishop does not himself speak words of his own devising; he only gives his exposition of the Word of God. For this purpose, each place of assembly has a reading-desk, from which the books of the Scriptures would be read in an order laid down according to the feasts of the ecclesiastical year. This desk is called an *ambo* (from *anabainein*, 'to mount'), because of the steps leading up to where the reader stood. The reader was a well-schooled young man, with a clear voice, who could read the handwritten codices and declaim them with ease, so he was called a '*lector*'. The bishop did not himself read the Scriptures aloud, as such reading was very tiring; and as he was often an old man, he could not compete with the *lector* in

strength of voice and eyesight. (It is no easy business to read fluently from a codex of the fourth century.) The *lector* also faced the congregation when reading.

The elements we have mentioned so far: the room for the gathering of the faithful, the *cathedra* of the bishop on his dais, and the reading-desk for the lessons, were all connected with the visible structure of the community and with what we now call 'preaching the Word'. These gatherings could be attended by anyone interested, by catechumens, Jews and pagans. During the 'service of the Word of God' the doors stood open, and anyone who wished, could step inside and listen. But after the lesson and the homily of the bishop (the sermon), the unbaptized were sent out. When they had all gone, the doors were closed. Meanwhile, the candelabra in the nave were lit; the bishop, his priests and deacons would 'step down from the apse and make their way to the Place of Prayer', in the main nave of the church.

This place was the altar, a small stone table covered with white cloth, that was separated from the crowd of the faithful (now only the baptized) by a low balustrade – the *cancelli* we have already mentioned. The altar stood in the central axis of the building, between the nave and the raised platform with the *cathedra*. But this was the place of prayer: at the altar, the bishop no longer faced the faithful but, standing between the people and the altar, he and his priests and the congregation assembled outside the *cancelli*, turned towards the East, and the bishop 'raised his hands', the attitude of prayer in the ancient world. The deacons placed the dishes with the bread, and the cup with the wine, on the altar. Then the bishop began the age-old prayer that had already assumed a fixed form in the fourth century, and so today is still called *kanon* – that is, 'the fixed rule'. After the remembrance of the Passion, Death and Resurrection of the Lord, he would bring to a close this prayer of thanks (the *eucharistia*), which included a prayer for the living and the dead, with solemn praise of God the Three in One, which the congregation would affirm, and as it were 'sign for', by a roar of 'Amen!' Then he would say the Lord's prayer, break the bread, and distribute it to the faithful who had come up to the entrance of the *cancelli*. The faithful, men first, then the women, took the consecrated bread with their right hand, 'so that they could use their left hand as a support for their right', and swallowed it, then they drank a sip of the conse-

crated wine from the cup, which the deacon offered them. After a short prayer of thanks, they would disband; the doors would open, and the basilica would empty.

The 'initiates' were those who had 'put on Christ' in baptism. Because of this, a special building stood beside the main basilica of every town, called simply *Fons*, the 'Fountain', representing the 'Fountain of Life' (Plate 23). There the 'living' water poured from the usual harts' or lions' mouths, into a basin (the *piscina*), that was reached by stepping down three steps (Plate 24). Veiled from spectators, those who had been sufficiently prepared would be baptized, on Easter Eve – on the night of the Resurrection; they too would rise again to a new life, and from then on would be among those who had been 'enlightened', who carried upon them the seal of the Spirit of Christ.

The two elements which we have just mentioned – the altar and the baptismal font – came into being to enable proper performance of the sacraments of the church; together with the *cathedra* and the *ambo* and the nave that contained the congregation of the faithful, they made up the interior of a Christian church. Everything else is of secondary importance.

When we turn from these essential elements to consider the basilica as an architectural ensemble, we cannot fail to be struck by the simplicity and the certainty of touch with which the basilica builders carried out these basic ideas. For the basilica is a building completely dominated by the purpose for which it is used. Anyone who had crossed the silent forecourt, stepped inside through the curtain and the open bronze main door, and could see before him the body of the church, roomy, untouched by the heat of the sun, lit by windows from above, would understand at a glance; here the community of Christ assembled, under the eyes of God. What baffled the pagans and the police in the house-churches of around 304, was the strange fact that, although they had found a meeting-place, they could not discover a single image of a god; what they confiscated in the end, was 'only books', which were then burnt on government instructions. Their impression was the right one: there was no place for images in the basilica, but only for thoughts of the Invisible God; and the most precious things it seemed to possess, were books that contained the Word of God. The most priceless treasures of all, however, were known neither to the police, nor to pagan well-

wishers: these were the 'mysteries', of which the altar, standing empty and hidden beneath a cloth, betrayed nothing to the eyes of the uninitiated. Even indifferent and tepid half-Christians, who may have gone to church and heard the lessons and sermons, but could not screw up the courage to be baptized until on their death-bed, did not know these holy secrets.

This message, simple and clear, was perfectly expressed in the spacious interior of a basilica. The well-informed visitor, who let his gaze wander throughout the massive, silent building, would instantly have noticed in the great niche which formed the blank end of the building, its semicircle of wall covered with incrusted marble-plaques, the high throne of the bishop surrounded by the raised benches of his clergy (Plate 8): nothing could have conjured up more plainly the idea of authority and of the Apostolic Succession. The small, empty altar table, always covered up, made inaccessible for the mass of believers by the *cancelli* that fenced it in, and placed beyond eye and thought by the silence that surrounded the mysteries associated with it, spoke to the initiated more plainly than did any book, of the simplicity, the sublime nature and the power of the 'Food of Life', as it was called, the 'Medicine of Immortality'. Even the uninitiated could not avoid the impression of a worship 'in spirit and in truth', that would be worthy of an invisible Ruler and King of the World.

The whole interior must have seemed to contemporaries a powerful, irrefutable contradiction of what they had been used to seeing in the temples. The temples had no spacious interior: they were the house of a God, not of a community. Their solemn rites would have been performed in broad daylight, fully open to the public view. The altars would have smoked, as the flute players blew and the sun shone through the heavy wreaths of vapour, in front of a crowd already impatient for the stage-shows that would, by custom, follow the ceremonies.

By contrast, a solemn emptiness reigned in the basilicas (Plate 4). Not a single statue: except for the leaf-patterns of the capitals and a slender cornice, not a single sculptured motif that stood out in high relief. Towards the end of the fourth century, the Christians had begun to decorate the high walls of the clerestory with Biblical scenes in mosaic, and to cover with mosaics the great niche of the apse and the blank end wall that surrounded it, from the top down

to the upper beading of the marble facing. Here, at the point at which the spaces of the main building converged, was placed (as a rule) the Redeemer in His splendour (Plate 11). This was done with restraint and with an artist's certainty of touch: the arched surfaces of the conch of the apse, that formed a quarter-sphere, for instance, would be given shape by broad mouldings and strips of frieze, so that the general composition remained a united whole, easy to understand, and the figures within the actual scene, though they stood in a stylized landscape, would not have seemed distorted. Figures on too large a scale–the mistake that so many modern artists make in decorating interiors–were always avoided in the art of the Early Christians.

In Rome, Christ was usually seen as the Lawgiver of the New Covenant: He stands on the New Mount of Paradise with its four rivers that flowed together into the spiritual Jordan, the prefiguration of baptism; flocks of white lambs, trotting out from the sheep-pens of the Circumcision and of the Gentiles, drink from this river: while the Lord hands over the Law of the Gospel to the new Moses, to Peter, easily recognized by his characteristic head and by the cross of his martyrdom. On the other side of the mountain stands Paul; and above a landscape, dotted with the palm trees of the heavenly paradise, in which can be seen the Phoenix-bird, the symbol of immortality, drift the fire-tinged clouds of the ethereal regions, warning the beholder of Him who would one day come again 'in the clouds of Heaven'. This famous composition, in which the two Apostles, who had died and were buried in Rome, appeared in the company of the Lord, could in all likelihood have been seen in the apse of the old church of St. Peter, which has vanished today: and, over many centuries, it was imitated by many other churches. Another mosaic showed the Lord holding sway in the city of the Heavenly Jerusalem, between Apostles seated on thrones, Peter and Paul on each side, and behind Him the sign of the Cross, surrounded by the Four Beasts of the Revelation of St. John: this can still be seen in the little church of Santa Pudenziana–the 'Church-house of Pudens', as it was called in ancient times that date back to the time of the persecutions.

The great blank wall around the apse was either divided up into several parts like a frieze, one above the other (as in Santa Maria Maggiore) (Plates 4, 9, 12), or it would have contained only one

great composition–often of the twenty-four elders praying to the Lamb, from the book of Revelation: there are examples of this in San Paolo Fuori Le Mure, in SS. Cosmas and Damian on the Forum, and in many other later basilicas. The walls of the nave were decorated with scenes from the Story of Salvation in mosaic or fresco, often arranged in such a way that the scenes from the Old Testament, on the left, echoed the scenes from the New Testament, on the right; an example is in the main church dedicated to St. Peter and St. Paul (though the picture cycle has disappeared). This marks the beginning of the famous 'typological' juxtaposition of the two Testaments, that was such an important feature of the decoration of churches far into the Middle Ages: it is the origin of that great cycle of Biblical pictures, which we find century after century, in mosaics as well as in fresco, on the walls of every church in East and West.

From a technical point of view, the basilica was an uncomplicated building. The middle nave was as broad as the beams of the roof-support would allow: the dividing of the church into three or five naves, quite apart from the natural structure of the building, was necessary to gain sufficient freedom of movement. The entrance-hall, the adjoining buildings, the forecourt with its four galleries (*quadri-porticus*) and the fountain for washing one's hands–all these were joined to the main building as simply as possible, in rectangular blocks, as in a modern ground plan. So the building as a whole impresses modern man as being unpretentious and matter-of-fact: it was not a mean building however, for even small churches of out-of-the-way townships were furnished with great care.

What is more, the basilica, as a building, had no ulterior 'meaning'. It may have been described as 'a mother's womb', that 'takes all inside it', as 'the royal throne-room for our King', as 'the house of all men', in inscriptions and in the verses of some poets, such as Paulinus and Prudentius; but the form of a basilica as such, was not dictated by concepts of this kind. The Gothic royal cathedrals of the Île de France may have been consciously contrived by all means calculated to impress the senses, above all by their stained glass, to evoke the Heavenly Jerusalem, built with precious stones, to which a basilica was compared in the liturgy of its consecration; but the basilica was not built to 'symbolize' anything. We do not know the rites for the consecration of the earliest basilica; but the thesis that

the basilica of the fourth and fifth centuries, with its 'street of colonnades', was a visual image of the City of Heaven, seems to me to lack foundation.

The basilica then is not a symbolic building; it is austere and matter of fact. But the historian is impressed by the fact that the very greatest and most magnificently furnished Roman basilicas – in Rome, or in Constantine's city on the Bosphorus, in Jerusalem or Ephesus – were built as broad halls of columns, roofed over with rich, gilt, coffered ceilings. Except for the conch of the apse, the basilica was never vaulted. It is plain that vaulting was consciously avoided in these mighty buildings. It is inconceivable that men who could build secular meeting-halls, such as the Basilica of Maxentius and Constantine on the north side of the Roman Forum, resting on a solid block of walls, in which the barrel vaults of the supporting side-naves covered a span of twenty-three metres (some of them are still standing today), were no longer capable of doing the same for a building of similar dimensions intended for Christian worship. It was a matter of not wanting to use vaulting; vaulting was common for public baths (some of which we can still see in Rome: those of Diocletian – now part of Santa Maria degli Angeli – and the ruins of the Baths of Caracalla); for some smaller buildings – cellars, storerooms, blocks of dwellings, mausoleums; also for underpinning on a large scale, as in an amphitheatre. Plainly in planning a basilica, vaulting was deliberately renounced. Why was this? Perhaps because it was not thought suitable for sacred purposes. The dim glow of a gigantic coffered ceiling would have been the admiration of all contemporaries; it was a continuation in the Christian basilica of the traditional rich coffered ceiling of pagan temples. (Theodor Klauser has also pointed out to me the way in which this flat ceiling would contribute to the total effect of the interior; in order to stress the crucial significance of the semicircular lines of the vaulted niche of the apse, the remaining parts of the interior are given a pure, cubic form; the flat floor, the flat ceiling and the severely vertical, straight walls on either side, converging by an effect of perspective, and leading the eye inevitably up to the apse with its altar and the *cathedra* of the presiding bishop.) Not until Baroque times did builders transform the remains of the Roman baths into vaulted churches.

The early Christian builders rejected the vaulted roof and chose

the solemn hall with its rich ceiling. This appears to us to be a transitory form, but in practice it would last very well; and in the eyes of the early Christian, it was an appropriate setting for sacred art. Two centuries later, the builders of the eastern half of the Empire would combine the motif of a dome, rising from a central position with its four sides open, like the domed covering above an altar, with the layout of the ancient basilica; and in this way they introduced the general use of vaulting in Christian ecclesiastical architecture. Their example was not followed in Rome. The first church here to be fully vaulted was built at the end of the thirteenth century by foreigners, who had come from Southern France: the Dominicans' Santa Maria Sopra Minerva, which has remained the only Gothic church in Rome. Only with the Renaissance was the distinctive Italian form of vaulting introduced into Roman churches.

But this 'utilitarian' air in the classical basilica did not imply that the founders and the faithful were grudging in their endowments. The Emperor himself set the tone in endowing the most important shrines: and at a time when so much wealth still existed, as in the first decades of the fourth century, the furnishings of a church would have been of an overpowering magnificence. We happen to possess, in the *Liber Pontificalis*, that invaluable chronicle of the popes, the authentic lists of the endowments that Constantine had made to certain famous basilicas, among which were the Lateran Basilica, St. Peter's on the Vatican Hill, St. Paul on the road to Ostia, San Lorenzo Fuori Le Mure, and some others. Not only do these endowments include many estates from the Imperial demesnes, whose revenues were devoted to the maintenance of the basilicas, of their ministers, and, not least, of their thousands of oil lamps, but they also included an immense number of golden and silver consecrated vessels, bowls, cups, jugs, candelabra, and ornaments to stand and hang in the church, ornamental columns, veils, metal railings and precious draperies. In the smaller basilicas, even in those founded in poorer times, the interior was furnished with a certain splendour. Candelabra with their innumerable oil lamps and veils hanging between the columns were never lacking. On Easter Eve and on other feasts, any basilica, great or small, in whatever out-of-the-way corner of the world, would have given the impression of being a murmurous festive hall: the crowd streamed in under the red glow of candles, beneath coloured hangings with bright embroideries

(Plate 48). Over their heads, far away in the depths of the apse, the mosaics reflected the light, and the whole building was immersed in the scent of herbs carelessly trodden under thousands of feet, of marjoram, laurel, myrtle and box.

All this has completely vanished; and only by reading the occasional text can we conjure it up in our imagination. It is not only the Goths and Lombards who have stolen the gold and silver ornaments: time itself has annihilated what remained. The only thing that has usually survived is the mosaic floor. Some are still intact. The oldest and the largest of these can be seen in the medieval Cathedral of Aquileia, once an important city, now a village. This floor, of around 310-20, lay under two layers of later flooring, and has now been uncovered between the early Gothic columns of the nave. Mosaic floors of a later time, especially of the sixth century, can be found everywhere. Right beside Aquileia, in Grado, there is a floor – again within the present-day cathedral – which was endowed in the sixth century, partly by the congregation of the faithful, and partly by their clergy: the inscriptions with the names of the benefactors of each piece can still be read (Plate 15). At that time, anyone who wanted to do something for the church would present a piece of mosaic flooring, or a ritual vessel, or a curtain: only the most distinguished would found a *memoria* (that is, a chapel of remembrance in honour of the relics of a saint) or a mausoleum for himself and his family; while only princes and bishops would have had the means to found, and largely meet the cost of, a basilica.

The magnificence of southern lands, always dignified and somehow subdued, that characterizes the early basilica, was a matter of course for the Christians of the fourth and fifth centuries. Poverty, in their opinion, ill-suited the 'house of the family of God'. Even the significant name that they used for their church – *basilica* – pointed to this: for this name meant 'a monumental public building'. Before 313, in the time of the persecutions, they called what were often handsome churches in private houses, 'the house of the community', or the 'house of prayer'. After Constantine, however, along with the accustomed word *ecclesia*, *basilica* suddenly becomes current, especially in the Latin West; the new term may well have some connection with the unexpected monumental quality of the more prominent new churches. After the dissolution of the old religion under Theodosius the Great, when house-churches everywhere, humble

and large, were replaced by spacious, and often monumental, colonnaded halls surrounded by courtyards and annexes, both names remained in use. But *ecclesia* was the original name, and was the more popular, as is shown by the survival of the word in nearly all Romance languages. With a fine instinct, the faithful preferred to keep, instead of the empty and secular name *basilica*, the older, richer and more striking word of *ecclesia*. By the nineteenth century, *basilica* became a purely technical term of art history: it stood for a very definite type of building, dating from Christian late antiquity: but for many centuries the basilica had been the keystone of European architecture, an inexhaustible theme on which the Romanesque abbey-churches, the Gothic cathedrals, the cupola halls of the Renaissance, even St. Peter's and the Baroque interiors, are but brilliant variations.

The 'Memoria'

Immediately after 313, Christians everywhere began to decorate with a memorial chapel the graves of the martyrs, that they had long revered; often they would erect a basilica instead of a memorial rotunda. Wherever a humble memorial already stood at a famous grave, as at the tomb of the Apostle John at Ephesus, this small building was included in a large basilica, which became the converging place of innumerable pilgrims. It was not long before every city of importance began to erect one or more basilicas over the graves of their martyrs. The altar of the graveside church was placed near or above the tomb of the martyr, who had offered up the sacrifice of his own life for the truth of God. Now, the mystical table of the altar was erected on top of the table (the *mensa*) of the tomb, at which the pious members of the Christian community used to eat their memorial meal, according to immemorial custom practised also by pagans. From then onwards, the remembrance of the death of the Lord would be celebrated at this altar, and would include as a humble accompaniment to the main harmony, the remembrance of the glorious death which the 'witness'–*martus*, the martyr–had undergone in the strength of the Lord. Martyrdom counted as 'witnessing' to the power of the Spirit of Christ, and when Augustine preached on the anniversary of one of these innumerable martyrs, who held the imagination of all African Christians, he never failed to stress this theme. The memorial church that rose above the spot where the famous Bishop Cyprian of Carthage had 'borne witness' in the mid-third century, that is, where he had been executed for his beliefs on September 14th, 258, was called by the people, quite simply, the *mensa Cypriani*–the table

for the funeral meal of Cyprian, and, in the new meaning of the word, the altar in honour of St. Cyprian.

The basilicas that now sprang up everywhere in the cemeteries outside the city walls, attracting many thousands of pilgrims, differed from the usual city-church only in possessing a richly decorated and widely revered tomb of a martyr. The actual altar did not always stand on top of the grave. In the most famous graveside basilica of the time, above the tomb of the Apostle Peter on the Vatican Hill, the altar stood perhaps some twenty metres in front of it: the *memoria* of the Apostle lay in the niche of the apse, and, between it and the altar stretched a spacious transept that could hold thousands. All that remains of this *memoria* is the shaft that gave access to the tomb, which has recently been excavated, with a remnant of the second-century *aedicula* (a miniature building) on top of the tomb, containing a niche. But we can, nevertheless, form some impression of it from the cover of an ivory reliquary, of the mid-fifth century, found in Samagher, near Pola (modern Pula, in Istria, Jugoslavia) (Plate 18a). Since the second century, a small memorial-niche had stood over the tomb, backed by a simple gable-roof, resting on two little columns. When the Constantinian basilica was built, on a raised ground-level, this niche came to lie underground, but was accessible through a hole in the pavement. An *aedicula* covered the opening, with rich silver doors, surrounded by six twisted columns of white marble, entwined with vine-scrolls and crowned with a magnificent baldachin, from whose centre there hung a golden candelabrum. The faithful could approach the *aedicula* along a low balustrade, to address their prayers to the tomb and pour balm on it: at a slightly later time, it was customary to lower little cloths down on to the holy spot, that could then be taken away as mementoes of this famous tomb. These little cloths were called *brandea*, and other souvenirs, such as the oil from the lamps that burnt there, were called *eulogia*, 'gifts of blessing'. But in other places, the tomb that lay deep down under the flooring, was invisible to visitors at the shrine: an inscription in mosaic would indicate the spot. As all the most important shrines have been rebuilt again and again, we cannot always say for certain what they were like in the fourth century. This applies to most of the Roman graveside basilicas: we do not know whether the tomb of the martyr Lawrence, or of the Apostle Paul, or of the martyr Agnes, were

accessible to the faithful in the time of Constantine, whether they could be looked down at from above, or whether they were placed under the floor of the altar-space, as they are today.

In the Roman catacombs, the tombs of the martyrs were so numerous, that it proved impossible to set up a memorial church over every one of them: sometimes many martyrs who had been laid together in the same place were honoured in a common basilica – for instance, 'Petronilla' (a legendary figure, perhaps), Nereus and Achilleus, in the basilica on the cemetery of Domitilla; and a whole host of martyrs were honoured in the basilica consecrated by Pope Sylvester, the Confessor, in the cemetery of Priscilla. It is true that famous tombs often lay unnoticed, deep down in the narrow passage-ways, indistinguishable from other, poorer graves. In 1845, a tomb of this kind, that had been passed over in oblivion – that of the martyr Hyacinthus – was found intact; the relics were then translated to the church of the Propaganda Fidei on the Janiculum. In the early Church, people were often content to make an easier approach to the martyr's tomb, and to build a vault in the grotto. Pope Damasus, a learned man – he caused Jerome, with his knowledge of three languages, to revise and re-edit the existing Latin translation of the Bible (which is the beginning of the Vulgate) – composed classical verses for the most visited tombs of the martyrs: these he had engraved on marble slabs in splendid lettering by an excellent cal-ligrapher, and set them up over the tombs. Many fragments of these inscriptions have been found; and the verses themselves had already been carefully copied out by pious travellers in late antiquity, by Anglo-Saxon visitors among others, and have been preserved in this way.

The sites in the Holy Land and its neighbouring regions, where the Biblical events had actually happened, exercised an even greater fascination than that of the tombs of the most revered martyrs. We hear that, in the second century, it was known precisely in which grotto in Bethlehem Jesus was born; where the Cross had stood outside the old Jerusalem that had been destroyed; where the cavern was in which Christ was buried and from which he rose 'on the third day, according to the Scriptures'. The Church had hardly received official sanction, before the mother of the Emperor went to the Holy Land, in order to remove the pagan monuments that

had been built there, to erect Christian *memoriae*, and, what is more, to have them paid for by the Imperial treasury. The layout of these *memoriae* is the same everywhere: on hallowed spots—in Bethlehem, over the grotto, in Jerusalem, over an uncovered piece of rock that contained the cavity of Christ's grave—a memorial building was erected. This was finally enclosed in a great basilica of the usual type, and forthwith became a centre of pilgrimage for vast numbers of the pious. But *memoriae* were also erected in places that did not have this central importance: in Bethany, on the tomb of Lazarus; by the Lake of Gennesareth, where the miraculous multiplication of the loaves and fishes, the prefiguration of the Eucharist, had taken place; in Emmaus, where the Lord had broken bread with the two disciples; in Nazareth, by Jacob's Well at Sychem (Plate 34a) on the Jordan; at Cana: indeed, everywhere where the memory of some event in the Gospel was still alive. *Memoriae* also came into being over spots connected with the Old Testament: on the site of the Oak of Mamre, near Hebron, where God had appeared to Abraham and Sarah in the form of three travellers; on the mountain range of Sinai in Arabia; and on the mountain from which Moses had glimpsed the Promised Land, and from whose summit he had been taken away to Heaven. In this way, the 'Holy Places' came to be the favourite place of pilgrimage—or, better still, the land of pilgrimage *par excellence* of the Early Christian world. But outside the Holy Land, the *memoriae* continued to be dedicated exclusively to the memory of the martyrs. The Greeks called these shrines *martyria*, the Latins, *memoriae*; but their origin was the same—a spontaneous and insistent reverence for the martyrs.

This reverence had its roots not only in the pious customs of the ancient world, but, above all, in the words of the Gospel: 'Greater love hath no man than this, that a man lay down his life for his friends'. And the Fathers of the Church continually emphasize that the power, by virtue of which a martyr bore witness with his own blood, did not spring from human beings alone, but was a creation of the Spirit of Christ: for this reason, the limitless hosts of the martyrs were sometimes described as *gloria Christi*—the glory of Christ.

What we now call the 'veneration of saints' sprang from this idea. It was practised from the beginning in Christian communities. After 313, at a time when hundreds of thousands joined the Christian

Church, with a paltry degree of preparation that took them no further than becoming catechumens, this practice created a genuine popular piety–the only form of popular piety indeed that existed in the early Church. The bishops did not intend to kindle such piety: in fact they found themselves forced to hold in check the excessive excitement, the belief in miracles, and the itch for pilgrimages. But they also saw what was good in it. On the great anniversaries with their fairy-tale 'vigils' at the tombs of the martyrs, they would deliver speeches of praise in the rhetorical tradition (panegyrics): they would conjure up the old heroic days, so different from the spiritual mediocrity that had become almost general, and, while the world may have been Christian in externals and the Empire called a 'Christian' Empire, the established Church was constantly under the thumb of the State, and had to suffer from the worldliness of so many of its members.

Only a few *memoriae* still survive, and hardly any have retained their original appearance. Yet at one time, they were the religious focus of Christendom. Whoever today stands lost in admiration before the mosaics on the walls of the nave of Sant' Apollinare Nuovo in Ravenna, contemplating the two long processions of men and women martyrs in white robes, framed in the palm trees of Paradise, against an abstract gold background, offering to their Lord, throned in majesty, the tokens of their triumph–the triumphal crowns and palms of victory in their hands–should also realize that these martyrs did more than any others to establish the moral criteria for the West. For over a thousand years, the world had celebrated them as its heroes and examples–selfless, brave, independent; the autonomy of the spirit, that typically Western form of human greatness, the finest flower of true freedom, is inseparably linked with their names.

These names have become honoured favourites throughout Europe. Italians are still called Lorenzo, Eufemia and Pancrazia; Swedes, Lars; English, Lawrence; Russians, Dmitri, from Demetrius of Thessaloniki, or Sergei, after Sergius of Sergiopolis, a city near the Euphrates; and many Germans, and others, are called, for instance, Peter or Paul.

Their *memoriae* have disappeared. They have been forgotten or absorbed into other buildings. But their story is not forgotten, and their names live on, in the pages of the calendar, in the loneliest

places in the world, on the lips of men who perhaps do not know at all that they are living *memoriae* of earlier generations, who unostentatiously laid down their lives for the freedom of the spirit.

The Baptistery

Beside every main church there stood, in every early Christian town, what was generally an octagonal building, roofed by a flattened dome. The popular name of this building was *fons* – 'the fountain', the 'font'. A lamp would usually be burning under the dome: all day long the doors would stand wide open, and passers-by would hear the gushing of the 'living water' as it poured from the mouths of stone animals into a broad basin, to which marble steps led down, its bottom covered with mosaic. Looking down through the clear, ever-flowing water, they would see fishes and the monogram of Christ in the mosaic; a lamp would be hanging from a canopy that covered the octagonal basin (Plate 24); the curtains would be looped up high and fastened with cords to the small supporting pillars. Beside the door, the mosaic paving would often show some symbolic representation of the 'Fountain of Life' – either a vessel from which branches sprayed outwards, or flowing water with 'Jordan' marked beside it, from which two harts were drinking, an allusion to the Psalm: 'Like as the hart desireth the water-brooks, so longeth my soul after Thee, O Lord' (Plate 25). This small rotunda was the *baptisterium*, the 'baptistery': the Greeks called it *photisterion*, 'the place where a man is enlightened'. 'Enlightened' meant that a man's eyes were opened to the divine truth, like those of the man born blind, who had to wash in the Pool of Siloam: 'Siloam' means 'the Messenger'; and this messenger is Christ.

The baptistery, built as a bath in which a man would be born again by water and the Spirit, was consciously brought into being to convey a symbolic meaning; and so it is the one creation of Early

Christian art which has most power to conjure up the presence of another world. What is evoked is the sacramental sign that was instituted by Christ and performed in His church from its very first beginnings. The accompanying rites, of course, came from the later tradition. Together with the original core, they formed an established ceremony that would be found in all countries and in nearly every baptistery.

To our way of thinking, the ancient baptismal ceremony was an exceedingly drastic affair. Over a period of at least seven weeks of strict daily preparation, those awaiting baptism – the *competentes*, that is, those who had 'begged' baptism – would undergo, not only a course of instruction, but a whole succession of exorcisms: they were regarded as 'infected' by the more sinister features of pagan culture – as was only too true. The Old Adam in them was not handled softly: when the demons were being exorcized, the *competentes* would stand, dressed in sacks, with their bare feet on the skins of animals, which symbolized their pagan past. On the night of the Resurrection, the moment would come in which they also would 'die in the fountain and rise again from the fountain to a new life'. This renewal of life was a literal rebirth: with not a single ornament, their hair undone, stark naked, just as they were born from their mother's womb into the natural world, so they would step behind the closed curtains of the canopy, down the steps into the baptismal basin (Plates 29a, 30b). Three times the bishop would hold them by the shoulders under the pouring water, and baptize them in the name of the Father, the Son and the Holy Ghost: then they would climb out of the life-giving water – newborn children from the womb of their new mother, the Church made fertile by the Holy Ghost. They would receive a long white robe, the symbol of 'the Lord Christ, Whom they have put on'. In an adjoining room, the bishop would anoint their heads with oil, the token of their inner anointing with the Spirit of Christ: in modern terms, they had received 'confirmation' immediately after their baptism.

When the whole company had been baptized – men first, and then the women (elderly deaconesses giving the necessary help at their baptism) – they would all put on their white robes 'as new lambs in the flock of the Shepherd', and would be received in the adjoining basilica, with its festive adornment, to the chanting of psalms, and with deep emotion and joy on the part of the elder members of the

77

faithful. Standing in the place of honour beside the altar they would see, for the first time, the holy secrets of the Eucharist, and would taste, for the first time, the body and the blood of the Lord. And the joy at the overcoming of death and Hell in the whole universe, that was part of the atmosphere of the Easter Vigil and made this occasion the feast of all feasts, mingled with the elated conviction that these people had risen from the dead, that they would be forever together with their Lord on the way to everlasting life. Neither the return to daily life, nor the backsliding of human frailty, could ever wipe out this reality, or obliterate its memory: in the words of the time, they had 'received the seal'; that is, they bore the mark of Christ as the owner of their souls.

Anyone who nowadays visits the Baptistery in Ravenna, and who asks himself what the scenes on the mosaics mean, and why the baptismal basin or font has this special form, would do well to remember all this. There is nothing accidental in this building; every motif contains some allusion to the sacrament of baptism or to its introductory ceremonies.

The representation of the baptism of Christ by the Holy Ghost in Jordan, which is in the crown of the dome, reminds us, that the anointing of the Lord with the Holy Spirit in the water of Jordan is the archetype of this sacrament. The solemn procession of Apostles carrying crosses, shown immediately below it, reminds us, that the confession of faith, which the newly-baptized had delivered in the words of the 'Apostles' Creed', agreed with that which the Apostles had handed down. And then, a stage further down, we see the books of the four Gospels, solemnly laid open on altars: a reference to the ceremony in which these books were shown to the catechumens, and explained as a whole; we also see the *cathedra* of the bishop on four occasions, a reminder of instruction on the authority of the Church. Further, we see here, as elsewhere (as, for example, in Naples), the white lambs in the Paradise of the Good Shepherd (Plate 14)—an allusion to the white robes, which symbolized the spotless purity of the baptized after the forgiveness of sins; again there are the harts, running to the Fountain of Life, sometimes with the text from the 42nd Psalm in golden lettering. The unique interplay of mosaic, marble and stuccowork, that has made the wall decorations of the Ravenna Baptistery so famous, also serves the even more subtle interplay of symbolic connections and combinations:

for such a building expresses this symbolism with all the magnificence the art of that age could provide.

The layout of the normal baptistery was the same as that of one of the larger, closed-in private bath-houses: the distinctive feature was the 'living', that is the 'running', water; its basin, the *piscina*, was an 'enclosed spring'. Later Christians–from the fifth and sixth centuries onwards–were accustomed to seeing only new-born babies brought to be baptized. They were no longer surprised by the changed conditions that reduced this ancient, drastic and telling ceremony, to a simple, unobtrusive, symbolic gesture. The gushing water became a few drops, no longer poured over the whole body but shaken on to a tiny head; the stripping of the baptized remained customary only in the Greek church, where the priest dipped the child three times. The anointing was administered only on particular parts of the body–between the shoulders and on the crown of the head–and not all over, as was fitting for an 'athlete of the spirit'. Naturally, the early Church knew of the simplified ceremony: as a matter of emergency–with small, weak children or at a death-bed. Origen mentions it in the second century. But baptism in a baptistery was the rule.

Of all Christian countries, Italy maintained for the longest time the grand style and expressive ceremonies of a spacious baptistery, standing beside the cathedral church. The baptismal basin of course became smaller, and a less drastic ceremony was necessary. But the magnificence of the baptistery itself remained. And today, the citizens of Pisa, of Ascoli di Piceno, Parma, Padua and of many of the old episcopal cities still proudly carry their children to the baptisteries old and modern, that stand beside their famous cathedral churches; and the Florentines, the possessors of the most beautiful baptistery in the world, know very well that their *bel San Giovanni in fonte*, opposite their Duomo, differs so little from its Early Christian prede-cessors in ground plan and layout, that until not long ago people thought that the building, which was erected in the eleventh century, must have dated from the fifth.

Finally, there is one peculiar feature that never fails to strike an observer, in the overwhelming majority of baptisteries and baptismal basins. It is its octagonal ground plan; and anyone acquainted with the construction of rotundas in late antiquity would assume it to be one of the regular borrowings of secular motifs. Even when the

outer walls form a square, the interior is octagonal, and the basin is almost certain to be so: when the basin is not, it is in the form of a cross (as came to be the rule in later Byzantine churches).

We know from the sermons of the Fathers of the Church, from inscriptions and from verses, that this shape was deliberately chosen: and that was because of the part played by the number eight in the symbolism of numbers in the ancient world. Educated Christians also practised this symbolism, and applied it enthusiastically to the numbers which occurred in the Bible and the Liturgy. The starting-point of these speculations was the number seven – for the days of the Creation. Six stood for the Creation – the number of days in which God worked; seven for God's resting on the Sabbath; eight for the New Creation that would dawn when the Lord comes again and transforms this Creation. In these speculations, therefore, eight came to be treated as the token of the Kingdom to come, the decisive, final state – Life Everlasting.

And so it came about, that the baptismal font and the house of the font, where Eternal Life had its origin in the sacrament, received an octagonal ground plan. When Bishop Ambrose composed the inscription for the new baptistery beside the great Basilica of St. Thecla (its foundations were discovered in the cathedral square of Milan not long ago), he remembered to point out that it was 'fitting' that 'this edifice should be built according to the sacred number eight: for here there springs eternal salvation'. And whoever wishes to know how a preacher of genius could develop this ancient, originally Greek idea, without giving less than due weight to the Christian message, should read what Augustine, Bishop of Hippo, had the boldness to say to the newly-baptized members of his congregation when, on the eighth day after Easter, they would again take off their white robes, and from now on would only enter their baptistery to kiss the baptismal font, and to be reminded of the sinless state with which they had begun their Christian life.

The Cemeteries

What is it that has made the catacombs famous? In the early Church, it was the renown of the tombs of the martyrs, which lay there in greater numbers, and closer together, than anywhere else. Associated with this, of course, there was the strange construction of this subterranean labyrinth, with its eerie darkness, and the narrow passages in which, at times, one's elbows would brush against the plaques that sealed off the humble graves. Jerome tells how, when he was only a student, he would always think here of the verse of the Psalm: 'Let them go down alive into the underworld'.

A hundred years ago, as we saw earlier, it was automatically assumed that the entire religious life of the earliest Roman church took place in this maze of passageways, lit by little lamps and candles: people imagined the Eucharist being celebrated in the narrow burial-chambers, and the popes, already marked out for death, as sitting on *cathedrae* of tufa-rock, while all around in the passages the bodies of the martyrs lay buried. This romantic picture has not vanished from men's minds even today; but anyone who has spent any time at all in a study of the literature relating to the catacombs, knows that it is unacceptable. The catacombs were ordinary cemeteries. They only happened to be laid out with particular economy, and in a quite exceptional kind of soil: as soon as it was dug out, and exposed to the air, it became as hard as stone, with the result that in the subterranean galleries hardly a single ceiling has caved in (Plate 27). Above all, they were the cemeteries of the common people: ornate family-vaults were out of place here – at least, before 313. The few sarcophagi decorated with sculpture that

81

have been found here, dating from the third century, stood in humble surroundings, and often we do not even know whether they had stood there from the beginning. At any rate, as the ancient world saw things, there was nothing in any way remarkable about the catacombs.

That is the first thing that strikes us about them: this contrast with the ostentatious monuments of the pagans. On all the roads leading into the city of Rome, along the old *viae consulares* – the consular ways – there lay innumerable burial grounds with thousands of monuments; and the biggest and most splendid of all usually stood right on the edge of the road. Today, as you take the usual stroll along the old Via Appia (the road that led from Rome, through Capua, to Brindisi), you can still see the bare bones, the brick core, of a whole row of such monuments: they are sometimes colossal edifices, real towers or hills surrounded by walls – like monumental *tumuli*. Then, if you turn to the ancient authors, you are reminded of a different aspect: sarcasm is heaped on the vanity of the great, who 'obviously believe that their remains could only rot away under a marble tower'; and, in another vein, they sing the praises of the piety of those children who had honoured their parents and grand-parents with a monument worthy of them. But what is always emphasized is the need for self-conscious and lavish show: in this the modern Italian *campi santi* continue a Roman tradition. We moderns are still touched by this reverence for the dead that is so marked a feature of the men of the ancient world. There are hun-dreds and thousands of gravestones, from all parts of the Roman Empire, from Rome to the furthest frontiers, along the Euphrates, the Rhine, the Main, the coasts of Scotland, the border-country – the *limes* – of the Algerian mountains, and far to the east of the Crimea: these inscriptions chiselled in beautiful capitals, in Latin or Greek, when taken in their totality, are an impressive testimony to the dignity of human beings. To live on in the memory of men, that is what 'renown' was for the Greeks; and the gravestones, with their inscriptions, sometimes terse, sometimes pompous, remind us over and over again, of that undying yearning for renown that was so marked in the ancient world, and no less of the piety that distin-guished ancient men, and was so important a feature of the ancient family.

Each grave, even the very poorest, was an inviolable *locus sacer*, a

holy place; its sacred character was protected by the Roman law; and the desecration of tombs was treated as one of the most heinous of crimes, hardly less despicable than robbing temples. To have no grave, counted as one of the cruellest blows of fate: after a hero's death, to have no honourable burial, no grave to be maintained in honour, was a theme for tragedy.

Each family grave was carefully maintained by the living, and frequently visited. On anniversaries and on particular days of re-membrance, as for instance, the *parentalia* of February, the relatives assembled there to join in a meal in memory of the dead: they believed, indeed, that the spirits of the departed were present, and so they placed an empty chair for the dead man between the seats of the participants, poured wine and incense over the gravestone, and spoke lovingly with his shade; afterwards, the conversation would turn on the virtues and idiosyncrasies of the deceased. These ancient customs continued right up to the end. The tomb might contain ashes in an urn, or – as was the case above all from the time of the Emperor Hadrian, in the beginning of the second century – it would enclose the body itself, buried in the earth or in a sarcophagus; but the meal in memory of the dead remained unaltered. The Christians, also, while abandoning the drink-offerings to the shades of the departed, did not dream of giving up this traditional form of piety. So we also find in their cemeteries, remnants of places at which, on special days, the members of the Christian community would celebrate together the meal of remembrance at the grave of a beloved martyr or of a famous bishop, in just the same manner as the members of a family at a family-grave. Like the Jews, the Christians never burnt their dead; but from the very beginning they buried them, following, in this, the Old Testament tradition, but one which would doubtlessly have taken on a new meaning: after all, their Lord also was buried, buried, in the words of the Gospel of St. John, 'as is the burial custom of the Jews'.

But that which distinguished so completely the atmosphere of the catacombs (as of all other Christian cemeteries, even of the more usual places located less mysteriously above ground) from the non-Christian burial grounds, is something other than the renunciation of all show, or the poverty-stricken appearance of their graves: it is the ineffable peace and the steadfast certainty of everlasting life that speak from their inscriptions.

It would be wrong to say that the pagan gravestones always show a kind of despairing resignation. Some impress us with their noble idealism, others touch us by a spontaneous outburst of an intimate warmth of feeling; with others again, we are struck by a cold cynicism, as in the famous phrase, 'I was not, I was, I am no more: it's all the same to me'; or by a stoical composure, as in the universal refrain – 'No man is immortal'. But the overwhelming majority of the inscriptions of the Imperial age bear the distinguishing marks of the Roman character: beneath the two letters D.M. (*dis manibus*, 'to the divine shades of . . .'), in lapidary brevity there stands the name, the title, the rank, at times the special merits, of the deceased; to the names of wives and children they often add laudatory, sometimes moving adjectives. Only in the last days of the Empire there occasionally come endless self-congratulatory recitals, often composed in verse, that bear little relation to the former brevity. But what is never to be seen there at all is the date of death: this fateful day must never be mentioned; it deserves only to be relegated to oblivion.

With the Christians, death has lost its sting. The stillness of their cemeteries is filled with profound peace. Countless gravestones carry not a single inscription, countless others only a Christian name, often wrongly spelt. But if ever it bears a date, 'on such and such a day before the Kalends of August', 'two days before the Ides of March', this date is always the hallowed day of death, of the entry into rest, of passing away in peace.

In pace, 'in peace': these are the words most frequently scratched on the stone. Sometimes they are replaced by a clumsy scribble, which shows two figures, one a veiled, praying form, with raised hands, and one the dove with the olive branch in its beak, from the story of Noah and the Flood: these two figures mean simply, *anima . . . in pace*, 'the soul . . . in peace' (Plate 28c). Later, after 313, these praying figures receive real faces: they stand, immobile, with raised hands, in groups of two, three, or four, close to one another on a field of flowers, and look out at us from tranquil, wide-open eyes. Sometimes they stand among trees, in grass. And sometimes the Good Shepherd Himself is in the midst of this Paradise, carrying on His back the lost sheep, and beside Him, a milk pail, that would remind the initiate of the Eucharistic food. At times, we see only the meadow, the trees of Paradise, the young shepherd resting on

a bench; and two small white lambs, one of which lies in the grass, pressed up against the sandals of the shepherd (Plates 28a and b), as in the Psalm: 'The Lord is my shepherd, therefore shall I lack nothing; he had led me into green pastures . . .' And sometimes, again, the Shepherd and the 'soul in peace' stand opposite the other, and look upon each other – the Saviour and the saved.

It is in this form, then, that Christ entered the world of artists: as the 'Overseer and Shepherd of our souls . . .'. There are other themes which occur again and again in the oldest parts of the first catacombs. They are always the same, and are composed in the same way. The first group makes us realize to what an extent the earliest preaching and the earliest liturgy of the church still adhered to the tradition of pious Jews. These are the great archetypal images of rescue from the jaws of death; of the righteous men of the Old Covenant, who took their refuge in prayer, and were heard. A fleeting hint of two or three figures, their setting barely indicated by a few signs: such scenes are shown on the walls above the stone-plaques that seal the graves. There we see how Noah was rescued from the Flood, Isaac from the hand of his father, Susanna from false-witness, the Prophet Jonah from the belly of the whale, Daniel from the lions' den in Babylon, and the Three Children of Israel from the fiery furnace of King Nebuchadnezzar. Sometimes, the Jewish theme of prayer is extended and filled with a new, Christian content: we see Jonah in the shadow of the gourd-vine, that had grown up in one night. This represented the *refrigerium*, the heavenly refreshment; it is, as it were, a translation into pictures of what we often read upon a gravestone – 'God refresh thee', just as the silent, praying figures seem to translate the ever-recurring words, '*Semne, Eutropius . . . pray for thine own*'.

On the other hand, there is a second group which no longer has any connection with the Jewish past. These scenes are peculiar to the Christian community and are intelligible only to the initiated; they are the meagre, shy hints at the innermost preserve of the Christian life, veiled allusions which were never divulged to the outsider, pointers, that is, to the holy mysteries, the sacraments of baptism and the Eucharist.

In some of the earliest burial-chambers in the Catacomb of St. Callixtus, we find the oldest of these motifs all together:

Three of them refer to baptism. First of all, we see the Fisher of

Men, who with his rod rescues the fish 'from the buffeting seas of this world'. Next, the fish themselves—'born in water, even as our great *ichthys*, our Fish, Jesus Christ', to use the pithy formula of Tertullian, the Carthaginian lawyer of around 200. Last, a direct representation of the baptism itself: a little child stands in the water, while water is poured over his head from the beak of the dove of the Holy Ghost, and the minister of the sacrament lays his hands on his shoulders (Plate 29a); the little baptized figure is shown as a new-born, naked child, and was called an *infans*, a new-born child. Another composition refers to the Eucharist, the 'food of everlasting life'. But the sacrament as such is not shown, only its prefiguration, the bread and fishes from the sixth chapter of the Gospel of St. John. Only once does a cup of wine appear beside the fish and the basket of loaves. Usually, there are seven men lying on bolsters (Plate 29b), as was the custom in the ancient world, around a table curved in an arc. This could have reminded you of the usual meal in memory of the dead; and the painter doubtless had that meal in mind, thus combining both the earthly meal for the dead and the heavenly refreshment. But the two fishes and the seven or twelve loaves, that are shown near the meal, would conjure up immediately to the initiated the image of that other, life-giving food of the Eucharist. Already in the earliest frescoes of the Roman catacombs, shortly after 200, the sacramental sources of immortality, the fount of life and the food of life, are shown on the graves, and under the veil of those same symbols as were already used in the Gospels. Even Christ Himself can only be seen in symbolic form: as the shepherd or the teacher. Sometimes the shepherd is shown as a teacher in the midst of his flock, with an unrolled scroll in his hand. Also, in the oldest pictures that directly illustrated the Gospel accounts—and never, at that, without some allusion to baptism or the life everlasting—Christ always appears, from the earliest times, as a teacher. In the wall-paintings of the baptismal chamber in the house-church of Dura-Europos (Plate 1), where we have the earliest-known representation of Christ (it dates from about 232), in the scene with the lame man, and in a second scene, in which Christ reaches out his hand to St. Peter as he sinks into the water, he is wearing the classical robes of a teacher, a garment he will not put off until the coming of the autumn of the Middle Ages. It consists of the white tunic (in Greek, *chiton*), and the white overgarment or *pallium* (in Greek,

86

himation); his feet are in sandals, and in his left hand he carries a scroll, while the right hand is raised in the gesture of an ancient orator – the two index fingers extended and the two outer pressed against the palm of the hand. Dress, stance and scroll, identify him as a teacher: on only one occasion did an artist – the sculptor of a Roman sarcophagus of around 300 – dare to give Christ the bare torso of a professional philosopher. But he maintained the honourable dress of an intellectual and the attributes of a teacher for longer than a thousand years: the Italian Renaissance restored the tunic and the pallium, after the compromise solution of the later Middle Ages (the seamless violet robe); and he remained in this costume until the nineteenth century. So we can say that the earliest-known picture of Christ, this primitive fresco in an out-of-the-way frontier post in the ancient world, already shows the definitive form, by which millions would recognize Him. What later seems strange to us, is the youthfulness of his beardless face and his close-cropped hair (Plates 11, 31, 32, 34a and b). There is no doubting that this beautiful, idealized figure of a teacher originated in a milieu of educated men – what the ancients called 'men dedicated to the Muses': we would say 'intellectual circles'. We do not find it difficult to guess where that milieu might be found – in Alexandria. Around 200, the actual centre of Christian culture was here, and much of what we see on the earliest monuments of the cemeteries, we also find in the writings of the Christian scholars of Alexandria, especially in Clement of Alexandria.

The Christian world was so closely linked together, that the first representations of Christ – and here I am thinking, above all, of the paintings of the Good Shepherd – are exactly the same in the two furthest ends of the Empire, in Dura-Europos in the East, in the catacombs of Rome and Naples in the West.

After 313, when the basilicas were built and masses flocked to be baptized, the cemeteries were also extended, and their monuments made noticeable by more definite pictures. The imagery changed almost overnight. It is not that the old motifs of rescue from the jaws of death or the allusive symbols suddenly disappear; but a number of new scenes occur beside these old themes, scenes which, although still bearing a symbolic meaning, are taken directly from the Gospels. But the figure of Christ, as he raises Lazarus from the dead, or as the hem of his garment is touched by the woman with

87

an issue of blood, as he lays his hand on the baskets of bread and the dish of fishes (Plate 32) and with his staff touches the six stone vessels of wine in the marriage-feast of Cana; this Christ, who predicts the denial of St. Peter, opens the eyes of the man born blind and orders the lame to take up his bed and walk, is unaltered – he is the youthful, idealized teacher from soon after 200.

These new scenes now occur also on sarcophagi above ground, as well as in the burial chambers of subterranean catacombs. Indeed, they become all too well-known clichés: they appear on the gold-leaf bottoms of drinking glasses, on the ornamental bands of tunics, on all the bric-à-brac of Christian craftsmen: on caskets for incense and for domestic use, on chalices, dishes and plates for ecclesiastical as well as secular purposes, on ornamental platters and on book bindings in ivory. Every one of these motifs contains a hidden allusion, though one which not everyone could follow in its 'spiritual sense'; there is not a single scene that has purely historical significance. Thus, the adoration of the Wise Men from the East means 'the first fruits of the gentiles'; the opening of the eyes of the man born blind, 'the enlightenment of the heathen'; the woman with an issue of blood is the symbol of paganism; she 'had spent all that she had on physicians and was nothing bettered'; the awakening of Lazarus brings home the meaning of the words, 'I am the Resurrection and the Life'.

It goes without saying that these themes, which occur in the fourth centuries in countless places in the catacombs and in other cemeteries, were not actually intended only for the decoration of burial places. Their original place was on the walls of the basilicas: the fact that we know of them, principally, as decorations on tombs and on small objects of personal use, is due to the accident by which just such things escaped destruction, while the large-scale compositions of the fourth and fifth centuries, have been almost completely destroyed. What the cemeteries of these two centuries show therefore, is only the afterglow of the beautiful old themes, and a pale reflection of the new.

The inscriptions, also, become more detailed, and the Christian symbols unambiguous and over-explicit. There is no longer a ship's mast with a sail, but, quite simply, the Cross; no longer an anchor with two fishes and some loaves, but, between the words *in pace*, the

monogram of Christ– *XP* (*chi ro*), the interwoven letters with which
the name of Christ (*XPICTOC*) begins in Greek (Plate 28c).

Then, soon after 313, in all cemeteries in which a martyr was
venerated, the famous grave was quite literally mobbed. Everyone
wanted to be laid to rest at the holy spot: *ad sanctos*, as they said–
'right beside the saints'. Those who could, would buy a grave beside
the martyr's vault: those who could not do this, at least wished to
be buried in that part of the cemetery. Soon things reached the
point, at which, under the floor of famous churches–as, for instance,
in the 'Basilica of the Apostles' on the Via Appia (the modern San
Sebastiano)–one *forma* (tombstone) would lie next to the other; and
the side walls were broken through, along their whole length, to
make way for entrances to the family-vaults, which the great had
built in rows against the outer walls of the basilica.

In this way there originated that marvellous spectacle, so familiar
to us from the abbey-churches and cathedrals of the Middle Ages: a
great shrine, ringed with burial-chapels, and inside, a floor consist-
ing entirely of the mosaic covering of graves.

Wise bishops shook their heads at this scramble around a revered
grave. Was it not better to follow the example of the martyrs, than
to fight for a few feet of earth for a dead body, that would go to
dust, before it became a vessel of the Resurrection? But the piety
of the common people and of the great would not be deflected, and
so Christian graves everywhere clung to the graves of the saints, like
iron-filings to a magnet.

Those who had no graves of local martyrs, would go out of the
way to obtain little relics, often no more than mementoes which
had actually touched a holy grave. In the East, it was the custom
for bishops to give such relics to other Christian communities; and
special *martyria* and *memoriae* were built for even the smallest of them.
Towards the end of the Early Christian period, the great basilicas
had often come to be surrounded by three or four such *memoriae*,
each with its own altar. This is the origin of the later multiplicity of
altars, and of the way in which many *memoriae* were brought together
to form the medieval ring of chapels around the choir, with its high
altar.

The Early Christian cemetery, originally a place in which the
visitor had gained the tranquil certainty of the life everlasting, had
everywhere become the image of the invisible 'Communion of

Saints'. The renown of the martyrs had caused the countless graves of the cemeteries to crowd in around a protecting holy place: the *memoria* of the martyr stood out above the vaults and the tomb-stones, as if to show who are the greatest in the Kingdom of Heaven.

The 'Historiae'

What was there to see on the walls of the basilicas? In the first decades after 313, there seems to have been some uncertainty, above all in the eastern parts of the Empire, as to which themes should be used to decorate the churches. Towards the year 400, Nilus of Ancyra could still write to a high official: 'Do not go on placing landscapes and medallions with scenes from nature on the walls: set up the sign of the Cross in the apse . . .' The bishops had no enthusiasm for elaborate decoration in the house of God, indeed they were tentative about art in general. But ever since the emperor Theodosius had made the Christian Church the Church of the Empire, and had officially liquidated the defeated pagan religion, extremely solemn, representative scenes appeared: an almost geometrical arrangement of the figures, with a severely hieratic personage at their focal point, had begun to replace the freer lines of the ancient friezework (Plate 11). These occurred in the West, and especially in Italy; and they were placed in the apse and on the blank wall face that framed it. This wall is called the 'Triumphal Arch' in the textbooks; it is quite an accurate expression, although it was never used in Early Christian times. (The term itself appears only in the ninth century in the *Liber Pontificalis*.) It has the proportions of a Roman triumphal archway, and is divided up in the same manner. The theme was always the *gloria Christi*, the glory of the Lord, which shone forth in both his own person, and in those of his saints; for that reason, Christ was usually surrounded by whole rows of witnesses.

Up above, on the wall of the nave, that is, on the surfaces above, beside and beneath the windows, and on the long stretch of wall

above the colonnade, would be the place for the *historiae*. The word *historiae* indicated what we now call 'scenes from the story of salvation' or, more simply, 'Biblical scenes' (Plates 33, 34). Almost the entire wealth of compositions from the Old and the New Testaments that we know of from countless medieval churches and manuscripts, the tradition of which lives on in both Latin and Greek Christianity, goes back, in the first instance, to the pictures made in the fourth, fifth and sixth centuries, called *sacrae historiae* by contemporaries. The Christians of those days were proud to be able to oppose real history to the fables of pagan mythology. The last pagans, who had retreated into a conservative attitude towards the whole of classical culture, held it against the Christians that they, along with their founder from the days of Tiberius, had had but a short existence, a mere day's span: what could they set against the venerable tradition that stretched back beyond Homer and Hesiod, and was lost in the twilight of prehistory?

The Christian apologists would answer: our history goes back to the beginning of Creation; our Christ has cast His glowing shadow in a thousand archetypal forms. Their sun, the Logos himself, has been announced by a thousand prophetic lights. They read the Scriptures in the light of this conviction. Christians have never been more vividly aware of the indissoluble unity of the story of salvation, of the Old and the New Testaments. For them, the Old Testament in its entirety was a 'prophetic word'; they took this phrase from the Second Epistle of Peter, quite literally, and so sought in the Law and the Prophets nothing other than their Lord and His Church. Each word of the Scriptures, they believed, spoke of The Word – that is, of the Logos, Christ. But at the same time they conscientiously maintained the historical nature of all that had been enacted in the story of salvation.

Again and again, we find these two features in the pictures of the events of the Bible as they are seen on the walls of the basilicas. On the one hand, they are strictly historical, often, indeed an exact topographical record of the past: many of the Holy Places of Palestine, as of Egypt, Ur and Chaldaea, are included. In their picture of the Birth of Christ, the artists would never forget to show the grotto, which all pilgrims had seen in Bethlehem; and, in the scene of the Easter morning, they would never fail to place, behind the stone on which the man clad in white speaks to the three women, the *memoria*

which stood beneath the dome of the Church of the Holy Sepulchre in Jerusalem, which contained the cave of the authentic grave. We even hear of a cycle of pictures which showed Abraham's Oak at Mamre, the Pillar of Salt (Lot's wife), the twelve stones in Jordan, the House of Rahab in Jericho, the burial cave of Lazarus, the Pinnacle of the Temple and many other of the sights of Palestine. Some of these topographical details, the grotto of Christ's birth in Bethlehem for instance, and the burial cave of Lazarus in Bethany, have been faithfully adhered to in the Christian East in the iconography of churches and icons.

On the other hand, they never saw Biblical history merely as a succession of single events, connected only by their chronological order. This history was, for them, much more a single great whole, a whole that was, moreover, made ever-present for them by its sacramental re-enactment in the Liturgy. And this whole is engulfed in the greater radiance of the one unchanging light of the world, the Logos, Christ, the Divine Wisdom that had ordered all things from the beginning to the central moment of the incarnation, and that will bring all things to completion when the Lord returns in glory.

A few examples will make this clearer than any long theoretical exposition could:

Let us begin with a great theme such as the representation of the first chapter of the Book of Genesis—of the making of heaven, of earth and of man, the centre of the story of the Creation. One of the most famous cycles that dealt with this theme, could be seen on the walls of the church of St. Paul, San Paolo Furoi Le Mure, built by Theodosius, outside the gates of Rome (Plate 2). This cycle was put up under Pope Leo the Great, in 440, forty years after the completion of the gigantic basilica. In the Middle Ages, it was restored by Pietro Cavallini, shortly before the time of Giotto, and was copied by Giotto himself, as many of his predecessors had done in other churches of Italy: it was taken as a model for the mosaics of the Baptistery of Florence, of the Palatine Chapel of Monreale, in San Pietro of Ferentillo, in the upper church in Assisi, and in innumerable smaller medieval churches, decorated with unpretentious frescoes. We know this cycle well, and can trace the enormous influence which it has exercised on the whole history of Christian art. This sober tradition, inherited from the ancient world, would

last until the Renaissance; only with the monumental frescoes of the Sistine Chapel, the 'Creation' of Michelangelo, would it be left behind.

For the old cycle, we can also refer to the commentaries which the Fathers of the Church had made on the Hexaemeron, on the Six Days of Creation. We shall soon see for certain, that preaching, exegesis and iconography are in complete agreement. The artists did not dare, as would Michelangelo, to show the Father. They had heard too often what was in the Scriptures: 'no man has seen God at any time', and likewise, 'only his only-begotten Son, He has declared him'. They did not want to be more knowing than the Scriptures; and for that reason, they never showed the Divine Majesty. What they would show all the more eagerly, however, was the Image of the Father, His Son. And, since they had read in the Epistles of St. Paul, that all things were made in him, that is in the Son, they recognized in him both the Divine Wisdom and the venerated Word, the *Logos*; and in this same Logos, they discovered yet again the mighty Word that God spoke, and through which all things came into being: so they placed, in each scene of the Creation, not the invisible Father, known to no man, but the Word, his Son. And unhesitatingly, they gave this Logos, the Creator, the features, the form and the dignified garments of Christ. In doing this, they still did not forget, that at the Creation, the Logos had not yet appeared as the man, Jesus of Nazareth. So little did they forget, that they never gave the figure of the pre-existent Logos a halo with a cross upon it, this halo being always the distinguishing mark of the Incarnate Christ. The Creator is the Logos, with the features of the later God made man, but without his attribute of suffering and resurrection. He sits in glory on the azure blue orb of the universe, and six times he speaks his mighty Word; and all things come into being; on the seventh day he rests—this means the Sabbath's rest of God. He had the youthful features of the idealized, timeless Teacher, that we have found already in the works around 200. These old masters succeeded in portraying the Son of God in the very first page of the Holy Scriptures: and right into the high Middle Ages, in all cycles of the Creation story, we are met by the same youthful creator, the Logos.

All this was equally true outside Rome. In the entrance-hall of St. Mark's in Venice, the great mosaic of the right-hand dome is

dedicated to the six days of the Creation. A Finnish scholar has shown how these pictures, which deviate completely from the Roman cycle, exactly follow another cycle, known to us from the manuscript preserved in the British Museum (the so-called Cotton Genesis), and whose origin is certainly to be sought in Alexandria, the most important centre of Christian culture in the earliest centuries. This cycle must have come into being in the fifth century, although the manuscript dates from the sixth century, and the mosaic cycle in St. Mark's from the thirteenth. Here again we see the youthful Logos, who, surrounded by pictures symbolizing the six days of the Creation, carries in his hand a cross on a staff, the ensign of his later incarnation.

Take another example. When ancient men read in the Book of Genesis of the death of Abel, they would think of the blood that would cry to Heaven louder than the blood of Abel, the blood of the cross of Christ, and also of the body and blood of the Lord, made present again on their altars. And they would think again of the bread and wine on their own altar as they read of Melchisedech, King of Salem (that is, of Peace), who was a priest of the All Highest, and offered up bread and wine when he went out to greet Abraham: nor would they forget, that in the 109th Psalm, it was said of Christ: 'Thou art a priest, after the order of Melchisedech.' When they read the moving story that was of decisive importance in the salvation of the whole human race, of how the father, Abraham, spared not his own son, Isaac (the theme on which Kierkegaard wrote his book *Fear and Trembling*), they would immediately recognize an image of the heavenly Father, who did not spare his own son.

And so it is, that in San Vitale in Ravenna, we can see the three -pre figurations of the sacrifice of Christ – the sacrifices of Abel (Plate 35), of Melchisedech and of Abraham – on the side walls to the right and left of the altar for the sacrifice of the Eucharist. The bishop of Ravenna, as he celebrated at this altar, would then have translated into explicit phrases the thoughts that lay behind this composition, when he recited the main Eucharistic prayer. This prayer, which is the key to these works of art, is still spoken today at altars, in Ravenna as in Rome and elsewhere: it begins with the words *supra quae*, and runs, in translation:

'And upon these do Thou deign to look with favour and kindliness, and to accept them as Thou didst deign to accept the gifts of

Thy just servant Abel, and the sacrifice of our patriarch Abraham, and that which Thy high priest offered to Thee, a holy sacrifice, an unblemished victim.'

This constant double-image – Prefiguration and Fulfilment, shadow and reality, past and present – is the distinctive, basic feature of Early Christian thought. It assumes the typological interconnection of the whole process of salvation in the Holy Scriptures, and especially that this process is made ever-present by what the early Church called *mysteria* and *sacraments*. Both words were understood as being all those tokens given by divine revelation, through which a higher world was presented, prefigured or made ever-present. (Today, the word 'sacraments' is used in a narrower sense, that is, only of those signs which are thought to bring the world represented by them into the present – as happens in baptism and in the Eucharist.) For this reason, we can say that the whole of Early Christian art showed forth the *sacraments* or *mysteria* of Salvation; and the *historiae* on the walls of the basilicas, also, were intended to do nothing other than to present these mysteries before the inner eye, through the facts of Biblical history.

This, again, is best illustrated by a few examples:

On the walls of the Basilica of Santa Maria Maggiore we can still see the mosaics set up by Pope Sixtus III, which show a series of scenes from the books of Genesis, Exodus and Joshua. They are unique achievements of an impressionist art, sumptuous miracles of colour; but they are also magnificently composed icons, almost all of which point to a deeper meaning than that shown in the picture.

In the foreground on the left, we see the 'Hospitality of Abraham', the visit of the three mysterious travellers to Abraham's tent at the Oak of Mamre (Plate 33). We see how the three heavenly messengers, the bearers of the Great Promise, draw near; we see Sarah laughing in her tent, and how Abraham waits on the three guests at table. But when the early Christians contemplated the mosaic, they would think of how Abraham 'saw three, yet worshipped one', and they would recognize, in the appearing of the travellers at Mamre, an appearance of God the Three-in-One. For this reason, the mosaic worker had surrounded the head of the middle one of the three unknown men with a wreath of ethereal fire – a *nubes divina* – a divine cloud.

A few pictures further on, they would see the children of Israel

passing through the Red Sea; they would at once recognize in it an image of baptism, as in the first Epistle to the Corinthians. When they saw the brazen serpent lifted up upon a pole, they would remember the words of Christ, 'that the Son of Man must be lifted up'; and they would see in it a prefiguration of the Son of Man hanging upon the Cross. And even in the Gospels, they were constantly on the watch for the hidden sense of the facts recorded there. They would understand the most conspicuous of the miracles performed by Christ, as symbolic actions, pointing to something other; and when they showed these miracles, they were concerned quite as much with the hidden mystery as with the fact itself. 'We have now heard the fact', Augustine was in the habit of saying, when he had taken his seat to preach after the reading of the Gospel, 'now let us search for the mystery that lies hidden behind it.' The artist and those who commissioned him, did likewise.

They would show how the Lord opened the eyes of the man born blind, but they would be thinking of the 'enlightenment' of baptism (Plate 31). They would show how the lame man took up his bed and walked, and would be thinking of the forgiveness of sins, the recovery of spiritual health (Plate 1). They would show, in their pictures, how St. Peter, following the Lord's words, caught so great a draught of fishes that his net was broken (Plate 34a); but they would associate this with the power of the words that were spoken in Christ's name, and how this word, despite the inadequacy of the nets, of the boat, of available labour and of the fishermen, could yet catch a draught of men. When they showed the miraculous multiplication of the loaves and fishes (Plate 32), they would think of the food of life, the new manna, of the Eucharist. On the mosaic of the Last Supper, in Sant' Apollinare Nuovo in Ravenna, we can see on the supper-table, not the bread and wine, but only the loaves and fishes—its mystic prefiguration. In the stained-glass windows of the Portal of the Kings in Chartres Cathedral, the bread and fishes of Early Christian art will still be lying on the table of the Last Supper.

These few examples show how important the content is for the works of Early Christian art. Whoever takes pleasure only in the interplay of coloured marbles, the gold background that blazes between white figures, offset with shadows of lilac and grey, has still not reached the heart of these remarkable works: for even

the colours sometimes have a symbolic meaning. In Sant' Apollinare Nuovo in Ravenna, again, we see the separation of the sheep from the goats in a mosaic: it is a representation of the Last Judgement. The silent angel, who stands to the right of the Judge, wears a robe of flaming red, and his head is encircled with purple ethereal fire; but behind the damned there stands one clothed in sombre blue – the colour of Hades and of the demons.

Doubtless, the purely historical character of the event predominates in very many pictures. Typological exegesis was not possible everywhere. Generally speaking, we can say that the artist only wished to give those pointers to a deeper meaning, which were provided for him directly by the Holy Scriptures, above all, in the Acts of the Apostles, the Revelation of St. John and the Epistles. As for the more subtle, often very far-fetched allegories of which the early commentaries on the Bible are so full, the artists only give us those that had become common property through the liturgy and preaching; the others were, indeed, quite unintelligible to the simple believer. Many of these fine-spun fantasies of the Alexandrian school were therefore not translated into pictures.

Taken as a whole, we can say of these *historiae* that they speak for a prodigious outburst of creativity. For in a short time, they banished the old mythology from the minds of men, and endowed the imagination of the Christian masses – which had to have something on which to feed – with a wealth of images and themes, that strove to do justice to the Word of God.

The same considerations explain the final selection of subjects and themes. Towards the end of the early Christian period, it is clear that the themes that were communicated in catechism and in services, were also those most frequently shown in pictures. They had finally taken on fixed forms, that would be recognized everywhere. Of the many themes, it is again those that referred to the mysteries celebrated in the great festivals of the Church, that will form the basic repertoire of Christian art. The Byzantines gave to these 'Great Feasts' – the Annunciation, the Nativity, the Epiphany in Jordan (the Baptism of Christ), the Transfiguration, the Last Supper, the Raising of Lazarus, the Entry into Jerusalem, the Crucifixion, the Women at the Grave, the Ascension and Pentecost (to those there was added, much later, the Descent into Hell and the Last Judgement) – the unsurpassed form that has been adopted by the

whole of Christendom. These classic compositions, a selection from the old *historiae* determined by the liturgy of the Christian festivals, live on to this day, on the church walls and icons of the Greek church, and in the traditions of Latin Christianity.

The Portraits

The early Christian world abounds in portraits. Wherever ancient mosaics are preserved and walls are still adorned with old frescoes, grave-eyed, expressive faces, dark in outline, yet glowing, look out at us. Sometimes, the garments worn are of ecclesiastical sobriety, if embellished with gold and purple, but usually they are white. It is almost certain that anyone recalling to mind one of the outstanding figures of early Christian times will envisage some such portrait as this: dark eyes in a countenance of solemn stillness, which surmounts a neckband on a white garment. Sometimes the shimmering gold or blue mosaic background comes right up to the line of hair, ears and shoulders, indicating that this is a portrait of a contemporary, of some donor or benefactor or high dignitary of Church or State. When the face is surrounded by a circle of light, the dominant colour of which is skilfully variegated, and which, though it does not overpower the bright highlights of the forehead and cheeks, creates an unearthly and abstract air, then it is the face of someone 'in glory', a saint (Plates 14, 19).

Go into San Vitale in Ravenna, and stand before the sanctuary (the *bema*: the raised floor) on which the altar stands. It is still covered with the ancient mosaics (Plate 7): on the arch above us which marks the beginning of the sanctuary, there are fifteen medallions, separated from one another by pairs of dolphins, each framed by a stylized rainbow; they contain the images of Christ, of the twelve Apostles, and of the two martyrs of Milan, Gervasius and Protasius – powerful heads, evidently meant as portraits, staring down at us. Up in the conch of the apse (Plate 11) the martyr Vitalis stands to the left of Christ in majesty, with his wreath of victory in his hand: it is an

officer's head, the hair fair and curly, which looks out, perspicacious and benign–again a portrait. On the right stands the donor (Plate 40) with a model of the church in his hands covered with his chasuble; it is the good Bishop Ecclesius, who died before his magnificent martyr's church, so famous today, was completed; here is a racy, very Italian face, with blue shadows on shaven chin, broad features and large, lively eyes, taking us in from beneath bushy eyebrows, with the expression of a distinguished, affable man–an authentic portrait.

Or go to Sant' Apollinare Nuovo: between the windows of the high walls of the clerestory are the life-size figures of the Prophets, Evangelists and Apostles, clad in white–the authors of the Holy Books; they all turn their gaze towards us, silently holding their scrolls, static, with the dignified bearing of ancient authors: these are portraits of writers. In the zone below, the placid faces of more than fifty men and women martyrs gaze at us somewhat emptily but nevertheless sweetly, moving in procession towards Christ and His mother: their names are written in clear, incandescent capitals between crosses on a golden ground (Plate 19)–again portraits. Finally, go to the chapel of the old archbishop's palace: here again are medallions with tense faces, eyes looking straight ahead, quiet and dignified.

It is the same in other places. At Rome, in the old church of San Paolo Fuori Le Mure (Plate 2), a visitor before 1823 would have been enchanted by more than a hundred medallions which contained the images of the Roman popes, in an unbroken succession from the first century to well into the seventh, each one a half-length portrait, seen full-face. The bishops of Ravenna are still to be seen in mosaic in Sant' Apollinare in Classe (Plate 42); the portraits of the bishops of the artist's own time are the most characteristic and effective, the others being high up over the columns of the central aisle. We know of mosaics from old illustrations, that showed the bishops of Naples and Capua. In the apse of Porec we can see the episcopal donor, his archdeacon and the archdeacon's little son (Plate 41). In a small chapel dedicated to the martyr Victor, we have his portrait and those of other martyrs of Milan, as also of some of the bishops of the city; and this is how we have come to find the only authentic portrait of Ambrose, which seems to be a faithful likeness of the great bishop.

A picture of the martyr, a simple portrait, could be seen in every

memoria (Plate 20). Unlike later, Baroque times, the pilgrim would not see splendid gesticulating figures of the saint in glory, but true-to-life portrait-heads. They were given the attributes of their profession, but their faces would show individual features. The martyrs Cosmas and Damian, bringing crowns to their Lord in a wonderful mosaic in their *memoria* on the Roman Forum, are sharply delineated as Persians; they are doctors, and have the shrewd faces of people conversant with human nature. The artists did not even forget the medicine-bags under their cloaks.

If a figure from the Bible was shown by himself and not in the setting of a Biblical scene, then an attempt was made to produce a revealing portrait. The Christians were so proud of the historical character of their revelation, that they did not want to give their holy men purely arbitrary features, as if they were mere products of the imagination. When it was not possible to provide an authentic portrait, it was common to agree on a definite type. This type was usually arrived at after some trials and hesitations, but once fixed, there was no changing it: and later it was no longer possible to fathom its origin.

This applies especially to the image of Christ.

'We do not know his external appearance, nor that of his mother', Augustine once wrote summarily; the legends of 'portraits not fashioned by human hands' (legends which, by the way, are all of Eastern origin), could not alter this fact. By degrees, a specific delineation of the face of Christ came to be accepted. In the West, the older type, that of the youthful teacher, remained current, beside the new and more historical one: in the Greek East, however, the figure of the youthful, timeless teacher was replaced by the face we all know, whose origin is still obscure – the young, bearded man, his hair parted in the middle and falling to his shoulders, with a finely-wrought, narrow, straight nose, an expressive but narrow tight-closed mouth (Plate 37, centre medallion). But the clothes did not alter; they remained those of an Alexandrian teacher. The figure of the Shepherd, and the other symbolic representations, vanished almost completely after 400 (Plate 13a).

That which happened with the portrait of Christ, happened also with the lineaments and figure of His mother, of the Apostles and of the other more important figures of the story of salvation. After some time the heroes of the *historiae* came to appear always with the

same features. They were immediately recognizable, and could not be mistaken for anyone else: they also became, in a formal sense, portraits. Peter always has a round face, framed by the slightly curly beard of a sailor, with a crown of grey hair around his forehead (Plates 37, 39). Paul always has the furrowed, nerve-racked face of a man with a gastric illness, piercing eyes beneath a bald forehead, and a plain, pointed black beard. Andrew, the brother of Peter, is always a robust fisherman, with tangled grey tufts of hair. John is always a very youthful apostle, with enormous eyes, except when he is shown as the hundred-year-old bishop of Ephesus writing his Gospel.

In Rome, the Virgin Mother of the Lord appears for a time as an Empress, clad in a *stola* studded with jewels, and with a white silk veil hanging from her royal head-dress (Plate 12): but soon Rome was to accept a new representation, certainly from the Greek East, and possibly from Palestine, that was so much more in keeping with the dignity of the Mother of God: the young but austere figure of a woman, clad from head to foot in a gown of deep blue-purple sometimes almost blue-black, her head covered with a dark veil which leaves only part of the forehead free, beneath which there shine delicate features closely framed by the white head-dress that covers her hair (Plate 37, top right, and 45). This severe, dignified figure so much resembles the traditional representation of 'Mother Church' that we have no difficulty in recognizing it: it is just this resemblance between the Mother of God and the Mother Church that the artist wanted to convey. Whoever has doubts about this should look at the classical representation of the Ascension of Christ: between the agitated groups of Apostles, straining upwards, there stands, un-moved, the Mother of the Lord, her hands outstretched in prayer, the image of the Church – abandoned, yet undaunted and impreg-nable.

The portrait had always been the best and the most interesting creation of Roman art. In Imperial times, every market-place was resplendent with statues of Emperors, officials and local worthies, the libraries were full of portrait-busts of Greek and Latin authors, and the private houses of pictures of ancestors, some in the guise of mythological heroes, but usually as marble busts in a small gallery. As early as the third century, the married couple who commis-sioned their sarcophagus appear on it, in the middle of the frieze on

its front; so the two portrait-busts are brought together in a round shield-like medallion called a *clipeus* (Plate 30c). In late antiquity, the *clipeus* became the usual form for a round portrait in relief, as indeed for any portrait, whether painted or in mosaic. And this convention is the one taken over by Christian artists, together with the standing figure seen full face. We can see the large figures in the apses on the walls and between the windows, with the series of *clipei* on the narrower surfaces, and on the under-side of the arches (Plate 39).

But the unique feature of the Christian portrait is the expression of the eyes (Plates 36, 37, 38, 39, 40, 41, 42, 43). The new man, illuminated by faith and born again by the Spirit, is a man of the inner life. It is as if this inner life were looking out at us from the faces of the *clipei* and from the great figures on the mosaic walls. They exert a strange fascination on us. We almost forget the world of flesh and blood; they make the secular portraits of an earlier, richer time seem like those of men of another universe. It has been pointed out that even the art of the court aimed at producing such wide-open eyes, just such an intense look and inner majesty, above all in the portraits of Constantine and his sons and descendants (Plate 46); but how very different from the forced immobility, the rigid majesty of the heads of these Emperors, is the unaffected look, betokening inner peace, that is shown in the eyes of the saints and of their humble devotees. André Malraux was right to emphasize that it is because of the eyes, above all, that these Christian faces–and those of the later Byzantine and Romanesque age–appear to be separated, as if by an abyss, from all that had gone before. There are hundreds of expressive faces in Roman art: faces that are lively, witty, supercilious, serene, highly intelligent, malicious, or supremely noble. And these faces–those also on the frescoes of Pompeii and in small mosaics–have real eyes; but the highly charged gaze of so many of even the most modest Christian faces, often very primitively executed, as in the catacombs, cannot be found among them.

I used to believe that it was the impressionist techniques of the late Imperial painters, the peculiar *tachisme* of the second and third centuries shown by the highlighting of the pupils and whites of the eyes, which must have led the artist naturally to create an expressive type of face. With the new techniques of wall-mosaic that suddenly came to the fore with such amazing success, this effect, once dis-

covered, was easy to achieve. On many Christian mosaics we see this sharp, jet-black look flashing out from the corners of the eyes, reinforced by the white of the eye-balls and the black shading of the recesses and brows of the eye. It is this penetrating sidelong glance that Burckhardt had in mind when, in a brilliant and malicious passage, he inveighed against the physical ugliness of these expressive faces, and rounded on the 'deadly malice' which he thought was typical of them (Plates 12 and 33). As if the mosaic artists had been trying to achieve the cold harmony of the faces of ancient statues!

This 'deadly malice' which so repelled Burckhardt, was certainly not there for the sake of emphasizing the beauty of the face, but was more a means of underlining the dramatic meaning of the whole composition: for the theme of this kind of art was never the exhibition of a physical beauty ennobled by the mind, but always of an inner world, which could only be brought to light by such means of expression – by an intense look, spontaneous gestures, vehement tensions. Today, we are more inclined to admire the classical reserve of such a treatment – we shall touch on this in the next chapter but one.

In the portraits, however, the look is always frontal (Plates 40, 42, 43). Even when the face, as is the classical custom, is turned slightly sideways, or at times is even shown almost in profile, the eyes always look straight at us. The look is never fixed above us, as is so often the case after the late Gothic period, after 1300. We are face to face with the inner life of a man; it is his soul that looks straight out at us. This is the beginning of the soul's supremacy. This is the time when people begin to inscribe on their gravestones, *anima dulcis, deo vivas*, 'sweet soul, live in God'.

The body is merely the instrument of the soul; the outer man has no other function than to act as a medium to express what is inside, and now it was saints that artists wanted to conjure up, sanctified men, *sancti*; and, if not saints, believers, men who would like to be saints, for they too are called *sancti* in the Liturgy.

With these expressive faces, their gaze directed towards us from the very depths of their soul, a personal encounter was possible: it was possible to pray before the faces of such saints and martyrs. No one has venerated the mosaics that dominated the interior of the basilica high up on the walls and the apex of the apse. Veneration is usually given to an image that one can meet eye to eye, that is to

a portrait that is not placed too high, that is sufficiently isolated, and that is as nearly as possible at eye-level.

An independent image of this kind, a complete painting on itself, was, of course, a portrait; in Greek, an *eikôn*. The pictures that first received direct and explicit veneration in Christian sanctuaries were portraits. The first icons were small, usually portable plaques, that could be fastened on a wall at eye-level. As a rule, candlesticks with wax tapers were set beside them, and transparent veils with golden tassels hung over them, between bowls of flowers: you would then be standing eye to eye with the martyr, could lift up your spirit to encounter his own and pray. This is how holy icons came to be venerated.

Moreover, this process took place almost unconsciously, and was not without parallel developments in the pagan world, as with the pictures of the Emperors. But it stemmed from a completely different attitude. The impulse which compelled the faithful to pray face to face with great advocates was their belief in the communion of saints, where the chasm of death was of no consequence; and belief in the glory into which these saints had been received, brought them nearer than they had ever been in their visible life.

In technique, these small, portable portrait-icons, painted on wooden tablets with encaustic colours, were derived from images, which in late Imperial times had been placed on the embalmed bodies of the dead in Egypt. A great number of these have been found, chiefly, in the cemeteries of Fayum to the south-west of the Nile Delta. All these portraits make a startling impact, with their directness, and with the charged look of their dark eyes. The fact that most ancient portable icons have been discovered on Mount Sinai (Plate 37), and that a few others from elsewhere show the same style and technique, might seem to reinforce the belief that this kind of art had its origin in Egypt, or at least in the eastern parts of the Empire. But, the art of the icon first reached its peak in the sixth century, when the whole artistic world was cosmopolitan, and Constantinople was the unchallenged centre of all important branches of art: apart from the special technique of painting on small wooden tablets current in Egypt, the typically Early Christian style of portraiture had arisen earlier: it was the creation of the whole Christian world.

It is well known that not only the veneration, but also the public

exhibition of images of Christ and His saints aroused opposition: 'It does not become us to carry around our God, as do the heathens', wrote Bishop Eusebius of Caesarea to the Princess Constantia, when she asked him for a portable icon of Christ; 'these portable images of Christ and Paul serve only to infuriate the heathen'. However, the writer and the recipient were Semi-Arians, and critics later were powerless against the Christian cult of images, which had developed in all good faith, as an attempt to express the historical nature of the Christian revelation. Bishop Epiphanius of Salamis, the Cypriot who had introduced monasticism into Palestine, once saw a curtain with an image woven into it, before the entrance of a village church, and tore it up. But he had to pay compensation; and those who shared his indignation were not, even then, very numerous.

However, it is true that neither the Fathers of the Church, nor any ecclesiastical writer, took much interest in what we call the iconography of their basilicas. Augustine, who seems to touch on most things in his sermons, hardly mentions the holy pictures. He knows of them, though, and very occasionally an edifying reference to them slips out; but he has no high opinion of the artists, and several times he points to their arbitrariness, and to some small mistakes. But his contemporary, Paulinus, the amiable Bishop of Nola, a man of great wealth who had given everything away, concerned himself with even the smallest details in the decoration of his basilicas in Fundi and Nola. He composed verses for them, described them in poems to correspondents, and was truly pleased when his peasants and the pilgrims came to gaze with attentive reverence at the holy pictures and the Biblical scenes: he would never miss an opportunity of giving a detailed explanation of them. But in the fifth century, the question of the conscious worship of icons had not yet arisen. What people worshipped, were the graves of the martyrs and the caskets that contained their relics.

It was not until three centuries later, in the second quarter of the eighth century, that an acute crisis developed in the Eastern Empire, as a result of the measures of the Emperor Leo the Isaurian. With one stroke, the Emperor had all icons destroyed through his edict; all frescoes and mosaics were to be whitewashed, scraped off the walls, or chipped away. The mass of believers, however, and their monks, would not be deprived of images, which to them stood as lasting testimonies of the Incarnation and of the heroic days of

the early Church. Those bishops who had set more store by freedom than by the favour of the court, elaborated a theoretical defence of the veneration of images that had come about so spontaneously. The last of the great Greek Fathers, John Damascene, formulated the classical theory of the permissibility, the value, and the relative claim to worship of holy pictures. He justifies this by stressing the evocative function which every image can exert, and which makes even the most unassuming icon of Christ an evocation of the archetype of all images – the Son Who, in the words of St. Paul, is 'the Image – the *eikôn* – of the nature of God'.

Iconoclasm had had its day, the icons have remained. The Greek Church, bravely seconded by the Pope of Old Rome, preserved the Christian inventive faculty from the arabesques of Islam. For they knew: the image is merely 'another language'; it can hold the Word of God in the imagination, but it can never take its place, and only rarely will it encroach upon it. And mention of this undeniable primacy of the Word of God – for the Christian faith professes the Word and the Sacrament, but not any image – brings us to the decoration of the Holy Books.

The Holy Books

Images placed on the walls of their churches were taken for granted by early Christians; yet they were only incidental. To listen intently to the words of the Holy Scriptures, however, was of the very essence of their faith. The tribes of Arab nomads who in the seventh century attacked and conquered the hinterland of the Eastern Empire, called the Christians 'the Men of the Book', and in this way they were right.

We do not know exactly how long it was before the holy books were written and illustrated in such a way as to rank as works of art. The infinite care expended on the writing and preparation of the books of the Holy Scriptures was devoted principally to the text itself, and to the task of translation, which was exceptionally difficult for scholars of the ancient world. Even so, they did their utmost to ensure that the works were as beautifully produced as possible.

The end of the great persecution of Diocletian falls exactly in the time when the papyrus scroll, which had been in general use, was everywhere replaced by the *codex*, that is, by a bound book, much like the books of today, except that it was written by hand (Plates 41, 42). With the end of the persecution, the Church attained a new legal status: everywhere, basilicas were erected, and the first things needed for services were codices with the texts of the Old and the New Testaments. Countless manuscripts of the Holy Books had been confiscated, destroyed or burnt, in obedience to the Edict of 304. It has been suggested that the almost instantaneous disappearance of the book scroll and the general preference for the more durable and more easily handled codex was due to the renewal of the common stock of Biblical manuscripts which then became essential, a renewal

109

that suddenly became possible financially. The Christians decided unanimously in favour of the new type of book. We do indeed see the book scroll even centuries later, shown as an attribute: with Christ as a Teacher (Plates 11 and 38), and with the Apostles and the Evangelists. But the real Biblical manuscripts that were had for reading from the lectern of the basilica, or were perhaps kept at home by those who could afford to do so, were all of them codices, certainly from 350 onwards.

The whole ecclesiastical culture of that time was so overtly literary, that works of figurative art are hardly so much as mentioned. Moreover, this culture hinged entirely on the Bible; so that it is impossible to imagine an event in the Church when the Holy Scriptures would not be called to witness at some time; they might even be quite literally opened at random, and what was revealed would always be taken as of the highest authority from God. This reverential awe before the Word of God lent an aura of dignity also to the codex, in parchment or in leather. At some of the great councils, the seat of the presiding bishop was not occupied by the legates of the Bishop of Rome, but by a codex of the Gospels: together with a Cross, shimmering with precious stones, these Gospels were laid, as the *insignia Christi*, upon the purple cushions of the throne; and in this way, they drew attention to the presence of the Invisible Head of the Church.

We know from mosaics and paintings what the codices looked like. As with today's books, tapes hang from them, to act as markers. The parchment pages were written in two or three columns, with wide margins and much space in between the columns, to include the little signs which mark the passages – the *pericopes* – to be read in the lesson for the day. The handwriting was large and beautiful, still mainly consisting of capitals, and later of the *capitalis rustica* – the rustic capital. Nevertheless, it was difficult for untrained eyes to read, since the book was written almost without any punctuation; and, on top of that, the single words were often placed all together, in order to save space on the precious parchment leaves. A special rank was bestowed on the person who read or recited the Scriptures in public from the lectern – the rank of *anagnôstes* (in Latin, *lector* – reader). He had to have a clear voice and to be practised in reading the text; we know that he was often quite a young boy. The singers, also, who chanted the Psalms from the same lectern

between the lessons, and intoned the refrains sung by the congregation, belonged to the order of *lectores*; and they, too, used no other book than the Book of Psalms and the *cantica*–the canticles–contained in the Holy Scriptures (that is, the hymns of praise of Moses, of Anna, of Ezekiel, Habakkuk, Zechariah, Simeon, and, finally, the Magnificat of the Virgin Mary).

We can also see from mosaics how the codices were decorated. On the mosaic of the Emperor Justinian in San Vitale at Ravenna, the codex carried by the deacon is already embellished with precious stones, as is that of deacon Claudius in Porec, and of Severus in Sant' Apollinare in Classe (Plates 41, 42): the codex, in these cases, probably contained the Gospels. On the other hand, the codices of the Gospels in the mosaic dedicated to St. Lawrence in the Mausoleum of Galla Placidia, lie in a cupboard, and although they are stoutly bound, they are without ornament (Plate 13b). The precious book-covers that are now preserved in many cathedral treasuries and in the exhibition-cases of European museums–they are often ivory-reliefs with metal borders–do not appear until Romanesque and Carolingian times. The Early Christian reliefs in ivory, even the larger ones, were no more than parts of a diptych, that is, of a small double tablet in wax, the inner side of which was for writing; only the very largest of these, such as the one in the Treasury of Milan Cathedral, are so big that they would serve to decorate a book cover–the Biblical scenes that can be seen on this diptych suggest that it had once covered a precious codex of the Gospels.

We do not know when the oldest miniatures first made their appearance. The scanty remains that we possess provide us with no information on this point. The earliest illustrations to texts from the Old Testament are on a few parchment leaves that have survived from a codex of the Book of Kings (the so-called 'Quedlinburg Itala'): they could belong to the fifth century. The book illuminations of the famous Vienna Genesis–a luxury manuscript from Constantinople, such as might have belonged to a prince–are not earlier than the sixth century. And the oldest codex of the Gospels that contains miniatures, also belongs to that time.

This last-mentioned manuscript is also astonishingly well preserved. It lies by itself in an exhibition case in the Archbishop's Palace of Rossano, a little town in the hinterland of Calabria (Plate 44). The parchment is coloured with purple, and the letters are

written in silver that is now almost black. In places, the text is interrupted by narrow bands; in these, we can see the earliest miniatures known to us – at least, the earliest of the Gospels. The lively, forceful scenes are painted in bright colours and excellently preserved: they differ only a little from the larger compositions that we know of from the sixth century, except that they are somewhat freer in drawing and expression. Beneath every scene were the heads of four prophets, placed over scrolls, on each of which is written an extract from their prophecy that bears on the events presented above them. Some of these miniatures take up a whole page. They are uncommonly gripping and vivid; above all, the scene of the Trial before Pilate gives an excellent picture of early Byzantine legal procedure. They provide too, a good idea of how much more freedom the illustrator of a manuscript enjoyed, compared with an artist in mosaic or a painter of frescoes, who had always to bear in mind the ceremonial style of his composition.

Another such manuscript, whose text is in Syriac, written about 586 in a Mesopotamian monastery, contains a series of scenes which evidently reflect the monumental compositions of contemporary basilicas; among these we find one of the earliest pictures of the Crucifixion (Plate 45, commentary).

We know little about Early Christian book illumination. The many Carolingian examples that one might assume to be copies of fifth- and sixth-century works, are not sufficiently clear as evidence to provide us with a complete picture. This much is certain: the usual codex of the fifth and sixth centuries, excepting perhaps some pictures of the Evangelists, and the inevitable *canones* of Eusebius of Caesarea (that is, the tables of parallel passages in the Gospels), was not, as a rule, illuminated.

The wonderful figurative art that the talent of the Celtic world was to display on the ornamental pages of its books of the Gospels a hundred years later, in Ireland and Northumbria, no longer belongs to the early Christian world, nor to late antiquity. The holy text, the *canones*, the prolegomena, and the divisions of the Scriptures, had all been taken by the Irish from beyond the Alps. But this was a unique creation: the initial letter, the idea of one page of a book as a decorative whole, the infinite variety of every page, and above all, that dreamworld of intertwining forms, which ever and again surprise and charm the eye – all this grew from their home soil.

In the Dark Ages the holy book, as well as being the vehicle for the text of the Christian revelation, represented the finest flowering of the artistic achievement of the times. Through century after century thereafter, the history of the figurative arts at their best will be also the history of precious books. In early Christian times, however, when so many laymen could read, and nearly everyone in the towns could still follow the Latin or Greek translation of the Holy Scriptures, the usual codex of a book of the Bible was no more extraordinary than the water, the oil, the bread and the wine that were the elements of the Sacraments. All were carefully guarded and held in honour. But the material vehicles of the Word and the Sacraments were not yet embellished with that lavish magnificence, which, as I believe, could only be achieved in the quiet of a monastery at a time when the world beyond the monastery walls was crude and uncivilized.

The Ancient Tradition

The architecture of the early Christians was sharply differentiated from that of the profane world by its function, and their art by its content, so that both would have been immediately recognizable. A Roman citizen of around 400 might have caught sight of a group of buildings rising up above a wall, and might perhaps have gone inside, crossing the forecourt and going past a splashing fountain. As soon as he set foot inside the basilica, he would have known at a glance: this was a Christian church. No gods, no statues, no people talking at the tops of their voices: just a great assembly-space, and, right at the end, a raised dais – a *bema* – with a high seat; in front of this, a small table, covered with cloths, scrupulously isolated by marble balustrades. In the corner of a side-aisle in a *memoria*, a few lit candles would perhaps be standing behind a railing. There was no mistaking it; this was a basilica of the Christians.

But what about its form? If the visitor happened to be an architect, he might, perhaps, have been taken aback: the overall impression of the interior was remarkable; a peculiar emptiness, the absence of three-dimensional decoration, all was in such marked contrast to the characteristics of the old temples. But the architecture itself would have been a matter of no astonishment to him. The coffered ceiling, the colonnades, the architrave, the way in which the walls were divided up, the capitals, the marble inlays, the mosaic floor; he could see all that anywhere else. Even when he switched his glance to the solemn figures that stood out from the dark ground of the mosaics (in around 400, this would still have been a dark blue background, or one filled with twisting vines), he would have seen, without surprise, the stock types which he had known since youth: the con-

ventionalized figures of the old man, of the dark-haired man in his prime, the matron, the young girl, the officer, the prince; and even, in the white figures of the angels (Plates 11 and 12), he would have recognized a dignified variant, dressed with more distinction and portrayed in a more abstract manner, of the old Winged Victory with which he would have been as familiar as with the City of Rome itself (Plate 48), a forbidding, slightly clad figure, bearing a staff, with wings just like an angel's. If he were, next, to stand in the cemetery in front of the sarcophagi, he would be struck by the typical Christian symbols—the crosses, the cups with vine-tendrils, the doves, the peacocks, and the many lambs; but, from a distance, the older sarcophagi would not be very different from those of the pagans (cf. Plates 30a and b): a trained eye might, at the most, have noticed how the densely crowded frieze of the front side showed a less dynamic composition than that on the allegorical sarcophagi, in which distinguished, earnest pagans of the third century had been buried.

No—in his eyes the Christians may very well have erected their own buildings; but they had not created a new architecture, or, as we would say today, a new style of building. Doubtless they showed curious and hitherto unknown themes, and portraits of people entirely out of place in the classical world, but they did this with the usual stock devices, even though preferably in a new technique of great promise—in wall mosaic. They liked to decorate the graves of their heroes, and to spend much time beside their graves; the jibe of the Emperor Julian the Apostate was right: 'They have filled everything with graves and corpses.' True enough, temple frontages on high rows of columns were no longer being built, and although monuments continued to be set up in the forums to honour the Emperor and high officials, these great ones no longer allowed themselves to be shown in the posture of a Jupiter or a Hercules. The colossal statues of the old gods belonged to the past. They stood, covered in cobwebs, in the temples of which the doors remained shut. No one paid any attention to them nowadays. In the Greek East, the Christian population had broken up the temples and made lime-rubble from the statues of the gods. The change there was so drastic, that the bishop of a little town in Commagene, Theodoret of Cyrrhus, could write without exaggeration, shortly after 400: 'The old festivals are forgotten and have been replaced by pious

vigils in honour of the martyrs; hereabouts, they hardly know these days what a pagan altar, a herm, or a god looked like.' In Rome, in Milan, in Gaul, these things were still known: but after 400, the conservative opposition to Christianity had become a literary attitude, a symptom of the tendency of over-educated men to dwell in a beloved past, coupled with a punctilious disregard of everything that had to do with the new religion.

But no one dreamt of a revolutionary 'Christian' architecture, or of a new technique, or of a new figurative style. There was no such thing to be seen, because no such thing existed. Whatever the Early Christian artists built, carved, painted or set up in mosaic, depended on the ancient tradition. They renounced certain art forms in the decoration of their churches; there were no statues in them, no naked sculptures, no moulded motifs that would have diminished and broken up the inner space.

The pagan myths, of course, lived on in secular luxury-goods – on ivory diptychs, on bridal caskets, ornamental coffers and, for some time, even on the coins. In Coptic Egypt, they survived up to the sixth century, on the carved decoration of churches, though these may perhaps have been given a Christian meaning. The precious marble statues of the ancient gods and heroes, stood peacefully in the bright sunshine, in the inner courts of the last great villas whose owners were not yet baptized. With the passing of time they, too, were to disappear, and much sooner than anyone thought: for the barbarians stood at the frontiers; and while rich collections might just survive the Christianization of the Roman Empire, they could not withstand plunder and conquest by Germanic barbarians. And so the past died, even in its monuments. Meanwhile the ancient tradition, like the Latin and the Greek language, was ineluctably 'baptized' by the Christians.

At the great distance in time which separates us today from the fourth and fifth centuries, we can see more clearly than contemporaries could, what the old form still meant, and what the new content had brought about. For we can also bring in the following centuries for comparison: we can see plainly to which 'style' the intuitions and creations of the artists of the Early Christian 'Golden Age' had paved the way. And it is just this distance that enables us to see Early Christian art as a whole; and, if we contrast and juxtapose it with other great ages of synthesis, with the Gothic period or

the Italian Renaissance, we can attempt to define its character.

What immediately strikes us as a breach with the past, with the ancient world, is the gradual turning away from 'things corporeal'. In architecture, this departure is marked by an obvious waning of the feeling for what is three-dimensional and weighty, in favour of a way of thinking only in terms of space; and in decoration, we see striving after effects through flat surfaces that would appeal primarily to the eye. Moreover, all erotic motifs are consciously excluded from figurative art, and inside the basilicas, sculpture in the round is avoided. Thus there came into being an interior space, formed with the utmost architectonic finesse. Eventually this interior was roofed over with slender vaulting domes, by means of which the world and the light of day were shut out; and on its walls almost immaterial motionless shapes on an abstract gold ground, would evoke a supernatural world, not only by optical effects, but, most of all, through the overpowering majesty with which such holy figures were represented.

Instead of the athletes, the heroes, the great men in their glory, the saints have entered into their own, men of the inner life. The classical ideal of flawless physical form was never opposed: it was just absorbed by this inner grace and so came to enjoy its radiance afresh.

For in the end, very little of the ancient notion of what constituted beauty in the human figure was sacrificed to the tense expression of the eyes and to the gestures that always expressed the same absorption in the inner life. On the contrary, the long-venerated concept of human beauty was saved from oblivion by Christianity during those unhappy fifth, sixth and seventh centuries, and made acceptable to the new nations–to the Celts, the Germans and the Slavs–by way of the new artistic sensibility and its Christian themes. And even with the Slavs, the late antique faces that had come from Byzantium to the workshops of the icon painters of Novgorod and Moscow, are never transformed by the imagination to such an extent, that the unparalleled creations of ancient Greece are wholly untraceable in them (as happened with the Irish, who put something else in its place). Even the barbarians grew aware of this ancient beauty: as they became more cultured, they were capable not only of sitting at the feet of Byzantium, but of making even the original prototypes their own, the works of art of the 'Golden Age' of Constantine, Theodosius and Justinian.

Early Christian works are whole-heartedly Christian, and yet they belong entirely to the ancient world. 'Late antiquity' is but one phase of this ancient world. In the plastic arts, also, there are branches that blossomed in late antiquity as never before. The mighty buildings of the age of Justinian (Plates 7 and 9) derive little or nothing from the Sassanian art of Persia, and even less from Armenia, or any other local culture: they are much better seen as the magnificent closing chapters of the architectural history of Rome, into which that of ancient Greece has also flowed. For the Hagia Sophia, which is as large as the largest baths of the Imperial age, is a typical achievement of Roman engineering (Plate 9), though carried out with the more finely adjusted techniques of Greek architecture, and, ultimately, inspired by the world image of a Christian Neoplatonism, whose universe still belongs wholly to the ancient world. Compared with the Hagia Sophia, the Pantheon, for all its crystalline clarity, appears squat and ponderous, and the Roman baths uncouth and dumpy. No ancient temple can offer anything to compare with the Hagia Sophia's glimpse of an infinity beyond. These ancient temples brought the divine before the eyes of men, despite their gods; but the Hagia Sophia, with its endless curves that seem to hover in mid air as if straining towards some inaccessible focal point, draws the whole universe into relation with the Invisible God. It was built by Greeks; they did not aspire to imitate some glory in the past; at least in this sixth century after Christ, what they had created seemed to satisfy them. They called themselves *Rhomaioi* – Romans: they were well aware that the Empire was not what it had been under Trajan and Marcus Aurelius, but they also knew that they were better builders than their forebears of the second century.

In the same way, the mosaic-workers of the fifth and sixth centuries would have admired the wall-mosaic of the first and second centuries, which were still to be seen everywhere, but they would have known very well that only they were able to use this medium to its full extent, and that their own mosaics were the greater works of art. The capitals which Christian stone-masons had carved for the Hagia Sophia, for the Hagia Irene, for the church of St. John in Ephesus and for San Vitale in Ravenna (Plate 10), no longer have much in common with classical Corinthian capitals. (Late Roman craftsmen were, however, able to achieve excellent variations of this type, as in the Church of the Nativity in Bethlehem.) But the artists

knew that they were producing effects which would have been impossible for followers of the old models; and like all creative men, they did not tread in the footsteps of their revered forerunners.

And yet all these new features succeeded the old with no break or crisis. Just as Christian Latin remained Latin, and Christian Greek is genuine Greek – even if it is slightly less of a living language – so later Roman craftsmanship retained the essence of the ancient spirit.

And if we hope to find what stands out across the centuries as unmistakeably classical in this art, I do not think that we will have to look far afield. What distinguishes Early Christian art in general from the art of later times, is that most distinctive feature of the Greek spirit: the keeping of the measure of the reasonable mean, called *sophrosyne* by the ancients. Not even the friends of Plato were able to define this idea, though everyone understood what it meant, and regarded it as the crown of all the virtues: the sense of measure, the feeling for what is fitting; restraint, self-control, dignity, good taste; it was all these and much more. And these qualities, moreover, are those which distinguish Early Christian art from all that comes after.

To someone who has just been looking at the expressionist miniatures of the Reichenau School (of around 1000), or Grünewald's altar at Isenheim, or even the little Passion by Dürer, and then finds the same themes shown on an Early Christian mosaic or ivory carving of the fifth century, there comes a moment of revelation: this ancient art is . . . static? No, not static, but temperate, measured.

The gestures are full of expression, but unobtrusive (Plate 11). The outlines are never forced. Even the man possessed by demons who is healed by Christ, and from whose mouth emerges a red-haired devil – even he, although portrayed with great intensity, is portrayed with restraint, so that he is not allowed to disrupt the total composition. Almost all the figures are either presented full-face, or very nearly full-face. Direct profiles are usually avoided, and a figure seen from the back would be almost unthinkable (Plate 12). A figure half hidden by another has no other function than to suggest a crowd. Every face is reverently isolated, and it is never seen half covered by another. With all that, the composition is of such clarity, the gestures, however restrained they are, are so telling; and the setting is quite unmistakable: it is sketched in with such economy, by

means of a few aptly chosen motifs – a red cloud, a yellow bar of light on the horizon, some plant-stalks, a stylized tree-top, the front view of a house with a curtain and a lamp on the lintel – that any child could understand what it is all about (Plate 33).

We never see anything that is too horrible or repulsive. The soldiers who carry out the Massacre of the Innocents in Bethlehem are standing undecidedly by the throne of King Herod; one has his hand outstretched, but not one of them so much as touches a child. The children are resting in the arms of their mothers, who with loosened hair, as if in mourning, stare at the soldiers, numbed with anxiety. This is how we see it on the mosaic of Santa Maria Maggiore. Only on tiny ivories can we find a different solution: a soldier elegantly posed, is holding up a small limp infant ready to dash it against the rock; on a large scale, such a scene would be unthinkable.

These ancient artists do not know how to cope with the Passion. What they show, on a sarcophagus of about 350 in Rome, is the 'Victory over Death'. Roman soldiers are sitting by the side of the triumphal emblem of the life-giving Cross (cf. Plate 14), like conquered barbarians sitting beside a Roman trophy of victory; nearby, a soldier is holding a triumphal garland over the head of the teacher, who is Christ. On the other side, Christ is standing before Pilate, motionless, in his hand a scroll, his right arm raised in the gesture of an ancient orator, a crown of victory on his brow: the servant with the basin is innocently and with graceful motion pouring out the water; Pilate turns his head to one side in shame, and in perplexity puts his hand to his chin. It is not the tears of St. Peter that we see, but again the hand holding the chin, the lowered eyes, and the cock perching on a pillar at the Apostle's side. The Man of Sorrows, the Mother of Sorrows, the lamenting pious women, the weeping for Christ around the white-bleached winding-sheet, the blood-drained corpse, the head covered with blood and wounds: none of these are to be depicted for eight hundred, for a thousand years to come.

The earliest representation of the Agony in the Garden is in Ravenna. The Lord stands erect above the group of sleeping Apostles, His hands outstretched in prayer, His features pale and serious, but nothing betrays the agony of death. Placid and unmoved, the martyrs carry the emblems of their victory – the crown and the palm (Plate

19). We do not know at first hand how artists portrayed their martyrdom and death; we only know of these from descriptions. Perhaps the miniatures of a late date, in Byzantine monthly calendars, are a reflection of these pictures: the faces of the witnesses betray no concern, the executioners are indifferent; but this, as already mentioned, can be seen only on miniatures, not on a large scale on the walls.

This reserve, an inheritance from antiquity, was not able to protect the Byzantine Emperors from their garments stiff with jewels, from high diadems, from strings of pearls to frame their faces; but it was able to protect Christ, even to the end of the Middle Ages, from being decked out in too worldly a splendour. The Lord on His Throne is still simply clad in a tunic and pallium (Plate 11). No one ever thinks of putting a crown on his head, or a sceptre in his hand, or of setting enemies under his feet – and that despite Psalm 110. The unearthly light that surrounds his head, containing the emblem of his cross, seemed to the early Church to be all that was needed. The strange mosaic of Christ in the uniform of a Roman Emperor, treading underfoot the dragon, the basilisk, the asp and the lion (as in the Ninety-first Psalm) has remained unique of its kind: he who treads underfoot Death and Hell is always the teacher, in noble white garments, in his hand, the Gospels. And how long it is going to be, before the teacher condescends to appear in a humble posture? On fourth-century sarcophagi, he touches with a rod the wine jars at the wedding feast of Cana, or the figure of Lazarus swathed in a winding-sheet, without inclining his body at all. The first time that he is shown leaning forward is at the washing of the feet, in the Rossano Codex, and the second, in the same Codex, in the parable of the man fallen among thieves on the wayside; for here he himself is the Good Samaritan. Not for centuries will the washing of the feet appear in the cycles of wall mosaics.

And how many centuries must elapse before a representation of the crucified Christ is possible? At first, even the Cross was concealed by a secret sign. Then the Cross makes its appearance in the form of the monogram of Christ. After 350, the precious reliquary of the True Cross, the 'Staurotheke' of Jerusalem, which contained a fragment of the 'Wood of Life', is shown everywhere. This is the Cross that we can see inlaid with gold and precious stones, in domes and the vaults of apses, surrounded with vine-tendrils or stars (Plate 14)

and by the four beasts of the Apocalypse. And when the artists dared, at last, to represent Christ Himself on the Cross (Plate 45), He is clad in a long robe and stretches out His arms 'the whole day long, towards a stiffnecked people'. The soldiers raise their lances to His side, and place the hyssop-bearing reed against His lips, but His features show no trace of pain; Sun and Moon stand darkened in the sky, and near at hand are His mother, a symbol of the Church, and His disciples, a symbol of the faithful. This moving picture is magnificently stylized and yet a clearly recognizable portrayal of the redeeming Death, deeply felt, yet with its own remoteness – like the chants of the liturgy which celebrate this same mystery.

The shouts and cries, the flood of emotion, the heart-rending tenderness: of these we hear almost nothing in the sermons of the time, even though, every now and then, as if by chance, the passionate outpourings of some warm heart interrupt the stately flow of rhetoric (and there are examples in St. Augustine). But none of this strong feeling is depicted; even the truly genuine works of art appeal to us in a different, perhaps a more discreet, way; in the way preferred by the ancients who knew how to temper compassion with restraint. It was this precious inheritance, the finest element in the ancient tradition, that was faithfully cherished by those unknown Masters who set the pattern for Christian imagery and iconography for ages to come.

The New Meaning

The imaginative outlook of the Christian world, in so many respects alien to the Greco-Roman, nevertheless retained the symbols inherited from that world which still had life in them; it was the outworn, moribund clichés that they utterly discarded. For the Christians took over what was best in the formal conventions and techniques of the time, and made use of them for conveying a quite different meaning. By degrees, such conventions took on new life, and the almost lifeless forms – the old husks as it were – were triumphantly transformed by a startling, even momentous content based on another set of ideas. This is of course a simplification, a useful if not over-profound description of the transition from classical to Byzantine and medieval art.

It is generally accepted today that in Early Christian art the purely formal elements were subordinated to the content of the works. In architecture, this was the liturgy and the general needs of a religious community; in representational art, it was the message. Therefore, the understanding of these works depends not just on the analysis of their form, but on a correct appreciation of their basic ideas. These are works which Burckhardt – who did not like them – described as follows: 'The style has little to offer to the eye, but in the historical and imaginative content there is some compensation.' Today we incline to the view that they had more to offer, to the eye also, than the earlier secular art of the Empire: yet, in a sense, Burckhardt was right. These remarkable works of art compel the beholder to take notice of their meaning and their function, and this is exactly what their makers intended.

Being Southerners, they never forgot the means of pleasing the

123

eye and warming the heart with the glitter of beauty. But, despite some modern opinions, these unsophisticated works that had come into being simply to comply with the demands of their situation, were not intended to furnish a meaningless existence with its only justification – the quest for beauty for its own sake.

The aim a great artist sets himself always follows its own laws, and is, therefore, as elusive as it is unique. This is true even for that long-forgotten time, when craftsmen had no pretensions to being practising artists. Yet if nowadays we try, with our meticulous analyses, to investigate the means whereby these Early Christian artists created something new out of the framework provided for them by their tradition and faith, we shall not fail entirely to fathom their motives, conscious or unconscious: the endeavours of modern man to understand the work of these artists are too intensive to remain wholly fruitless.

The service of beauty came naturally to men of the ancient world and to the early Christians. Yet I think it must be said that the artists' patrons (at first laymen and later churchmen preoccupied with the cure of souls), were more concerned with the literary than with the aesthetic aspects of these works, and especially with their didactic purpose. They were mainly interested in the subject-matter and far less in the manner in which it was made explicit: they took the form for granted and turned their attention to the content.

This content, however, was infinitely diverse: it was as inexhaustible as the Holy Scriptures themselves. Classical mythology had been rich and varied, but compared with the Christian story of salvation, the myths seemed mere random fantasies, strung together without organic connection. By contrast, this was a landscape, firm upon solid bedrock, immeasurably vast, yet assimilable at a single glance, a landscape in which everything – both man and nature – had its appointed place, bathed in the constant light of the mighty Sun, Christ, the Word of God.

This divine Logos was not merely some sort of abstraction devised by solitary misanthropists and eccentric philosophers. He was a man of flesh and blood – Christ. One could get in touch with him through a knowledge of the past, as well as through inner experience. His grave could be visited; it was known who his mother was, and his friends; his ancestors and his people were known too. The educated Greek or Roman who read the Gospel met a man like himself,

resembling him in everything but his sins; but even this absence of sin was no barrier; He exercised a fascination of which no other man had been capable. He was constantly surrounded by ordinary men: not by heroes, not by great men who can afford to snap their fingers at destiny. With him there are sinners as well as the pious and the self-consciously upright. His disciples are men like ourselves, as weak, as well-meaning, as wrong-headed, as ignorant, as appealing, as infuriating as we are ourselves. And he himself–he had nothing of all this, and yet was one of them. Even the simple workman and the ignorant slave, as they stood and listened beneath the reading desk, understood the glad tidings completely. They may not have been able to speculate profoundly about the divine Logos; but they could understand Christ their master. No man had ever spoken as he spoke.

The profound humanity of the Gospel not only suffused Early Christian art with an all-pervading mellowness, but it raised the whole of humanity to the majesty of the First Man, Christ. To the ancient Greeks, man was the measure of all things; but the complete man was an aristocratic being with a heroic tenor of life, blessed with noble ancestors and a thoroughly sound education. Even the Stoics of later times, who were reluctant to despise the poor and lowly, just managed to tolerate them with nonchalant courtesy. In the Scriptures, however, no man was contemptible, though he may bring about his own ruin against his wiser judgement. The sinner, however, who acknowledged his own presumptuousness was the prey that the love of God must ensnare; he was preferred to the ninety-nine who have good reason to count themselves among the just.

It is this new humanity which determined the content of Christian art. An enormous widening of the field of vision resulted, and with it, there came an opening up of the heart to that part of humanity, and to those dark corners of human nature, which until then, had been neglected and as good as forgotten. Not only will foreign lands of the East suddenly appear in the artist's repertoire–the desert, the tents, the pastures with the flocks of the patriarchs, the great cities of Mesopotamia. The events of the religious life, as they were described in the Bible, would also be presented in all their manifold aspects: the nomad chieftain who had faith in the Word of God, and to whom this was accounted righteousness; the great king

who does penance for his sins; the prophets who followed their call-
ing, like Elijah; but also the others, who, like Jonah, were untrue to
the divine call; young men who put tyrants to shame; children, who
had to announce the judgements of God to venerable priests, as the
child Samuel did to Eli . . . and finally, the many, many encounters
in which the Divine Wisdom, in the Gospels, confronts the most
ordinary men, to praise, to admonish, to warn, to hold out a helping
hand, with a word not to make it an occasion for pride.

In art as well, the change that took place was not only in the
themes, but in the whole ability of men to feel. Before the majesty
of an Invisible God, the gods paled into insignificance: beautiful,
seductive figures, who had once been, perhaps, the tools of demons.
Exalted yet friendly, the humanity of Christ gave significance to
everything that he ever touched by word or deed, and bestowed
importance on every man he encountered. And ancient men read
on the very first page of the Gospel of St. John, that he meets every
man that comes into this world. For this reason, they were not sur-
prised, when on the walls of their churches, they were confronted
with the whole range of mankind: with bad kings and cowardly
judges, innocent executioners and false accusers, with the sick and
the ignorant, with hypocrites and honest men, with the hard-faced
rich and the expansive poor, the sour Pharisee and the precious lost
sheep; among all these there glow the faces of those men and women
who keep the commandments of God, and, because they are in the
truth, hear directly the voice of the divine Logos, who had appeared
in human form.

And all these people together, make up the innumerable multi-
tude that appear in the scenes of the Bible. It is they who will con-
tinue to provide the great theme of the plastic arts, that will hold
the imagination of the peoples of Europe. But–and could it be
otherwise?–they are dressed in a plainly recognizable antique gar-
ment, still serviceable, graceful and simple.

Commentary on Plates

1. The Healing of the Paralytic: the oldest pictorial representation of Christ.
 Wall-painting on the left-hand wall of the baptismal chamber of the house-church at Dura-Europos on the Euphrates: 232–256. Yale University, Gallery of Fine Arts.

On the right: the paralytic on his bed. Top centre: Christ speaking the words: 'That you may know that the Son of Man has power to forgive sins: rise up, take up your bed and walk.' On the left: the man takes his bed (the ancient *kliné*, a couch) on his shoulders and walks away. As would be expected in a baptismal chamber, there is a reference to baptism in the words: 'That you may know that the Son of Man has power to forgive sins'; baptism being the forgiveness of sins (compare the earliest creed: 'I believe in one baptism, for the remission of sins'). To the right of this scene, Christ is again shown stretching his hand out to Peter, who sinks in the waves of the sea; the ship with the disciples appears in the background.

The figure of Christ on the left half of the fresco, reproduced here, is the oldest we know. He wears a tunic and pallium, with sandals on his feet; he has close-cropped hair, and his face is that of a youthful, distinguished intellectual: it is already the definitive type of the Logos-Teacher, the Word of God as the teacher of men. The picture is almost exactly as old as the earliest representations of the Good Shepherd in the Roman catacombs: we can see a very similar Good Shepherd in this baptismal chamber, behind the font, under the baldachin-covering that arches over the basin. The oldest Roman picture of Christ as a Teacher, similar to that of Dura-Europos, but much more distinct, is of a slightly later date. Despite the very primitive execution, this figure of Christ from Dura is deservedly famous: for it is the oldest known representation of Our Lord.

2. San Paolo Fuori Le Mure, before the fire of 1823, after an engraving
 by Piranesi of the 18th century.
 Begun after 385 by the Emperor Theodosius and completed after
 400. The mosaics on the 'Triumphal Archway' that frames the apse
 are from the time of Pope Leo the Great (after 440), as is the series
 of Biblical scenes on the walls above the colonnades.

The five naves are separated by four rows of fluted Corinthian columns,
connected by springing arches. Above them are round shields (*clipei*) with
portraits of the popes, and above these, two rows with scenes from the
Old and New Testaments, and from the Life of the Apostle Paul, restored
by Pietro Cavallini shortly before 1300, though entirely in the style of
the 5th century. The old coffered ceiling had already been replaced, in
the middle ages, by an open ribbed vault.

In the fire of 1823 the colonnades were partly destroyed, and the
frescoes almost entirely. The mosaic on the 'Triumphal Archway', heavily
damaged, was preserved but has been most ineffectually restored. The
12th century mosaic in the apse, behind the transept, has survived. The
little altar above the tomb of the Apostle Paul, with its high, slender
superstructure, makes this gigantic interior seem even more powerfully
impressive: it is Gothic, from the 13th century, by Arnolfo di Cambio.
The present-day basilica is a largely new building, begun in 1830.

3a. Santa Sabina on the Aventine, Rome. Exterior.
 Built under Pope Caelestine, 422–430, through the generosity of
 Petrus, a priest from Illyricum (Dalmatia).

A typical example of a small urban basilica. The walls and the great
windows are ancient, but the window-panels have been filled in with
remains of Carolingian work. The two chapels beside the side-porch are
Baroque. The illustration gives an impression of the sober exterior of a
Roman basilica – a brick building without towers or decoration.

3b. Santa Sabina on the Aventine, Rome. Interior.

The magnificent Corinthian columns, the capitals and the marble inlays
above the arches are original. The floor is medieval: the restorer, Antonio
Munez, made use of medieval models for the roof and the layout of the
altar.

4. Santa Maria Maggiore on the Esquiline, Rome. Interior.
 Founded after 431 by Pope Sixtus III, as the first church dedicated

to the Virgin Mary in the West. The famous mosaics in the nave and on the 'Triumphal Archway' also date from that time.

The whole interior has been restored on more than one occasion – last of all, by Ferdinando Fuga (1740–1752). Even the old Ionian columns and the architrave were brought into line at that time. In the Baroque age, entrances were made to the great side chapels (the arches on the right and left) by breaking through the walls, and the windows were half walled-up. The floor is 13th century, the magnificent pale-gold coffered-ceiling dates from the years after 1492, and the present apse from the end of the 13th century: the high altar is by Fuga. Yet the proportions, the way in which the walls are divided up, and the ground plan, are ancient. The little mosaics, with scenes from the Book of Genesis (cf. Plate 33), Exodus and Joshua, are in the strip of wall beneath the windows. The mosaic by which the Roman community commemorated its loyalty to the Christological doctrine of the Council of Ephesus (by which Mary was the Theotokos, in that she gave birth to God) covers the 'Triumphal Archway' (cf. Plate 12).

5. The ruins of a basilica at Philippi, Macedonia.
 Aerial photograph of a basilica excavated near the forum by a French expedition. 6th century.

This group includes a basilica with its adjacent buildings. To the left and right of the central apse there are two little chapels in memory of the martyrs (*martyria*); in front of the apse, the foundations of the *cancelli*, the balustrade that surrounded the altar; to the left, the narthex – the entrance hall.

6. Qalat Sem'an: the narthex of the main basilica beside the column of Symeon the Stylite.
 Built shortly after 480 (Symeon died in 459).

Symeon the Stylite, the most famous of the Stylite saints, was the Apostle of the Bedouin, a great ascetic and peacemaker. Qalat Sem'an is the most extensive group of Christian ruins in Northern Syria: it lies to the north-east of ancient Antioch, to the north-west of Beroea, modern Aleppo. The ruins of an octagonal, open-plan complex of buildings stand on a hill of the Djebel Sem'an (St. Symeon's mountains), with four basilicas. The base of Symeon's column is still standing at the centre of the buildings. The carefully worked-out architecture and the elaborate ornamentation of the capitals, columns and arches, point to builders and masons from Antioch, in the hinterland of which Qalat Sem'an stands.

7. San Vitale in Ravenna, *bema* and apse.
 This, the best-preserved building of Christian antiquity, was begun
 in 522 by Bishop Ecclesius (cf. Plate 40) and consecrated, in 547, by
 Bishop Maximian.

The church is a *memoria* in honour of the martyr Vitalis. The *bema* (the
raised dais on which the altar stands) and the niche of the apse are seen
from the space beneath the dome. In the apse (and the whole sanctuary)
all the mosaics are mid 6th century, and have been preserved intact.
There are mosaics on either side, which show the Emperor Justinian and
the Empress Theodora, with their court and bodyguard. In the conch
of the apse, Christ sits in majesty, surrounded by angels, with the martyr
Vitalis to the left, and Bishop Ecclesius to the right (cf. Plates 11 and 40).

8. The *cathedra* and the benches of the priests in the Euphrasiana in
 Porec, Istria.
 The basilica was built by Bishop Euphrasius in 535–543. Porec is
 the Jugoslav name for the ancient Parentium (Istria), once called
 Parenzo. (It is one-and-a-half hours by car from Trieste.)

The *cathedra*, the bishop's throne, and the *subsellia*, the benches that run
along both sides of the wall for the presbyters or priests, still survive
from the time of Bishop Euphrasius, as also do the marble-inlays of the
wall of the apse. The white surfaces of these are in mother-of-pearl, the
dark in porphyry, the rest in *cipollino, verde antico* and other kinds of
coloured, veined marble. Above the *cathedra* is a Cross, surrounded by
stars, standing on the mountain of Paradise with its four streams, and to
left and right of it, burning candles in candlesticks. The *cathedra* was
usually covered with cushions and a rich cloth, the *velum*.

9. The Hagia Sophia in Istanbul. Interior.
 From a drawing by the Italian Fossani, of the last century. It was
 begun in 532, after the Nike Riot and the burning of the old Hagia
 Sophia, and consecrated in 562 by the Emperor Justinian. The
 height of the dome is 55 m., the diameter 33 m. The church as a
 whole is 74 m. by 61 m. (Cf. the Cathedral of Amiens, 144 m. long
 and 42 m. to the spine of the vault.)

This drawing communicates better than any photograph the impres-
sion made by the structure of the interior, of being suspended in mid-air,
yet firmly held together. It is drawn from the dais of the altar, which
has now disappeared, near the west door-way. Here, over the narthex,
was the dais for the Emperor; his suite sat in the galleries, the people and

clergy stood below them, in the nave. The mosaics here are still covered with the layer of whitewash with which the Turks coated the walls; but the ancient inlaid marble, from the topmost moulding of the wall to the floor, is undamaged. The furnishings and round shields were added by the Muslims. Since 1934, the church has been a Byzantine Museum: many of the mosaics have already been uncovered.

10. A capital from the gallery in San Vitale, Ravenna.
 Ca. 530–540. One of the capitals from the left-hand *trifora* (an opening in the wall of the apse, made up of three small arches resting on two columns) above the *bema*, the area of the altar.

A typical example of the new forms of capitals in the 6th century. Although plainly an elaboration of the classical composite-capital, the form is a new departure that fits in beautifully with the decoration of the whole building, characterized by flat surfaces. The capital, resting on the highest ring of the shaft of the column, is folded into eight arched pleats, its surface pierced with filigree decoration. Above the narrow abakus (the brim on the top of the capital) there is a distinctive connecting-piece, the impost, which ensures a harmonious transition from the capital to the two spring-arches, covered with a mosaic-work pattern of scallop-shells.

11. The Enthroned Christ. Apse-mosaic from San Vitale, Ravenna.
 Before 547 (the year of the consecration of the church).

Christ, as the youthful Logos Teacher, is enthroned in glory on the blue orb of the universe. The orb's meaning is made clear from the landscape of Paradise and the mountain with four streams, on which it rests. The *Staurotheke*, the cross as it was preserved in Jerusalem in a precious reliquary, shimmers in the corona that encircles the head of Christ: in his left hand he holds the Book with the Seven Seals; in his right, the wreath of victory which the martyr Vitalis (to the left, out of this picture) has brought to him. He is dressed in a tunic with golden *clavi* (ornamental bands that run from top to bottom) and a purple pallium. Red morning clouds drift across the sky.

12. The Infant Jesus, with Mary and Joseph, in Egypt, Santa Maria Maggiore, Rome.
 Part of a mosaic on the 'Triumphal Archway' of Santa Maria Maggiore (cf. Plate 4); date: the pontificate of Sixtus III, 431.

The frieze-like composition to which these figures belong shows the solemn welcome prepared by the governor, Aphrodisias, with his philosophers and courtiers, for Christ, the little Logos, in the Egyptian town of Sotinen. The theme is taken from an apocryphal Gospel (the genuine Gospel only records the flight and residence in Egypt). In this mosaic, the scene is chosen to show the recognition of Christ by the pagans, so as to accompany his recognition by the Jews, Simeon and Anna: the companion to such a scene is the Adoration of the Wise Men, 'The First-Fruits of the Heathen'. It is remarkable that these popular apocryphal stories, the reading of which in church was strictly forbidden, and which are never mentioned in sermons, should nevertheless provide the artists with such a theme. This would not have happened without the permission of those who commissioned the work, the Pope Sixtus III and his archdeacon, the future Pope Leo the Great.

Mary is dressed like a Roman Empress, while Joseph is a simple and ordinary young man of the people. The little Jesus wears the solemn robes of the Teacher; and in the halo around his head is the sign of the Cross. The Holy Family is surrounded by angels: this is an allusion to the doctrine that in this child the one and only divine Person is revealed. It is the dogma of the Council of Ephesus, to which the Roman community erected this church, and the mosaic in particular, as a grandiose monument. The glowing colours cannot be seen on this reproduction, but it does do justice to the searching eyes, the solemn atmosphere of the scene, the impressionistic technique of the artists in mosaic. It was restored by Pius XI in 1931, on the 1500th anniversary of the Council.

13a and b. Two niches with half-moon surfaces from the so-called 'Mausoleum' of Galla Placidia, Ravenna.
Above: the niche above the entrance, with the mosaic of the Good Shepherd. Below: the South niche, opposite the entrance, with the mosaic of St. Lawrence, the Roman deacon and martyr. Ca. 430–450.

The famous little building was not, originally, a mausoleum, but was probably a *memoria* in honour of St. Lawrence, near the entrance-hall of the near-by church of Santa Croce. This entrance-hall is no longer there, but the church is still standing. Galla Placidia, the regent of the Emperor Valentinian III, was the founder of both the *memoria* and the church: we do not know where her sarcophagus stood.

The mosaics have been preserved in their entirety. The Good Shepherd on the mosaic is the last we meet in Early Christian art: he has already become a Prince, dressed in gold and purple; in his hand he bears a staff

with a jewel-studded cross. Lawrence, opposite, is carrying the cross of a martyr and, as a deacon, the books of the Gospels. Beside him is the grid-iron on which he was tortured; to the left, the cupboard in which the book of the Gospels were usually kept; the names of the Evangelists are placed beside the books. Note the remarkable distribution of the mosaic in relation to the window (closed with sheets of alabaster). In the arch of the niche, there is a medallion of the Cross on a dark blue ground.

14. Mosaic in the apse of Sant' Apollinare in Classe, near Ravenna. The centre.
 The basilica built over the grave of the martyr Apollinaris is in the cemetery of Classis, the port of Ravenna. It was founded by the banker, the *argentarius*, Julius, in 533/6 and consecrated by Bishop Maximian in 549. The mosaics date from shortly before 549.

This is an excellent example of the half-historical, half-symbolic pictures which usually adorned the apse of a basilica. The whole composition shows the Transfiguration, against the landscape of Paradise. But Christ is represented by the symbol of the Triumphant Cross, surrounded by a jewelled corona. Where the arms of the Cross meet, there is a tiny picture of his face. The Cross is raised on high, up among the stars. On a sky of red clouds, Moses stands on the left, Elijah on the right. The three Apostles are shown as three lambs (not quite visible in this illustration). Below: Bishop Apollinaris, the patron-saint of Ravenna, in glory: he is shown in an attitude of prayer and wears the *phelonion* (the chasuble) and the *omophorion*, with the white bands of a pallium, the mark of an archbishop. The procession of lambs symbolizes the believers, the newly-baptized, the 'new-born lambs', being clad in white. Note the abstract motifs on the landscape: they are scattered over the light-green background that represents the pastures of Heaven.

15. A fragment of the pavement of the main church of Grado.
 The basilica of Grado, to the south of Aquileia (in the Roman Venetia), was rebuilt and decorated in 571–588 by the Patriarch of this small town after he had abandoned his residence in Aquileia, that had been destroyed by the Lombards. The present floor lies on top of the ancient pavement.

This is a typical example of a simple mosaic floor, endowed by bishop, clergy and people together. The name of the donor is shown in each portion of mosaic; and, at the top, there is an inscription recording the initiative of the bishop.

16. The Mausoleum of the Princess Constantia, Rome. Interior.
Mausoleum of a daughter of Constantine the Great, ca. 350. It stood
against the side wall of the old basilica of the martyr Agnes (of
which only the ruins survive, near the present church of Sant' Agnese,
that dates from the 7th century), in the cemetery of St. Agnes on
the Via Nomentana, in the north of the city.

The mausoleum is a rotunda with a circular corridor and a dome
which rests on a circle of eight pairs of columns. Each pair of columns is
crowned by an architrave. The mosaics in the vaulting of the ambulatory
have been preserved; they still show classical themes, known to us from
mosaic pavements.

17. The so-called 'Mausoleum of Galla Placidia', Ravenna. Interior.
Cf. *supra* Plates 13a and b, with commentary. Ca. 430–450.

The mosaic in the dome has as its theme the glorification of the Cross
as symbol of triumph: in the tympanum supporting the dome, eight
Apostles (of whom two are visible) worship this 'Trophy' – the Cross.
The mosaic of the martyr Lawrence (cf. Plate 13b) is in the South niche.
The origin of the sarcophagus is unknown.

18a. The *Memoria Petri* over the Tomb of the Apostle in Old St. Peter's
on the Vatican Hill.
Details of an ivory carving found at Samagher, which is kept in
Pula (Italian, Pola) in Istria. Ca. 400.

The *memoria* can be recognized down to the smallest details (cf. p. 71).
Two of the faithful are standing in front of the doors of what is called
the *confessio*, the little miniature building that stands above the tomb;
four others are in an attitude of prayer in front of the curtains that hang
between the twisting columns that support the architrave. Four of these
columns are still in St. Peter's.

18b. Worshippers before the *memoria* of a martyr.
Another detail from the ivory-casket from Pula; cf. Plate 18a.
Ca. 400.

Here the *memoria* is a special chapel beside a basilica. Note the chandelier,
the lamps, the lattice doors, the curtains and the dress of the worshippers –
plainly very important people.

19. The martyrs Vincent and Pancras. Sant' Apollinare Nuovo, Ravenna.
 Two figures from the long procession of martyrs shown on the
 mosaic frieze in the nave of the church. Date: 566–70; after the
 conquest of Ravenna by Justinian. The church was originally the
 palace-church of the Arian King of the Goths, Theodoric: the
 Catholics dedicated it to Bishop Martin of Tours.

The martyrs bring their wreaths of victory to the Lord on his throne
(to the left of the group shown here). They are the 'white clad host of
Heaven' (cf. *Revelation*, 22), advancing between the palm trees of Para-
dise. Vincent is the deacon from Saragossa in Spain (Roman Caesar-
augusta), Pancras is the young boy, Pancratius, who is buried in the
Roman catacomb named after him.

20. The martyr Menas in his *memoria* in the Egyptian desert.
 An 11th century copy of an ivory of Egyptian origin from the
 late 5th or the early 6th century: Milan, Castello Sforzesco. The
 model was probably a souvenir for pilgrims from Menapolis, where
 the shrine of St. Menas stood, south-west of Alexandria (Karm Abu
 Mina).

The cloak fastened across one shoulder – a *chlamys* – shows that the
martyr was a soldier: his dress is that of an Egyptian of around 500. The
camels are associated with the desert in which the tomb of the saint lay;
the stylized buildings are a schematic impression of the *memoria* which
was set up in the middle of the gigantic basilica at Karm Abu Mina, now
a ruin.

21. The translation of the relics of a martyr to a *memoria* (Constanti-
 nople).
 An enlarged detail of an ivory-carving of unknown origin. From
 the Cathedral Treasury at Trier. Probably 6th century.

Two metropolitans (bishops of provincial capitals) carry the *theca* con-
taining the relics of the martyr on a ceremonial carriage: to the right (not
shown) the Emperor, with his court and the people, carries a candle as
he marches at the head of the procession that receives the martyr (perhaps
Euphemia of Chalcedon) in front of her *memoria*. Over the city gate on
the top left is an icon of Christ; in the windows above the colonnade, the
faithful swing incense-burners.

22. A silver flask (*ampulla*) from Palestine, with the Adoration of the
 Magi.

A pilgrim's souvenir presented by Pope Gregory the Great to Queen Theodolinda, see p. 52. Monza, Cathedral Treasury. Ca. 550–600.

To the left of the Mother on her throne, the Three Wise Men (*Magoi* in the inscription), to the right, the Shepherds of Bethlehem; above, two angels pointing to the star; below, the flocks of sheep. Between these, an inscription, 'Emmanuel, God with us', and, inscribed round the edge, 'Oil from the Life-giving wood in the Holy Places of Christ'. It is believed that this relief is a schematic picture of a mosaic that adorned the gable-end of the Church of the Nativity in Bethlehem.

23. Picture of a Baptistery.
 Detail from the side of a sarcophagus (Lateran Museum, No. 174, Rome). Mid 4th century.

The bronze doors decorated with lions' heads stand open, the curtains fall over them. The round arcade, inside, is not shown; but we can see the windows in the dome, the roof covered with pantiles, with a monogram of Christ (XP) at its top. This is the only known picture of a baptistery in Early Christian art.

24. The font basin, the Baptistery of Cuicul (Africa).
 The font and the baldachin – the domed covering – of the baptistery of ancient Cuicul (modern Djemila), a little to the north-west of Constantine. 5th century.

A lamp would hang under the baldachin, and curtains would be drawn between the columns. At the foot of three steps, a mosaic would cover the floor of the *piscina*. The dressing-niches in the surrounding arcade are not visible.

25. Mosaic on the floor of a Baptistery at Salona (Dalmatia).
 Fifth century.

The mosaic is in front of the door: the text: 'Like as the hart desireth the waterbrooks, so longeth my soul after Thee, O God' (Psalm 41, 2 [Vulgate]), was sung when the candidates for baptism trooped into the Baptistery in the Easter vigil. It is an excellent example of the usual geometrical design for a floor; the *tabella* with the picture of the harts at the fount of life, and with this text, is placed directly in front of the threshold.

26. Burial-crypt of the popes of the 3rd century, in the Catacomb of St. Callixtus in Rome.

The illustration shows the crypt as it was in 1854, immediately after its discovery.

Fragments of tomb-inscriptions still lay in the simple graves hewn into the wall (the *loculi*) and on the floor; the relics had already been transferred to the city in the 7th century, for better protection. In this burial-chamber the martyr-popes Pontianus (d. 235), Anterus (d. 236), Fabianus (d. 250), Lucius (d. 254) and Eutychianus (d. 283) were laid to rest. On the back wall, right at the bottom, there is a fragment of the inscription that Pope Damasus had placed here shortly before 366. Popes Xystus and Cornelius were buried in other chambers not far from this crypt.

27. Underground passage with wall-graves in the Catacomb of Alexander, Rome.
 The cemetery lies to the north of the city; the passage dates from the 4th century.

The exceedingly simple graves (*loculi*) are sealed with only one stone: often they do not even have an inscription.

28a, b and c. Three grave-inscriptions from the Roman catacombs.
 Now in the inner courtyard of the Lateran Museum, set into the wall.

 a: 'Gerontius, live in God'. The picture is of the Good Shepherd and the Lamb. Ca. 300.

 b: 'Callimeres, God refresh your soul, together with that of your sister, Hilara'. The picture shows the Good Shepherd with the two lambs that symbolize their two souls, and the dove with the olive branch – the symbol of 'peace'. Beginning of the 4th century.

 c: Picture of an unknown woman. This symbolic scene means: 'In the peace of Christ' – peace being shown by the dove, Christ, by the monogram.

29. Baptism and the Eucharist in the earliest catacombs, Rome.
 a: Fresco on a grave in Chamber A2, in the oldest part of the Catacomb of St. Callixtus. Shortly after or around 200.

See p. 86. The candidate for baptism, the *infans* (hence shown as a small child), the person administering baptism, the green brush-strokes standing for the water, and the dove of the Holy Ghost, are plainly visible; immediately beside this scene, there is a picture of the Fisher and the fish.

b: Fresco on the wall of a grave in Chamber A5 of the Catacomb of St. Callixtus, not far away from the last-mentioned picture. Shortly after or around 200–220.

The meal is shown with the 'Food of Life' from *John* 6 with the bread and fishes, and the seven partakers of *John* 21; the seven baskets are also plainly an allusion to this passage in the Gospels. The meal, which is probably an ancient meal for the dead, was taken by the initiated as a reference to the Food of Life in the Eucharist. See p. 86.

30a. A sarcophagus with a hunting scene.
 A non-Christian sarcophagus in the crypt of the Cathedral of Palermo. 3rd century.

The 'Hunt' symbolizes a heroic working-out of one's destiny in life and death. To the left, the Lion of Death wraps itself around an antelope. The pagans of the 3rd century also decorated their coffins with symbolic themes. The inscription on the cover is 13th century.

30b. One of the oldest Christian sarcophagi. Santa Maria Antica, Rome.
 This sarcophagus stands in the left-hand side nave of Santa Maria Antica in the Forum: it dates from the 3rd century (perhaps from the first half).

The dead woman stands in an attitude of prayer (the head is unfinished) near her husband (whose head is also incomplete): they are shown as Teacher and Disciple. In pagan terms, they are 'people of the Muses', which meant, for Christians, disciples of True Wisdom, that is of Christ. Nearby on the right, Christ as Good Shepherd; next to him, Baptism, with an *infans*, water and the dove of the Holy Ghost. To the left, the 'Refreshment' – Jonah in the shade of the gourd, beside his ship.

30c. 4th century sarcophagus.
 Lateran Museum, No. 161, Rome. Ca. 320.

A typical Christian frieze-work sarcophagus of the age of Constantine. The inscription reads: 'To Sabinus, companion in marriage, who lived 44 years, 10 months and 13 days – of high merit. In peace.' On the cover, to the left, the dead man is shown, between scenes of the four seasons, a non-Christian theme that refers to the eternal cycle of life. On the right, a hunting scene. On the outward face of the sarcophagus, the soul of the dead man stands veiled, in the form of a praying woman. Further

along, from left to right: Peter strikes water from the rocks of the Mamertine prison, the arrest of Peter (both scenes point an analogy between Peter and Moses); symbolic scenes – the water-jars at the marriage-feast of Cana, the healing of the man born blind (Baptism), the bread and fishes (the Eucharist), and the raising of Lazarus ('I am the Resurrection and the Life').

31. The opening of the eyes of the man born blind.
 A detail from the front of a sarcophagus in the Museo delle Terme, Rome. Ca. 320–330.

Christ, dressed in a tunic and pallium, touches the eyes of the blind man with a paste of spittle, before he sends him to the pool of Siloam: it is the usual allusion to spiritual 'enlightenment' through baptism.

32. Christ and an Apostle with the two fishes.
 Detail from a sarcophagus decorated with niches in the Musée Lapidaire Chrétien in Arles. Mid 4th century, from a workshop in Arles.

In his right hand, Christ holds a staff, with which he touches the basket of bread: with his left, he touches the two fishes: this 'sign' from the Gospel of St. John is the usual symbol, at this time, of the Eucharist. Note the highly-expressive heads.

33. The Hospitality of Abraham at the Oak of Mamre.
 The mosaic nearest to you, as you enter, on the left nave of Santa Maria Maggiore. It dates from the pontificate of Sixtus III, shortly after 431.

See p. 96 for the description and interpretation of the scene. Above: the arrival of the three strangers; the middle one is encircled in a pale blue cloud of ethereal fire, and all three have haloes of fiery ether around their heads. Below, to the left: Abraham rebukes Sarah for laughing. To the right: Abraham waits on the three mysterious guests. In the background: the Oak of Mamre.

34a. The miraculous draught of fishes in the Lake of Gennesareth.
 Mosaic on the left wall of the nave of Sant' Apollinare Nuovo, Ravenna, the former palace-church of Theodoric. Shortly after 500. Part of a cycle of pictures.

See p. 97 for the interpretation of the scene. It stands for the unerring efficacy of the Word of God, and for the power to catch men in the name of Christ. This is a typical example of an *historia*.

34b. The Dialogue on the Living Water: Christ and the Woman of Samaria.
Mosaic on the left wall of the nave of Sant' Apollinare Nuovo. Ca. 500–520. Part of a cycle of 26 pictures.

The 'Dialogue on the Living Water' at Jacob's Well always ranked as one of the great Scriptural passages on baptism. It is already shown on the wall of the baptismal chamber of the oldest church in a house known to us, at Dura-Europos (see Plate 1); and it already bears the same meaning. Here it is shown in the manner of an *historia*. Note: that Christ, as a Teacher, is dressed in purple, while the woman of Samaria is wearing the peasant garb of the 6th century.

35. 'The Sacrifice of Thy righteous servant, Abel', San Vitale, Ravenna.
Detail of the mosaic on the half-moon surface behind the arch on the left wall of the altar-space (the *bema*) of San Vitale. Before 547.

Abel, a young shepherd with a wild-beast's skin for a tunic and a short cloak thrown over one shoulder, raises a lamb to the altar. Melchisedech is on the other side of the altar, on which bread and wine are standing. Behind Abel, the straw-thatched hut (the *capanna*) of a shepherd. See p. 95 for a detailed explanation of this figure, one of the three shown on both sides of the altar: their 'three sacrifices' are those named in the main prayer of the Eucharist.

36. Family-portrait on gold-leaf in glass, Brescia.
Gold-leaf in glass from the 4th century, now set into a cross encased in hammered gold, Museo Civico, Brescia.

The most beautiful that we know of its kind in Early Christian art. It shows an aristocratic mother, with her son and daughter. The inscription is still to be explained. It is a brilliant example of the refinement achieved by late antique artists; it is also impressive evidence of the abiding characteristics of specifically Italian faces, and shows the great spiritual sophistication of persons of quality in the ancient world.

37. The icon of St. Peter from Mount Sinai.
An Egyptian, perhaps an Alexandrian icon from the 5th century,

or the beginning of the 6th. It is now in the new picture-gallery of the monastery of St. Catherine on Mount Sinai. Discovered in 1954.

This is the oldest portable portrait-icon of a Christian saint so far known. The Apostle Peter is carrying the 'Keys of the Kingdom of Heaven' in his right hand, the cross, the sign of his witness to Christ through a martyr's death, in his left. The head is surrounded by a halo of golden ethereal light. The background is an *exedra*, a niche. Above the niche we can see three more icons: to the left, possibly Moses; in the middle, Christ; to the right, the Mother of the Lord. All three are of the usual Alexandrian type, which will later become the model for all icon-painters.

38. Christ as the Teacher. Sarcophagus No. 138 in the Lateran Museum, Rome.

Type of the idealized, timeless, youthful Logos-Teacher of men, holding a scroll in his hand. Note the technique of 'drilling' for the hair.

39. Portrait-shields (*clipei*) in San Vitale, Ravenna.
Part of the inner-face of the arch between the central area covered by the dome and the altar-space (the *bema*). Mosaics of before 547.

Left, the right-hand wall of the *bema*. At the very top, tendrils sprouting from a drinking-cup, with doves beside it – an allegory of the 'Mystical Vine' and of the Eucharist in the form of wine: underneath this, the Evangelist Mark with the symbol of his gospel, a lion – one of the four beasts of the Apocalypse; at the very bottom, the prophet Isaiah. On the inner-face of the arch, there are some medallions or *clipei*, with portraits of Christ, of the twelve Apostles, and of the two martyrs of Milan: from top to bottom, the distinctive and highly individualized portraits of Peter, Andrew, John the Evangelist, Bartholomew, Matthew and Judas Thaddaeus. The single portraits are surrounded with rainbow motifs and stylized gems, and are separated by pairs of dolphins. In the squinch of the vault, a peacock on a globe – the symbol of eternal life. To the extreme right, we can see a supporting arch of the dome, and, underneath this, a portion of the gallery beneath the rotunda.

40. Bishop Ecclesius with the model of the *Memoria* of the martyr Vitalis, Ravenna.
The last figure on the right on the apse-mosaic of San Vitale. Dated before 547. The mosaic is a portrait of the founder of the *memoria*.

Bishop Ecclesius began building this *memoria* in 522. He died in 532, so that his successor, Maximian, consecrated the church. Led forward by an angel (we can see a part of the angel's left wing to the left), he hands the model of his *memoria* to Christ throned in glory: the *memoria* is resting on the folds of his purple *phelonion* (the garment in which he would stand at the altar), while the white pallium of an archbishop is draped across his shoulders (see Plates 7 and 11). Note the dark panes of the windows, in some transparent material, probably selenite, the green tiles of the roof, the red tiles of the roof of the ambulatory, the outer walls with pillars against them, the stylized top of the roof with a cross. The archbishop already wears the great tonsure which, in the Latin West of the 6th century, was usual for anyone holding higher orders. The background is made up of golden mosaic cubes, merging gently into a brownish glow.

41. Bishop Euphrasius with his archdeacon Claudius, Porec.
 Detail from the left half of the apse-mosaic in the 'Euphrasiana', the famous basilica of Parentium (Jugoslav, Porec; Italian, Parenzo) which is exceptionally well-preserved. 535–543.

The two founders of the church: right, Bishop Euphrasius, carrying a model of the basilica, his hands covered with his *phelonion*: the crosses on the peaks of the roof, the pantile roofs, the windows, the apse and the curtain hanging behind the open door are shown in schematic form. Left, the archdeacon Claudius (CLAVDIVS ARC), in the long dalmatic of the deacons, the book of the Gospels in his hand; the book is decorated with precious stones and closed with many clasps. Beside the deacon stands his little son, Eufrasius, probably named after the bishop, who had baptized him (EVFRASIUS FIL ARC). The child is wearing high boots and what is called a *birrhus* with a cape. He is carrying two votive candles in his hands which are covered with the *birrhus*; an offering to the Mother of the Lord, who is the central figure of the whole group.

42. Bishop Severus of Ravenna, in the cemetery-church at Classis.
 One of the portraits of bishops in the basilica erected in the cemetery outside Ravenna, at Classis, above the grave of the martyr Apollinaris (the modern Sant' Apollinare in Classe, on the motorway to Rimini).

The most famous of the early bishops of Ravenna were shown above the bishop's *cathedra* on the apse-mosaic, each one in a richly-decorated ornamental niche, between drawn-back curtains. Severus, an old man, is

dressed in a *tunica*, a dalmatic with wide sleeves, a gold-coloured *phelonion* (a cloak) with a white pallium with an embroidered cross draped over it. He is holding up his right hand in the gesture of a teacher when speaking; his left hand is reverently covered, as he carries a bejewelled codex of the Gospels.

43. Portrait of a mother with her child, Coemeterium Maius, Rome. Fresco on the back wall of a burial-niche (an *arcosolium*) in a chamber of the so-called *coemeterium maius*, on one of the streets to the north of Rome.

The young mother, her hair covered with a delicate veil, a chain about her neck, holds her hands apart in an attitude of prayer: the child is in front of her. In my opinion, there is no reason to see, in this family portrait, a picture of the infant Jesus and his mother. On both sides (not visible on the illustration) we can see the monogram of Christ: XP. This detail shows only the head; the portrait goes down to the waist.

44. The Wise and Foolish Virgins, Rossano Codex. A page from the 6th century codex of the Gospels, now kept in the Archbishop's Palace of Rossano, on the east coast of Calabria.

The parchment is dyed purple, the letters are in silver. It is the oldest codex of the Gospels in which the miniatures have been preserved. The text – in Greek – is of the Gospel of Matthew and Mark. On top: the parable of the wise and foolish virgins. The marriage-feast is seen as Paradise, with its flowering trees and four streams springing from a rock. Each of the five wise virgins holds a burning lamp in one hand and a little pitcher of oil in the other. Christ, the Bridegroom, is standing in front of the door. Behind the closed door stand the five foolish virgins: their pitchers are empty, their lamps are burnt-out; the one nearest the door is a *sanctimonialis*, a nun, shrouded in black. On the lower half of the picture, there are three figures of David and, on the extreme right, the prophet Hosea: the scrolls that these figures hold contain passages from the Old Testament that refer to the scene above them – three from the Psalms of David, one from the prophecy of Hosea.

45. The Crucifixion and the Easter morning, Rabbula Codex. Miniature, taking up a whole page, from the Syriac Codex written in the monastery of Zagba in Mesopotamia around 586. Biblioteca Lorenziana, Florence.

Above: one of the oldest representations of the Crucifixion. Christ is fixed to the Cross with four nails. He is wearing a long purple robe with golden bands (*clavi*), called a *colobion*. Above the crosses of the two robbers we can see the mountains around Jerusalem: above these, the sun and moon are darkened. To the extreme left, Mary and John: beneath the Cross, the man with lance, Longinus (from *longê*, a lance), the soldiers casting lots for the seamless robe, and the soldier with a flask of vinegar and the sponge on a reed; on the extreme right, three of the pious women.

Beneath: Easter morning. In the middle, the *aedicula*, the miniature building, of the holy grave at Jerusalem: a beam of light shoots out from the open, bronze door, and strikes the soldiers, who are 'like dead men'. To the left, the white-clad angel is talking to the two women, of whom one is, surprisingly, the Mother of the Lord. To the right, we see, also, in the garden of Joseph of Arimathaea, the first appearance of the Risen Christ, to the same two women.

46. The bronze statue at Barletta.
 A statue of an unidentified Eastern Emperor, five metres high, probably of Marcian. After 450.

An excellent example of the hieratic, majestic style in which an Emperor was shown at that time. Marcian is wearing a diadem of precious stones on his carefully stylized hair, a chlamys, pinned above one shoulder with a clasp, is draped on top of his breastplate; he carries the orb of the world in his hand. The right hand and the legs are (largely) later additions. The statue is now standing on a low base, beside a medieval church, instead of on a high, honorific column in a wide forum. It is the largest Roman statue of an Emperor that we possess.

47. Bird-catcher from a hunting scene, Piazza Armerina.
 One of the numerous mosaic pavements of the gigantic, 4th century villa discovered in 1956 near the town of Piazza Armerina, in the interior of Sicily.

An example of a non-Christian mosaic pavement from a villa in which there is not a single sign of the new religion, but many mythological and erotic scenes, so that it seems unlikely that the owner was a Christian. The ground of these mosaics is, naturally, white: their technique and the geometrical motifs along the borders are in no way different from the technique and motifs of Christian basilicas and baptisteries. The bird-catchers are hunting singing thrushes; their hunting satchels hang over

their chests; they are dressed as the slaves of a very rich owner, to whose *familia* they belonged, and in which they could make a good career. These are excellent parallels to contemporary Christian wall-mosaics: everybody can now compare the two.

48. Curtain between two pillars of a colonnade, Ravenna.
 Detail of a mosaic in the palace-church of Theodoric, the King of the Ostrogoths, now Sant' Apollinare Nuovo. Shortly after 500.

The mosaic shows plainly the way in which curtains hung between columns in basilicas as well as in palaces. The mosaic of which this is a detail originally showed the inner-courtyard of the palace of Theodoric. The members of the family of Theodoric, or his courtiers, once stood between the columns, with their hands apart, in prayer. After the conquest of the Goths by the Byzantines, these figures were removed: we can still see traces of a hand on the shaft of one of the columns, and the outline of a head on the blue background. Curtains, or *vela*, with embroidered crosses have been put up in the place of the figures. Over the capitals, mosaic pictures of winged victories, holding little garlands: a thoroughly secular motif, typical of a Roman Imperial palace, taken over by the Gothic king. These were left as they were: this could not possibly be a picture of a basilica, but of a palace. The curtains, however, are just the kind of *vela* you would find in a church.

Sources of Plates

Index

1. The Healing of the Paralytic, House-church of Dura-Europos

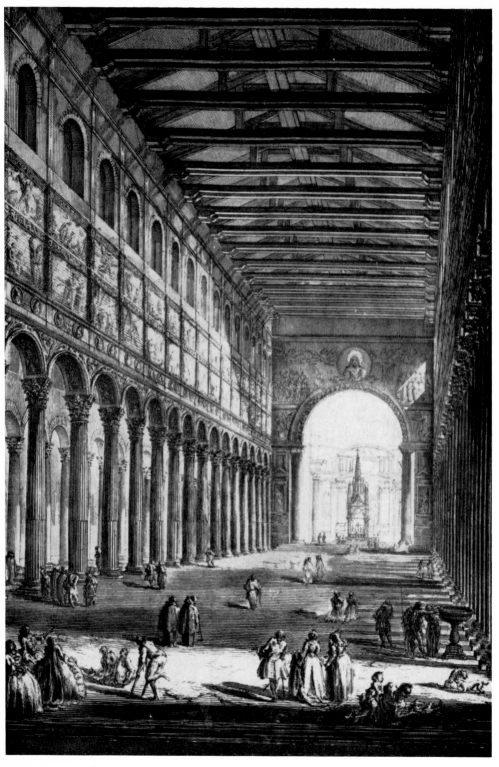

2. San Paolo Fuori Le Mure, before 1823, Rome

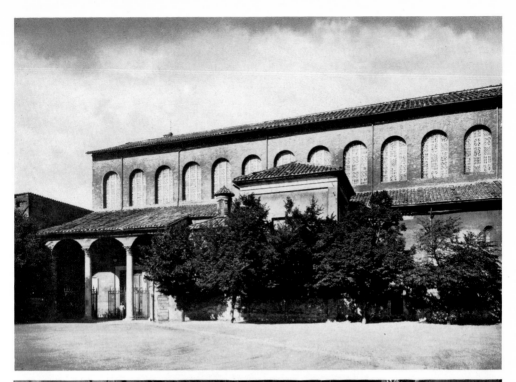

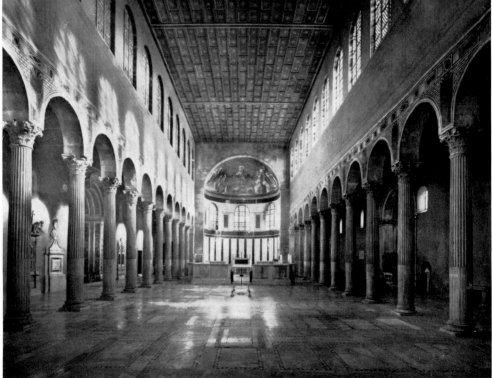

3. (a) Santa Sabina, exterior, Rome
 (b) Santa Sabina, interior

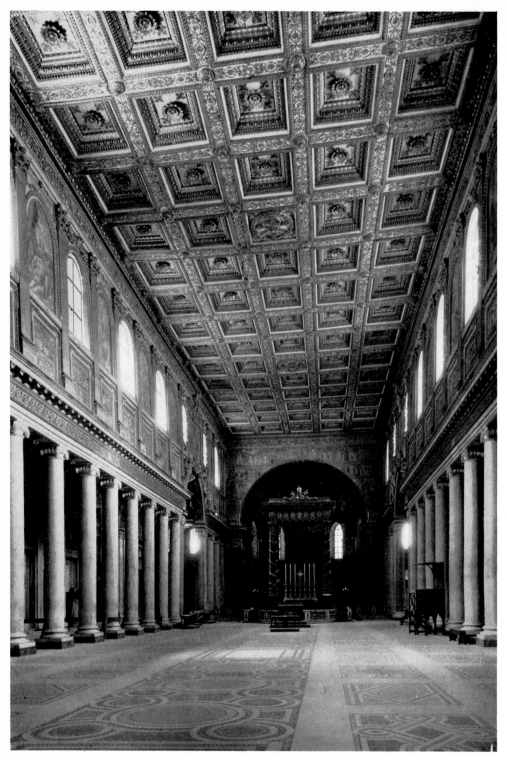

4. Santa Maria Maggiore, interior, Rome

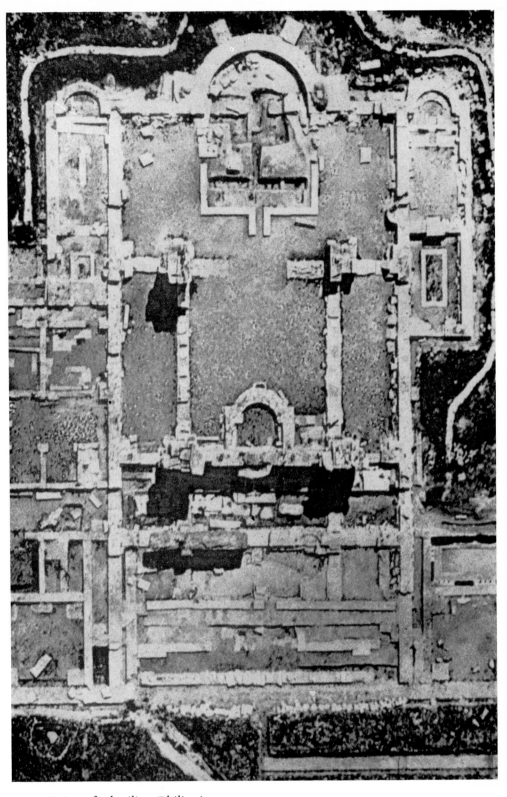

5. Ruins of a basilica, Philippi

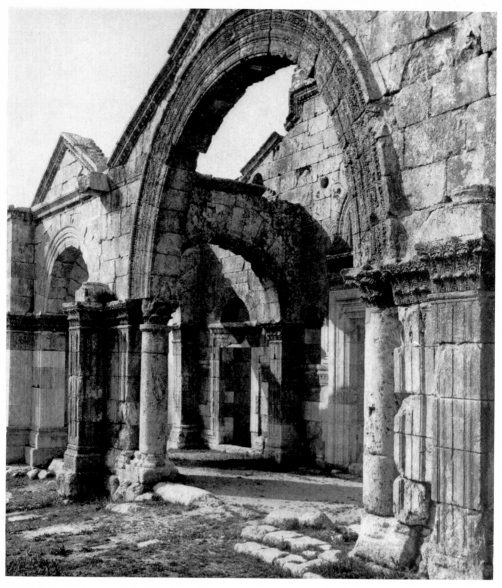

6. Narthex of the basilica of Qalat Sem'an

7. *Bema* and apse from San Vitale, Ravenna

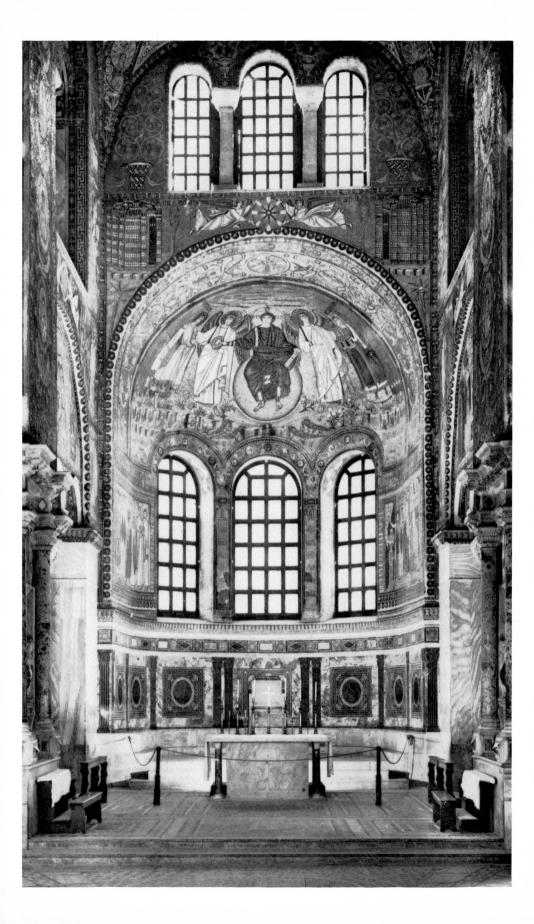

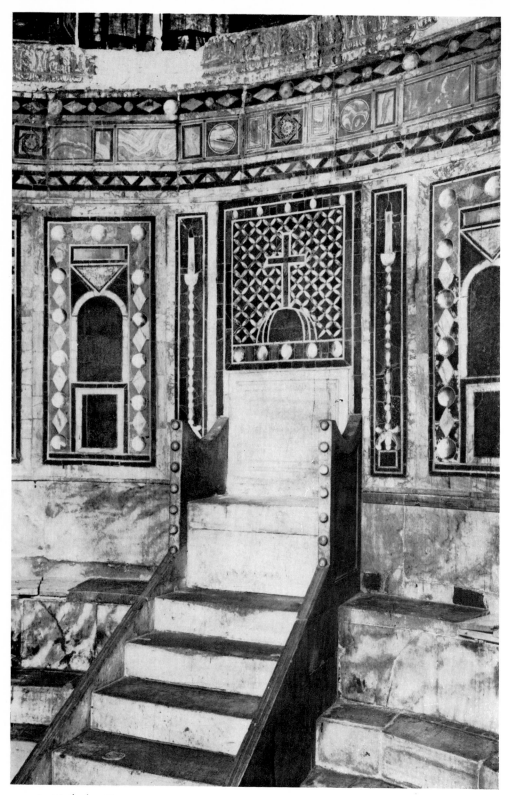

8. *Cathedra*, Porec

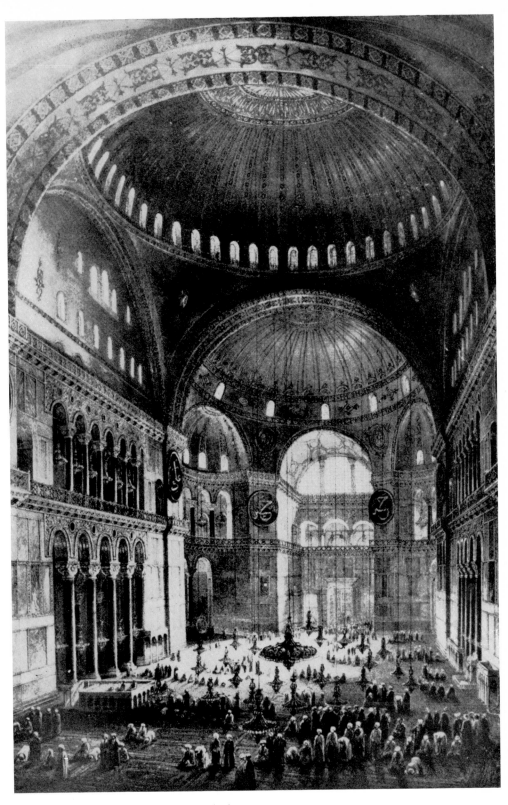

9. Hagia Sophia, interior, Istanbul

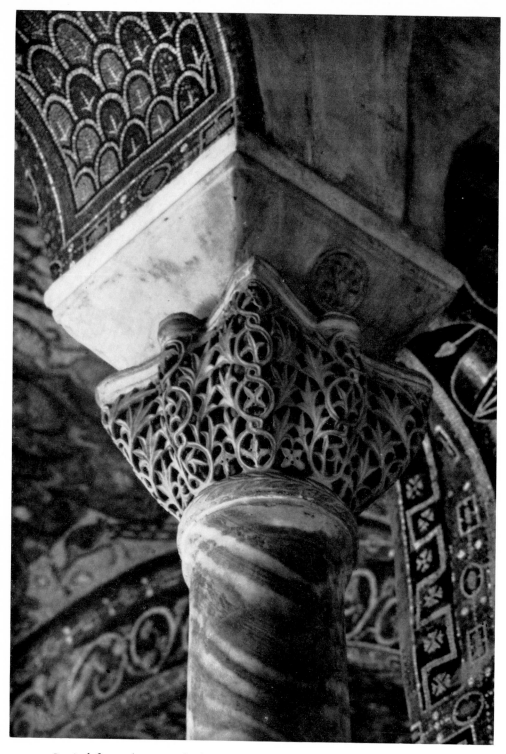

10. Capital from the *emporé* of San Vitale, Ravenna

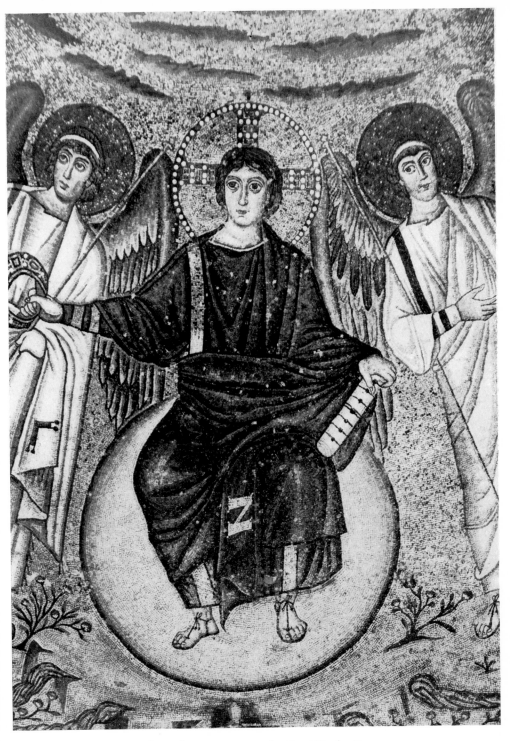

11. Christ enthroned in glory, apse-mosaic, San Vitale, Ravenna

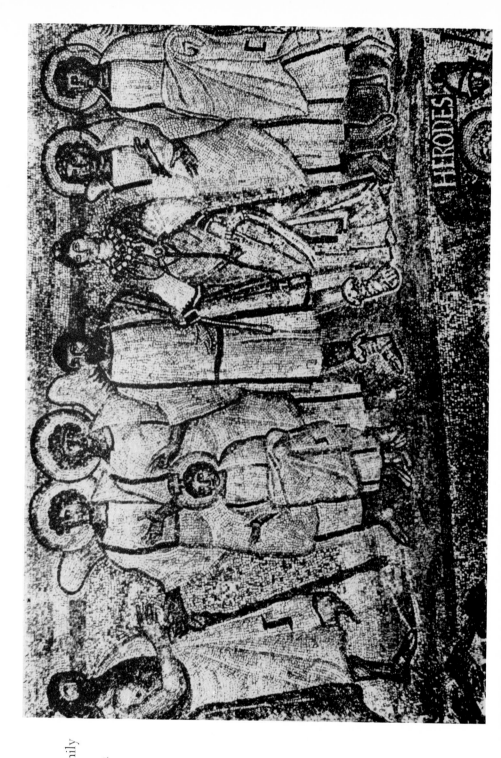

12. The Holy Family in Egypt, mosaic from Santa Maria Maggiore, Rome

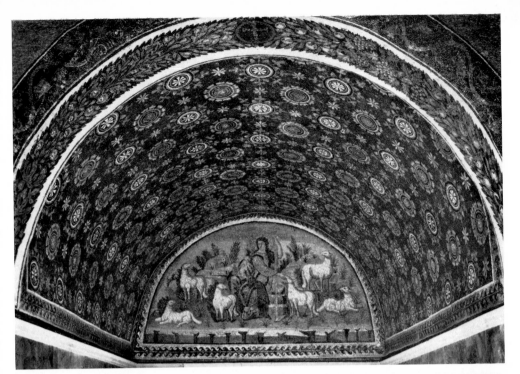

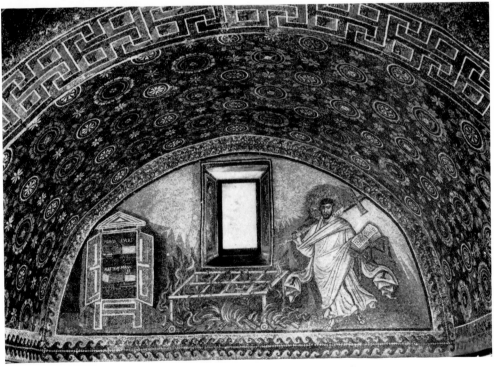

13. Two half-moon surfaces from the 'Mausoleum' of Galla Placidia, Ravenna:
 (a) The Good Shepherd
 (b) St. Lawrence

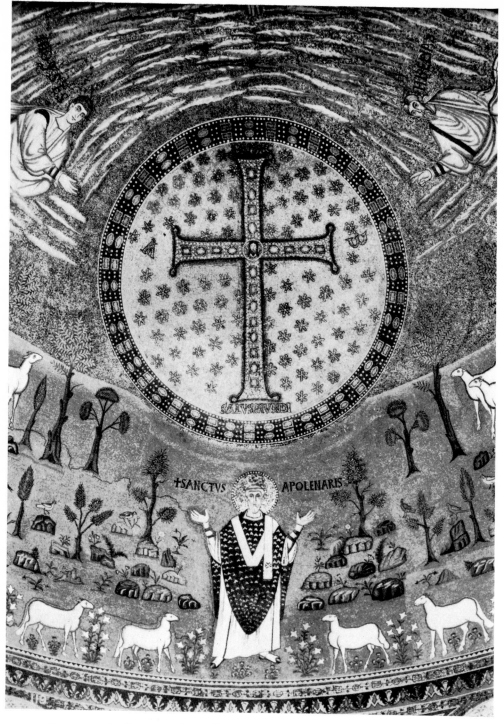

14. Apse-mosaic from Sant' Apollinare in Classe, near Ravenna

15. Mosaic-pavement in the Cathedral of Grado

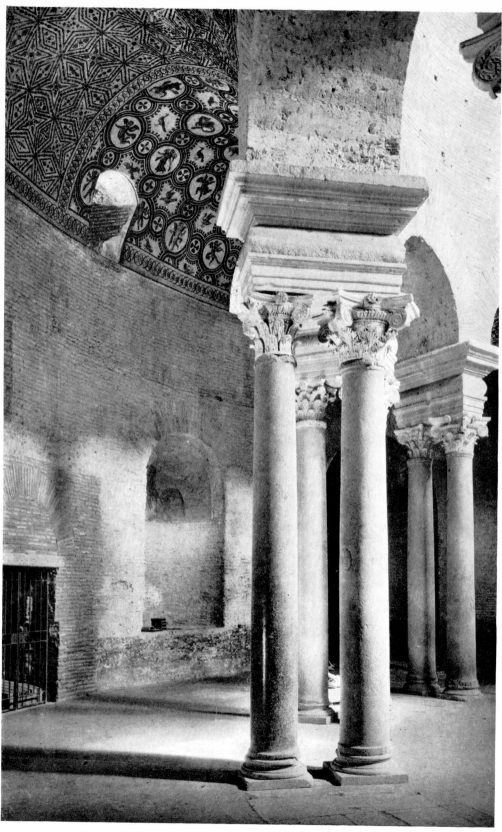

16. Mausoleum of Constantia, Rome

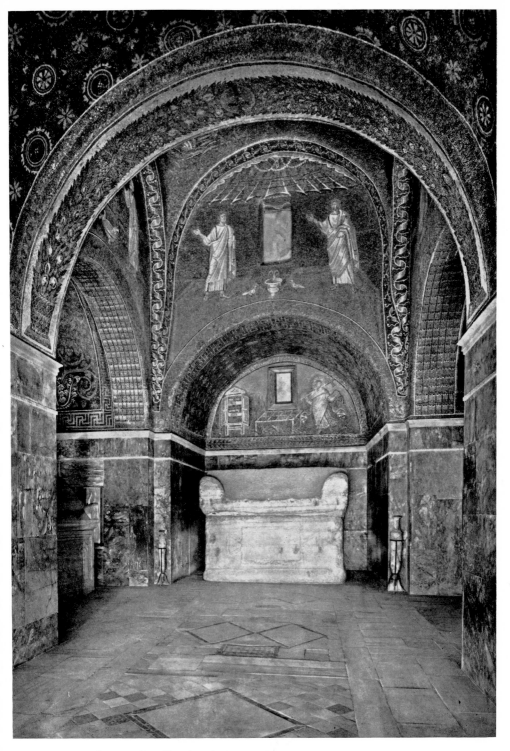

17. 'Mausoleum of Galla Placidia', Ravenna

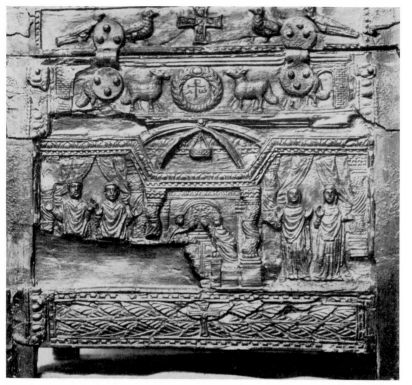

18. (a)
The *Memoria
Petri*: ivory-
casket from
Pula

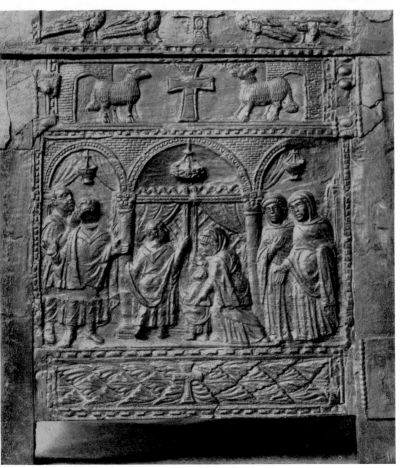

18. (b)
Worshippers at
a *memoria*:
ivory-casket
from Pula

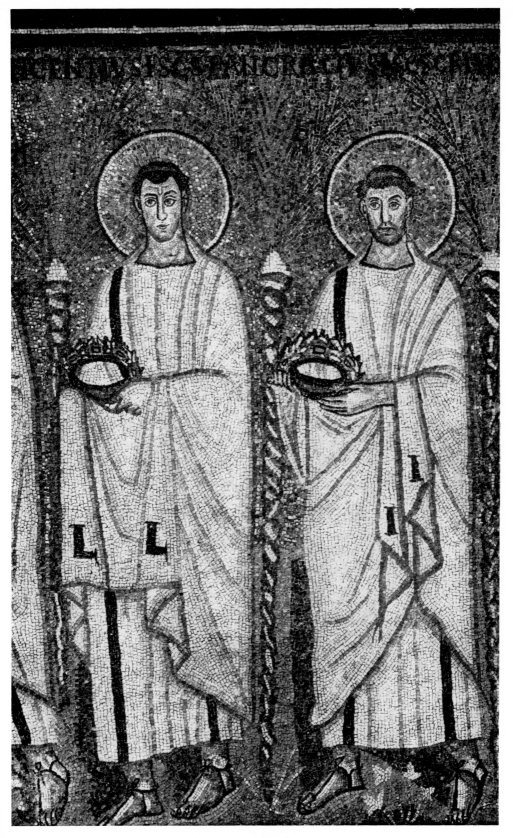

19. Two martyrs, a mosaic from Sant' Apollinare Nuovo, Ravenna

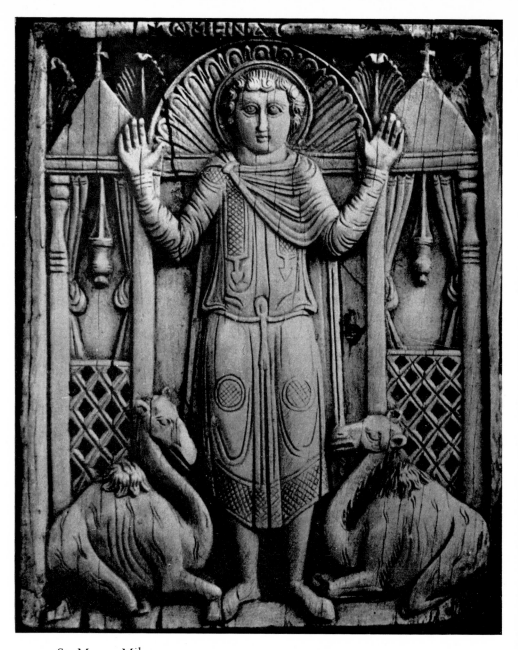

20. St. Menas, Milan

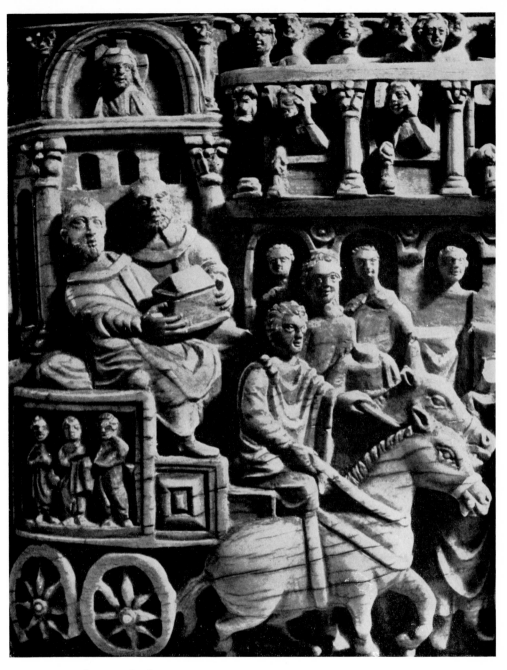

21. Translation of relics, Trier

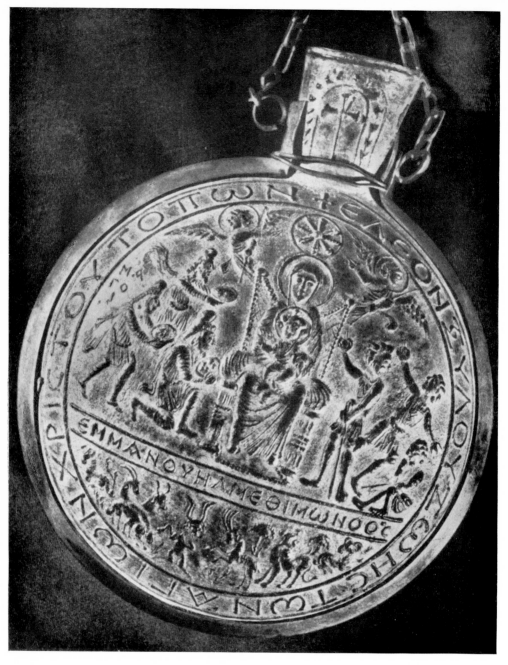

22. *Ampulla* from Palestine, Monza

23. Baptistery, sarcophagus relief, Lateran

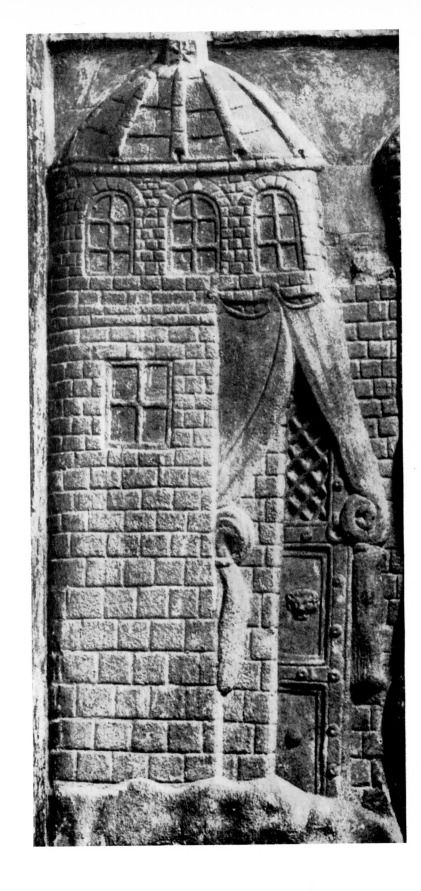

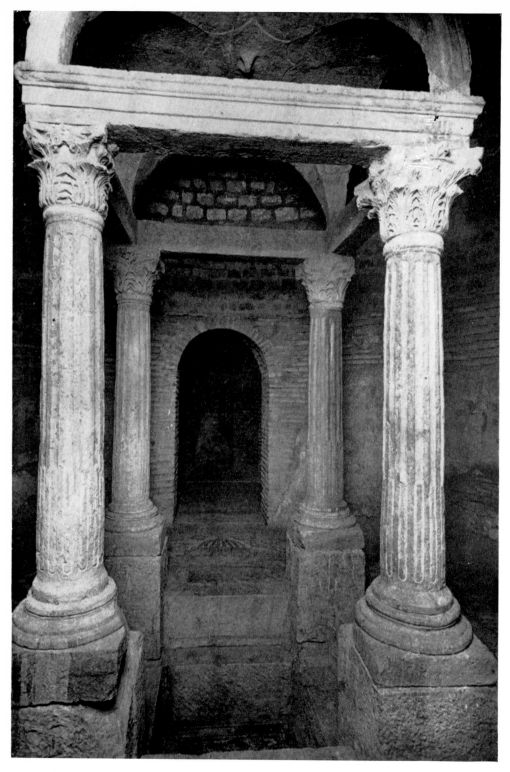

24. Font, Cuicul

25. Pavement, Baptistery at Salona

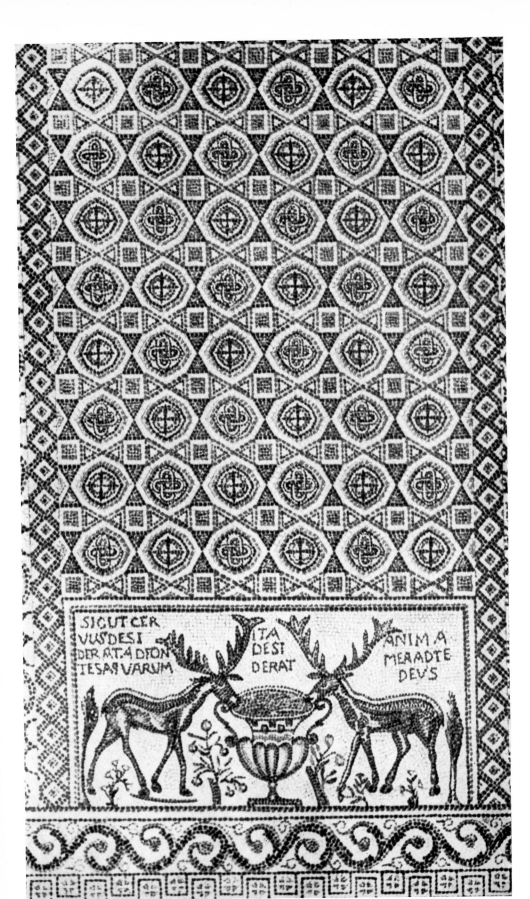

SICUT CER
VUS DESI
DERAT AD FON
TES AQUARUM

ITA
DESI
DERAT

ANIMA
MEA AD TE
DEUS

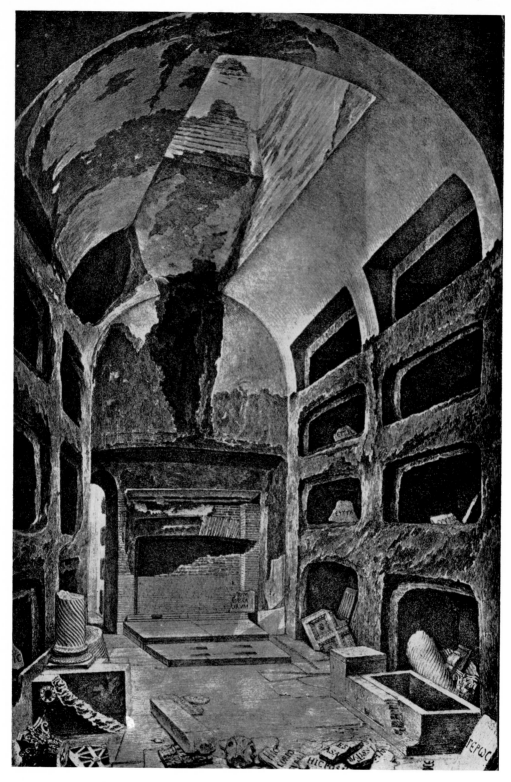

26. Crypt of the Popes, Catacomb of Callixtus, Rome

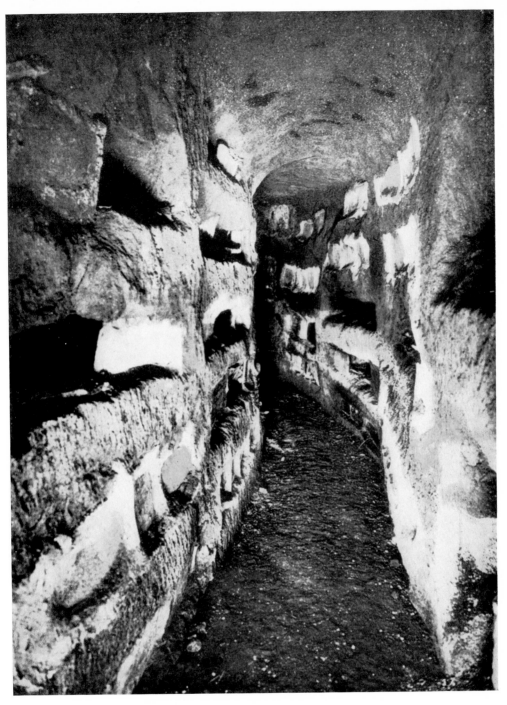

27. Gallery in the Catacomb of Alexander, Rome

28. (a), (b), (c). Three tomb-inscriptions, Rome

29. The oldest catacomb frescoes, Rome:
 (a) Baptism
 (b) The Eucharist

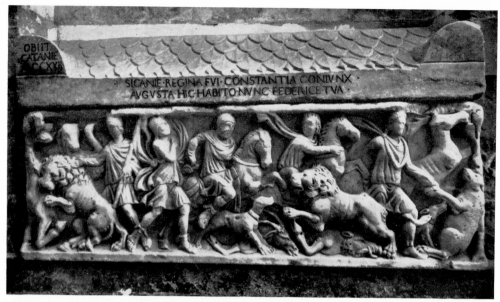

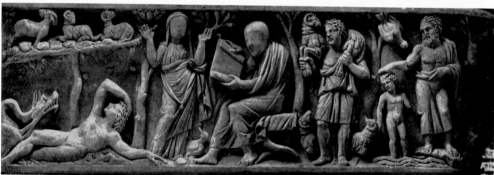

30. Three sarcophagi: (a) Sarcophagus with a hunting scene, Palermo
(b) Sarcophagus from Santa Maria Antica, Rome
(c) Sarcophagus No. 161, Lateran, Rome

31. The Healing of the Man Born Blind, Terme, Rome

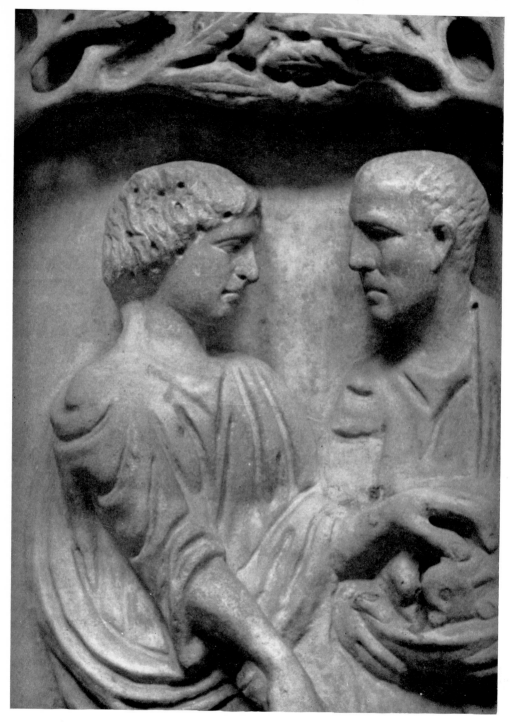

32. The Bread and Fishes, Arles

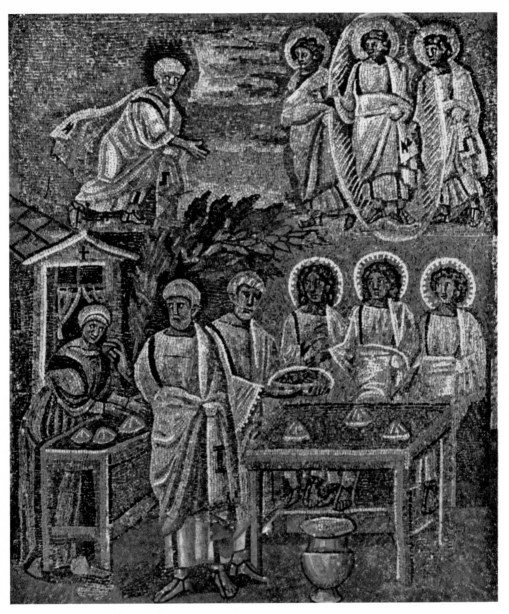

33. The Hospitality of Abraham, Santa Maria Maggiore, Rome

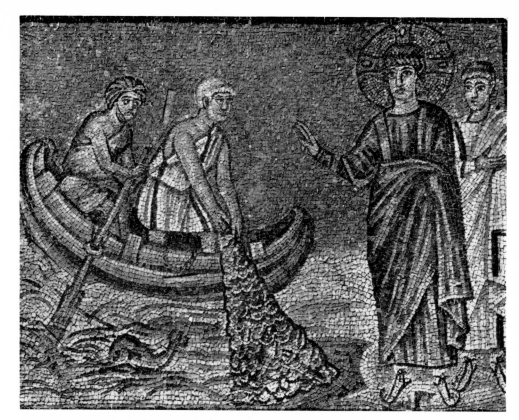

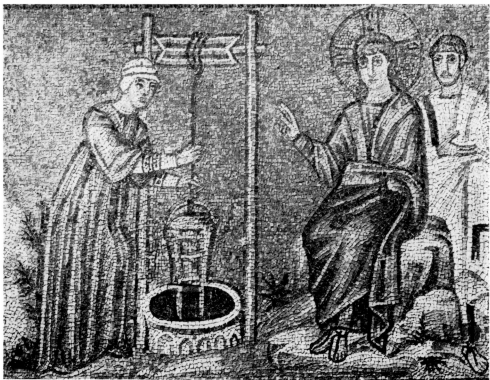

34. Two *Historiae* from Sant' Apollinare Nuovo, Ravenna:
 (a) The Miraculous Draught of Fishes
 (b) The Dialogue on the Living Water

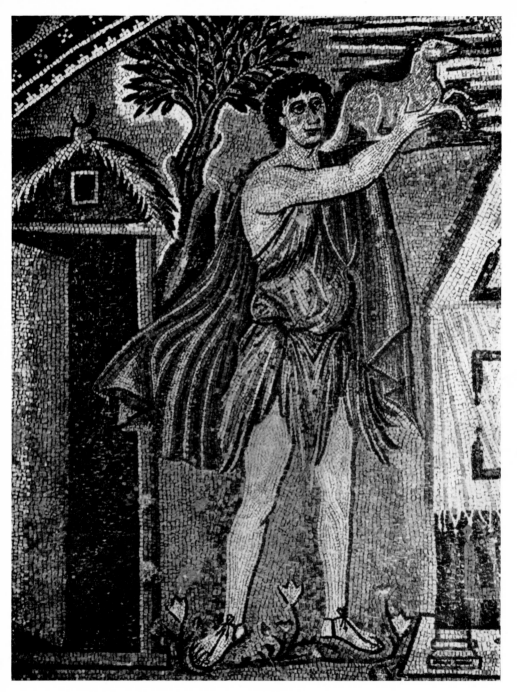

35. The Sacrifice of Abel, San Vitale, Ravenna

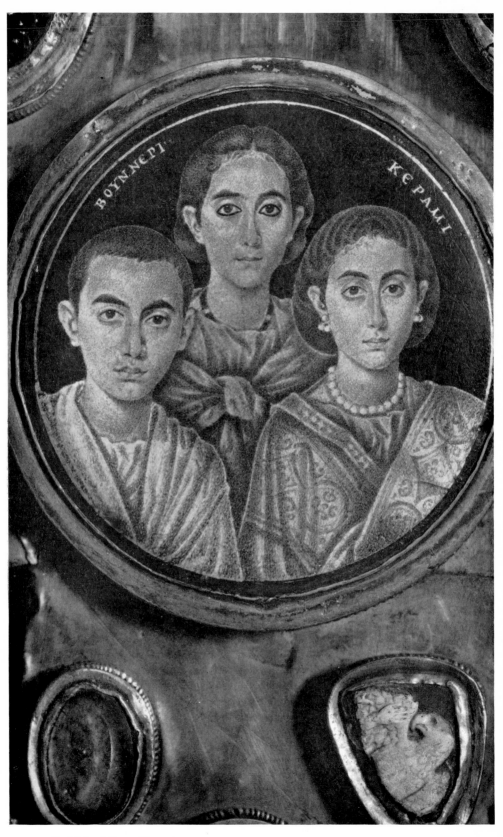

36. Gold-leaf from Brescia

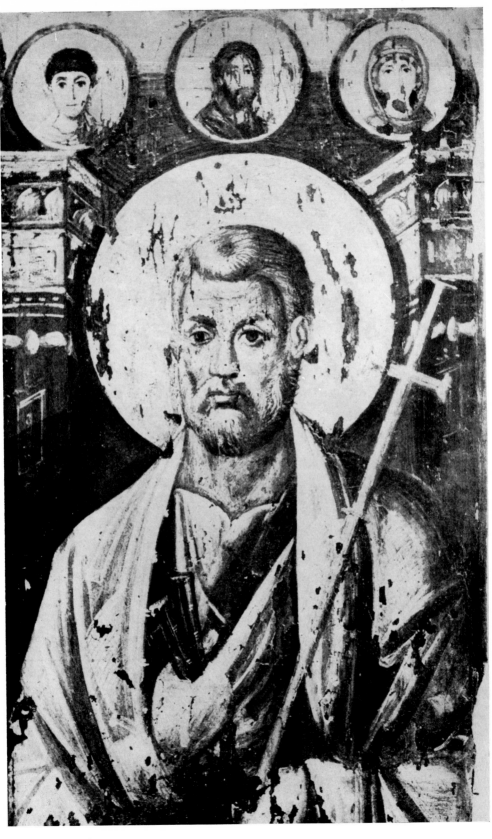

37. Icon of St. Peter, Sinai

38. Christ as the Teacher, Sarcophagus No. 138, Lateran, Rome

39. Medallions with portraits of the Apostles, San Vitale, Ravenna

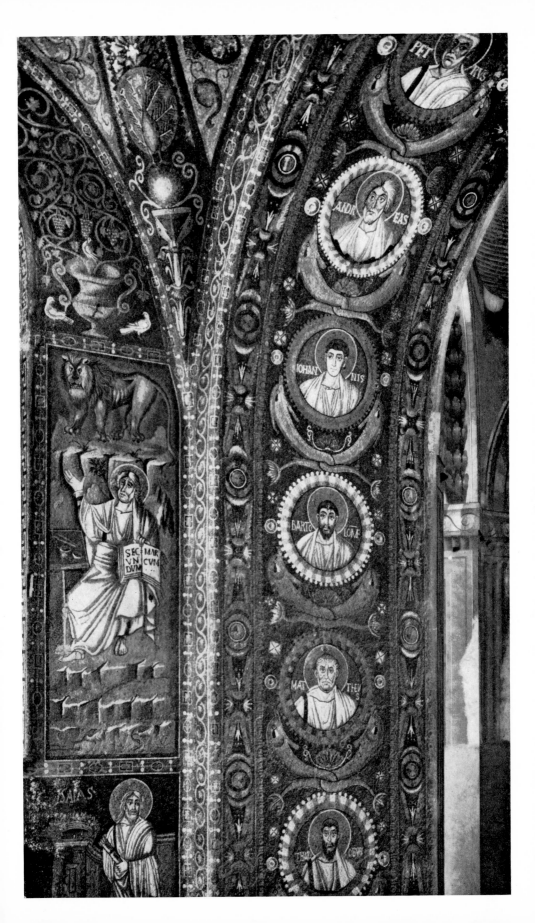

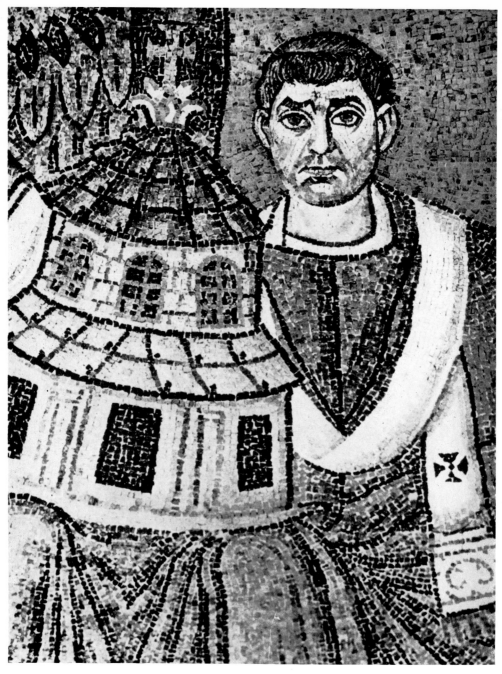

40. Bishop Ecclesius, San Vitale, Ravenna

41. Euphrasius, Claudius and their little son, Porec

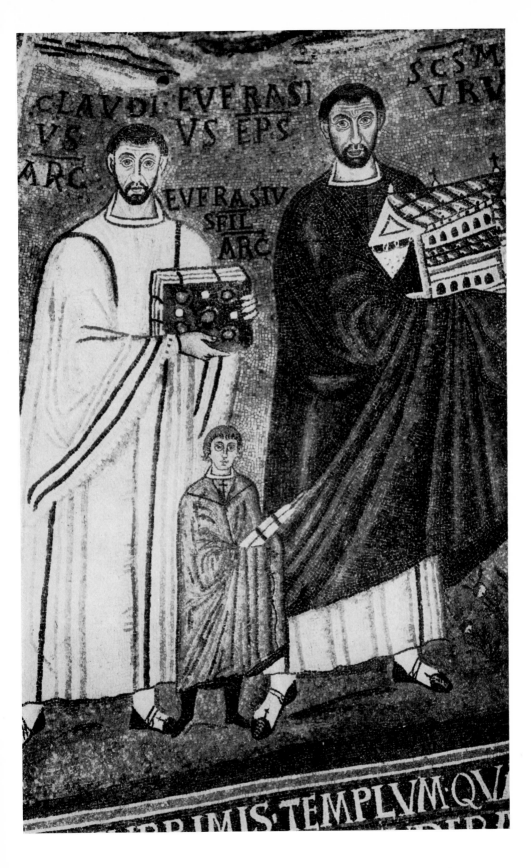

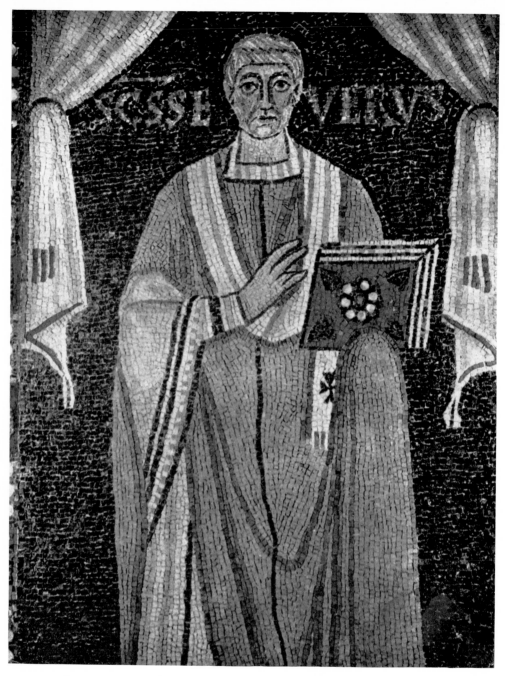

42. Bishop Severus, Classis

43. Mother and her child, Coemeterium Maius, Rome

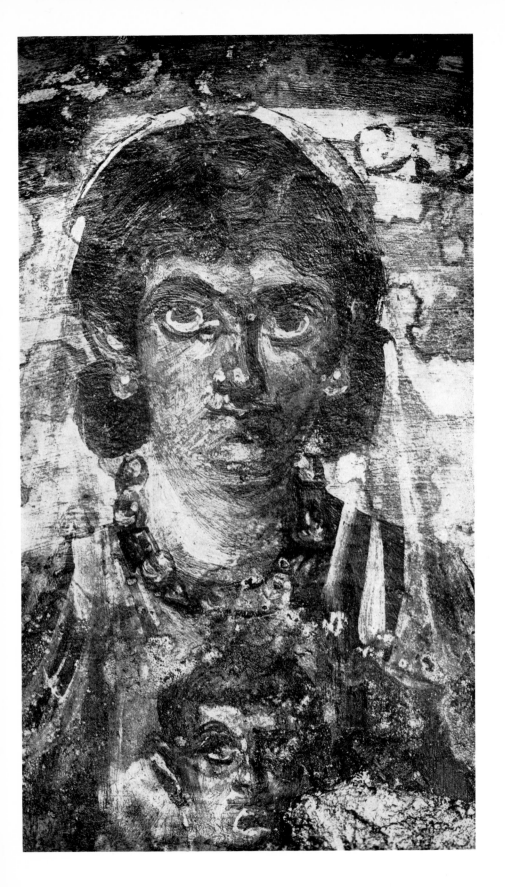

44. The Wise and Foolish Virgins, Rossano Codex

45. The Crucifixion and Easter morning, Rabbula Codex

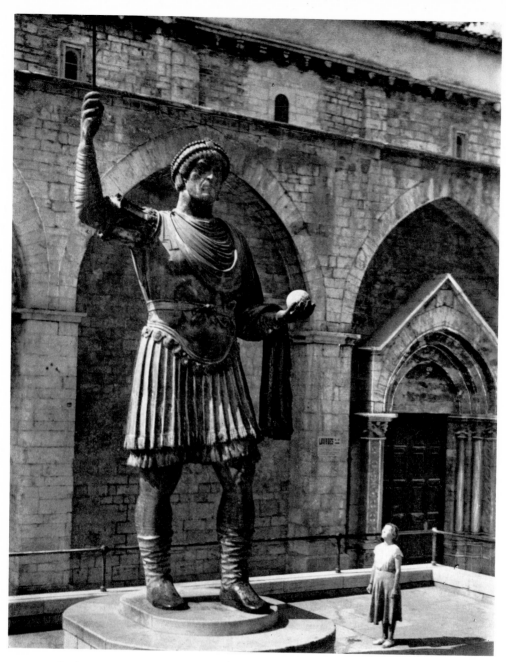

46. The bronze statue at Barletta

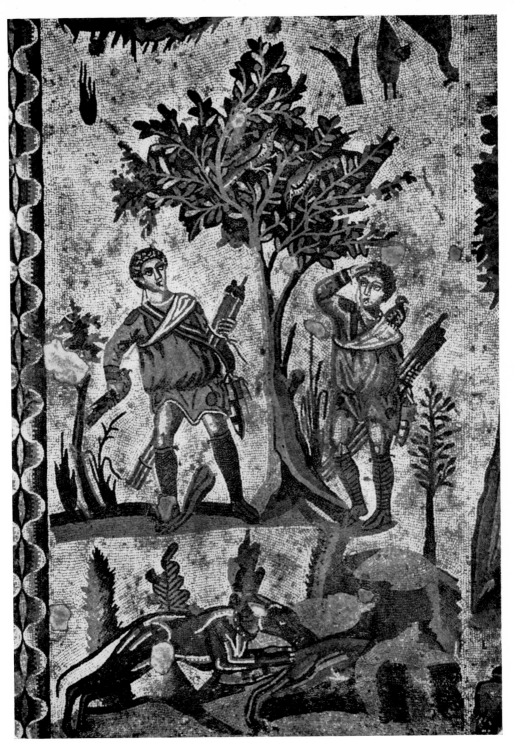

47. Mosaic pavement, Piazza Armerina

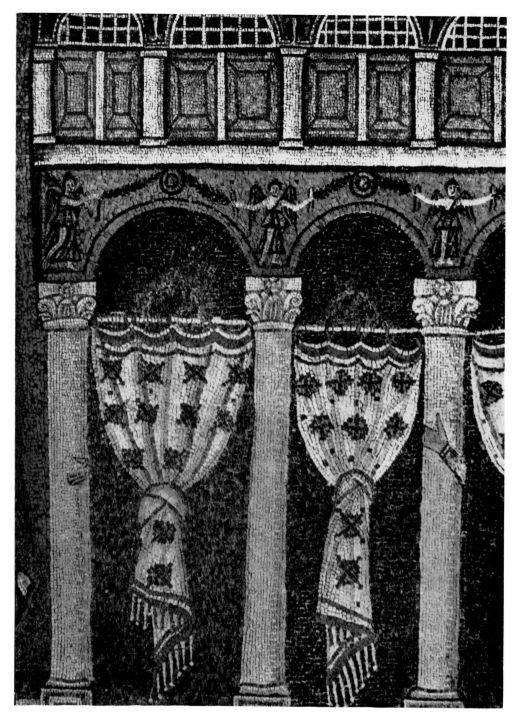

48. Curtain, Ravenna